The Lightning Field Kenneth Baker

The Lightning Field

Kenneth Baker

Yale University Press, New Haven and London

Published in 2008 by Yale University Press, New Haven and London
www.yalebooks.com

Designed by Laura Fields Design
Set in Minion and Helvetica Neue
Edited by Bettina Funcke
Managing editor, Karen Kelly
Proofreading by Philomena Mariani, Richard Gallin, Barbara Schröder, and Jeanne Dreskin

Printed in the United States at Capital Offset Company Inc.

Library of Congress Cataloging-in-Publication Data
Baker, Kenneth, 1946–
The Lightning field / Kenneth Baker ; with a preface by Lynne Cooke.
 p. cm.
Includes bibliographical references.
ISBN 978-0-300-13894-8 (hardcover : alk. paper)
1. De Maria, Walter, 1935– Lightning field. 2. De Maria, Walter, 1935– —Criticism and interpretation. 3. Earthworks (Art)—New Mexico. I. Title.
N6537.D432A68 2008
709.2—dc22

 2008002510

A catalogue record for this book is available from the British Library.

The paper in this book meets the guidelines for permanence and durability of the Committee on Production Guidelines for Book Longevity of the Council on Library Resources.

10 9 8 7 6 5 4 3 2 1

Page xvi: Walter De Maria, *The Lightning Field*, 1977. © Walter De Maria.
Photo: Kenneth Baker.

Contents

Preface *Lynne Cooke*

The Lightning Field *Kenneth Baker*

Introduction 1

1978 ... 7

1994–2007 31

Notes .. 140

Bibliography 152

Preface *Lynne Cooke*

I

In "The Loss of the Creature," Walker Percy ruefully explores the difficulty of having a meaningful encounter with a great work of art, a renowned landmark or, even, a prosaic artifact.[1] First published in 1958, his prescient text begins by probing the constraints and impediments that preclude a transparent—that is, direct and immediate—approach: "Why is it almost impossible to gaze directly at the Grand Canyon . . . and see it for what it is?"[2] If predictable with the benefit of hindsight, Percy's answer to what is essentially a rhetorical question is nonetheless still persuasive today: "It is almost impossible because the Grand Canyon, the thing as it is, has been appropriated by the symbolic complex which has already been formed in the sightseer's mind. . . . The thing is no longer the thing as it confronted [the first viewer]; it is rather that which has already been formulated."[3] In encouraging viewers to become arbiters of their own experiences rather than passive consumers of prepackaged or professional formulations, Percy's analysis identified key issues that would dominate cultural discourse in the sixties and, hence, issues that would preoccupy many artists who came to maturity in that decade.

As viewers struggle to avoid routine interpretations, some types of confrontation, in Percy's opinion, are more viable than others; most sightseers—especially those least familiar with the terrain, nonetheless often unwittingly forfeit their sovereignty. "Their basic placement in the world is such that [by recognizing] a priority of title of the expert over his particular department of being," Percy argues, they cede their autonomy as subjects. "The worst of this impoverishment is that there is no sense of impoverishment. . . . The caste of the layman-expert is not the fault of the expert," he concludes. "It is due altogether to the eager surrender of sovereignty by the layman so that he may take up the role not of the person but of the consumer."[4] In Percy's opinion, such surrenders are made not only to theorists but to those whom he terms "a class of privileged knowers"[5]; it is the spectators', automatic—often

even unconscious—estrangement that impels them to capitulate again and again to the relevant authority figures in order to validate their experiences.

These two quite different processes, operating in tandem, produce what Percy deems "a double deprivation"[6]: "The [work of art] is obscured by the symbolic package which is formulated not by the art work itself but by the media through which it is transmitted, the media which . . . is believed to be transparent."[7] In addition, theory may also render the object invisible; that is, the object is radically devalued when it is seen as a prime instance of a certain class or category. In attempting to reassert the "sovereignty of knower over known,"[8] the key challenge becomes one of finding ways to circumvent the expert's presentation so that the layman's encounter will lie outside familiar and approved channels and will recognize the individuality and specificity, as distinct from the typological or generic character, of the object of study. "First, the thing is lost through its packaging. The very means by which the thing is presented for consumption, the very techniques by which the thing is made available as an item of need-satisfaction," remove it from direct apprehension.[9] The second loss, which Percy deems "the spoliation of the thing . . . by the layman's misunderstanding of . . . theory" comes about when "it stands in the Platonic relation of being a specimen of such and such an underlying principle."[10] As the layman adopts the theory, the theorist's expectations are reversed: "Instead of the marvels of the universe being made available to the public, the universe is disposed of by theory."[11] Too often everything the theorist does succeeds only in becoming, for the novice, part of the educational package into which the object is subsumed.

II

A work of art "should have at least ten meanings,"[12] Walter De Maria asserted, in 1972 in an uncharacteristically forthright interview. He followed this pronouncement with a comment

about his practice that echoed a key statement he had made over a decade earlier on one of the very few other occasions he has spoken for the record: "The work of art should make an unforgettable impact, comparable to that of a major natural event, such as an earth-quake or hurricane."[13] Famously reclusive, De Maria has otherwise rigorously eschewed the public role of author and has hence repudiated the option of serving as the primary filter for the reception of his work, and as the principal guide to its meaning. He also noted, later in the course of that exceptional conversation, that he had no plans for a gallery show that year; instead, he intended to focus on three conceptual pieces all devised specifically for art publications.[14] All three would take the form of photo essays addressed to what he deemed "a mass audience."[15] Thus, neither then nor subsequently did De Maria's famed reclusiveness bespeak indifference or hostility to the media: on the contrary, like certain others of his generation who came to artistic maturity in the early sixties, he has shown himself highly sensitive to the most potent channels of public communication by astutely engaging with its principal mechanisms: image and text.

In light of his desire for manifold rather than fixed meanings and for intense affect, De Maria remains consistent in trying to assure that his monumental in situ works stand outside the normative contexts of art historical and critical exegesis; moreover, in attempting to prevent their immersion in what Percy calls "the symbolic complex," which creates a preformulated impression, De Maria has delimited as far as possible their unregulated circulation within mainstream media channels. Just as he refrains from spoken and written commentary on his art (or anything else), so he has continued to control closely the rights to reproduction of his artworks, restricting not only the number of images available of any specific work but also the contexts in which they may be reproduced.

In this way, he has adopted a position diametrically opposed to that of his peer Robert Smithson, who grounded both his aesthetic and practice in the belief that art objects only

exist in and through discursive networks. With much comic irony, Smithson often hijacked the language routinely employed by tour guides and scholarly educators, those key players who, in Percy's estimation, typically distance spectators from their objects of study by mediating their engagement rather than providing the tools that would enable their audiences to become arbiters of their own experiences.[16] No artist of that sixties generation (nor any previous one) more brilliantly and inventively formulated this influential position than Smithson, and nowhere did he do this more fully and forcefully than in relation to his great Land Art work, *Spiral Jetty* (1970). Smithson clearly believed that most of his audience would only ever know the remote sculpture indirectly—that is, not through actual personal interaction but via reproductive forms. He consequently devoted considerable energy to the making of what he termed Nonsites, aesthetic intermediaries that filter all such encounters into a discursive arena. In the case of the *Spiral Jetty*, the Nonsites took the guise of a film and an essay. Designed to serve not as documents but as variants on the Land Art sculpture, they would be circulated through printed matter, galleries, cinemas, and related channels. In both of these closely related works, he overlaid into a beguiling discursive network fact, fiction, and fantasy culled from geological, geographical, and cartographical data, literary sources, science-fiction film, and much else.[17] In addition, he commissioned photographs of the iconic sculpture, which were exhibited and widely published from the moment it was completed. Today, everyone (and the numbers have grown unexpectedly in recent years) who makes the journey to Rozel Point, located on the edge of the Great Salt Lake in Utah, does so already deeply primed by knowledge of the piece, knowledge that inevitably shapes and governs their experiences as much as their expectations. Given such levels of fame and familiarity, the question becomes not how any visitor can encounter this work afresh, innocent of its sedimented histories, but how to negotiate the prescriptive formulations that encrust it.[18]

In its canny embrace of the perils of predigestion as a necessary and ineluctable challenge, Smithson's modus operandi was radical when formulated, but now is commonplace. By contrast, De Maria's well-honed stance is today rarely recognized as a considered position and so appears simply intractable. Paralleling Percy's analysis, De Maria's approach is twofold. He seeks to orchestrate a viewer's encounter with his art by foregrounding as far as possible an unmediated experience that resists easy consumption; at the same time, he attempts to preclude any unwitting surrender to expert opinion in the guise of theoretical exegesis. Under the terms upon which a visit to his monumental Land artwork *The Lightning Field* (1977) takes place, there are never more than six visitors permitted at any one time and all participants are required to spend a full day there. The restored log cabin where they stay overnight not only has no communication systems such as radio, television, and phone, but there are no art history books or magazines, and no publications on the climate, geography, history, and related features of the location. Those who come to see this work in its remote desert plateau in New Mexico are offered food and shelter but no ancillary information beyond a short text the artist published in *Artforum* in 1980.[19] This basic fact sheet provides straightforward itemized information of the kind that guarantees visitors are not distracted by the need to tease out fundamental relations between the land and the material components that comprise the sculpture, and instead can focus on the immaterial—the ever-changing light, the elusive spatial dimensions, and the specificity and singularity of the shifting relationship between the sculptural grid and the land and the sky. From such observations, larger, perhaps metaphysical, questions may arise. Irrespective of whatever meanings abound during that encounter, they will not be fostered by authoritative or renowned specialists. By slowing down the interaction with the work, De Maria seems to trust that the richness of the in situ experience will gradually

override all preconceptions, allowing the work to have an impact comparable to that of the most powerful natural occurrences, his long-standing aesthetic yardstick.

If De Maria has proven resistant to serving as the primary vehicle through which interpretation occurs, he has been equally resistant to the notion of accredited authorities whose studies might corral and fix the meaning of the artwork within a historic or theoretical framework. Consistent with this position, he has not made himself available to researchers and scholars for interview or consultation during the writing of books and dissertations on his art. Unlicensed reproductions of *The Lightning Field* and even unauthorized use of its title have been vigorously prosecuted. In this, he, like Percy, may be less suspicious of the disciplinary specialist than worried about the layman who either surrenders too readily to the expert's opinion or is seduced by sensational journalism.

Wanting to ensure that from its inception *The Lightning Field* would have an ongoing audience long into the future, the artist was faced with the conundrum of how to attract a broad audience of visitors beyond the narrow confines of the art world and its affiliates. One way to build interest might be via a book commissioned from an individual who, after spending considerable amounts of time on site, might write a situated account based on his or her extensive experience. In 1977, the year in which the *Field* was completed, the art critic Kenneth Baker was invited to undertake such a task: the resulting manuscript was to be published by Dia Art Foundation, the organization that commissioned and now cares for this artwork as part of its collection. A well-known contributor to the vanguard magazine of the day, *Artforum*, Baker was less of a partisan theorist than many of his colleagues identified with that publication; and the range of work he responded to was more catholic than that championed by many on its masthead. No directives were provided concerning his approach to the subject. Nevertheless, the venture was derailed when the artist found

Baker's long first draft to be too descriptive.[20] Some two decades later, in the mid-1990s, Baker, who was by then the resident art critic for the *San Francisco Chronicle*, sought to revive the project. Encouraged by De Maria to visit the *Field* during seasons other than those when he had previously been on location, the author renewed his deep acquaintance with the now-famous artwork he so revered, before beginning to write a second part that would expand the manuscript to a book-length text. Once again external circumstances intervened, forestalling publication. Soon after September 11, 2001, Baker returned to the challenge and, several years later, completed his text with a recursive section very different in spirit and content from his initial essay.

The first monograph devoted to *The Lightning Field*, this book has not been sanctioned as the official, nor even the insider, interpretation. Though it is doubtful whether any future writer will experience De Maria's magnum opus so intimately over so long a period of time, Baker's text is unlikely to become the definitive interpretation. Moreover, it hazards few constraints to future approaches to the piece; for nowhere in his manuscript does Baker parade his professional credentials nor the singular set of circumstances that were generated by the original commission, nor does he attempt to consider De Maria's artwork in standard art historical terms, according to academic formulas. *The Lightning Field* is neither discussed in relation to the evolution of the artist's practice over his forty-year career, nor is it situated in relation to works made concurrently by close associates, like Smithson or Michael Heizer. From his opening paragraph, Baker grounds his experience in the personal and particular; though autobiographical reference is not unduly foregrounded, his own reactions always constitute the point of departure for subsequent rumination and reflection. Filtered through a broad range of quotations and citations from writers who have long fueled and shaped his thinking, Baker's speculations have a timely, not to say urgent, relevance. Always the educated observer rather than the partisan apologist, he remains

an unapologetic humanist.[21] Questioned recently about his methodology, he focused on "the exercise of critical perception": "If, when you look at an object and you try to say something about why it stirs you, why it excites you—something that isn't simply intellectual, something that really is at the level of feeling—then you're trying to connect to language something that is basically nonlinguistic or nontranslatable," he argued. "That effort to try and shine the light of language on these dark areas of our experience is very much connected to what I do in critical practice," he continued, adding an important rider, "It's also about the challenge to the ruling values of this culture at the moment, when there seem to be these psychological billboards everywhere saying 'You've got to win at all costs,' and 'Take no prisoners' and 'Yield to no one.' It's an alternative path around these hardened goals and priorities that are invisible or unarticulated, and really not what we want if we're right-thinking people."[22] Unassailably independent, Baker's deeply considered response reflects upon a series of encounters stretching over half a lifetime.[23]

While not conceived as required reading for those who plan to see this celebrated artwork for themselves, his book may come to be as valued by those who have not made the trip as by those who have. Presupposing that sustained and probing responses to individual works of art can elicit speculation of a profound kind, Baker's text ultimately offers more than an exemplary model through which to address this singular sculpture. For it encourages us, his readers, to explore at length and over an extended duration our own particular, personal, even idiosyncratic, relations with great works of all kinds so that they may become crucial experiences in a life journey rather than merely casual encounters, trophies in a chain of masterworks consumed en passant.

Notes

1. Walker Percy, "The Loss of the Creature"(1958), in *The Message in the Bottle* (New York: Farrar, Straus and Giroux, 1975), pp. 46–63.

2. Ibid., p. 47.

3. Ibid.

4. Ibid., p. 54.

5. Ibid.

6. Ibid., p. 58.

7. Ibid., p. 57.

8. Ibid., p. 59.

9. Ibid., p. 62.

10. Ibid., pp. 62–63.

11. Ibid., p. 63.

12. Walter De Maria, interview by Paul Cummings, October 4, 1972, Oral History Interviews, Archives of American Art, http://www.aaa.si.edu/collections/oralhistories/transcripts/demari72.htm. Tellingly, the statement was made in the context of this extended interview, conducted for posterity (rather than for immediate consumption in the form of publication) over several hours in New York City on two separate occasions. The conversation closely tracks De Maria's artistic formation, from his student years in San Francisco in the mid-1950s, to the onset of his mature work following his arrival in New York City at the beginning of the 1960s through to the date of the interview.

13. De Maria, "Meaningless Work" (1960), in *An Anthology*, ed. La Monte Young (1963; repr. New York: Heiner Friedrich, 1970), np. In the 1972 interview with Cummings, De Maria went on to suggest that in order for sculptural works to realize this affective role, they need to be considered like films rather than like discrete modernist objects—that is, they would be ensured the scale and budget, the technical means, the length of construction and complexity of process that was normal with a feature film. It would only be in 1974, however, that he would first have the opportunity to instigate an ambitious work of this kind, when he began preliminary discussions with the Lone Star Foundation (which would later become Dia Art Foundation) on a project that would finally be realized in 1977 as *The Lightning Field.*

14. See De Maria, *Avalanche* 4 (Spring 1972), pp. 52–63; De Maria, "Conceptual Art," *Arts Magazine* 46, no. 7 (May 1972), cover and pp. 39–43; and Grégoire Müller and Gianfranco Gorgoni, *The New Avant-Garde: Issues for the Art of the Seventies* (New York: Praeger Publishers, 1972), pp. 150–57.

15. De Maria, interview by Cummings. It is doubtful whether these ventures foregrounding the structures of media communication should be considered works in De Maria's oeuvre, in contrast to those of his peers such as Robert Smithson; rather, they could be considered strategies in which he formulated his aesthetic. Thus, for example, when asked by photographer Gianfranco Gorgoni to pose for photographs for a forthcoming publication in which many of his peers would also be featured, De Maria demurred. He requested instead that Gorgoni make portraits of his six gallerists, whom he deemed, with a sly wit and aplomb, his representatives in the public sphere. And, for an article on *The Lightning Field* to be published in the April 1980 issue of *Artforum,* De Maria persuaded the editor to alter the normal layout to accommodate one he designed, comprising four double-page spreads preceded by a monochrome blue-green page. See De Maria, "The Lightning Field: Some Facts, Notes, Data, Information, Statistics and Statements," *Artforum* 18, no. 8 (April 1980), pp. 52–59.

16. See Smithson's essay, "A Tour of the Monuments of Passaic, New Jersey" (1967), in *Robert Smithson: The Collected Writings*, ed. Jack Flam (Berkeley: University of California Press, 1996), pp. 68–74; and the slide lecture

given to students in the architecture department at the University of Utah in 1972, known as "Hotel Palenque."

17. Purloining and ventriloquizing authorities from myriad disciplines, Smithson's multivalent voice has proven enormously influential. It is not surprising, given the importance and influence of Smithson's own collected writings, first published in 1979, that the contents of his library, now part of the collection of the Archives of American Art, has also been made public for scholars and others alike.

18. This issue is deftly explicated by Smithson specialist Ann Reynolds in her incisive text "At the Jetty," in *Robert Smithson: Spiral Jetty*, ed. Lynne Cooke and Karen Kelly (Berkeley: University of California Press, in association with Dia Art Foundation, 2005), pp. 73–77.

19. See De Maria, "The Lightning Field: Some Facts, Notes, Data, Information, Statistics and Statements." The very heading, the subtitle of the text, is telling. After asserting his priority in the field of Land Art, De Maria brackets his collection of data with three key statements: "The sum of the facts does not constitute the work or determine its aesthetics. . . . The invisible is real. . . . Isolation is the essence of land art."

20. See Diana Sherman Kash, "Critiquing Art," *Bucknell World* 27, no. 7 (November 1999), http://www.departments.bucknell.edu/communications/bucknellworld/1999-11/feature2.html.

21. See Kenneth Baker, "San Francisco Frequency," interview by Oriane Stender, *Artnet*, http://www.artnet.com/magazine/features/stender/stender10-7-03.asp.

22. Ibid. The context of this discussion is illuminating. The quoted passage was preceded by the following:

[Oriane Stender]: I understand that aikido is an important part of your life. Is this a spiritual retreat?

[Baker]: No, no, it's central to my understanding of what I'm doing professionally. I teach a class in aikido at the California College of Arts and I do that because so much of the work that I see is too head-driven, and aikido is about, among other things, bringing the heart forward, both in posture terms and in terms of a source of action, a source of the spirit in which you do things. It's a heartless world, in all sorts of ways, and this kind of practice wins back some ground from that condition within which we all have to exist. And because it's a partner practice throughout, with the partners always changing, it's also a way of experiencing people in a kind of detail that ordinary social existence doesn't permit. I mean you really have intimate contact with people in a way that continues and develops and becomes quite deep. But it's also impersonal, it's asocial, it's nonsexual, it's ritualized and formalized in the sense that most of what you experience on the mat seems to be completely cut off from language, but when I'm teaching I try to speak some of the unsayable, try to bring up some of that proprioceptive knowledge into the level of what can be shared. . . . To me that's very close to the exercise of critical perception.

23. It is doubtful that any writer in the near future will have Kenneth Baker's particular credentials, few will ever have the opportunity to spend such unimpeded amounts of time there, none will be able to experience it "raw" or will have been part of that historical downtown New York milieu of the late sixties and early seventies in which artistic ideas and visions were formed and honed.

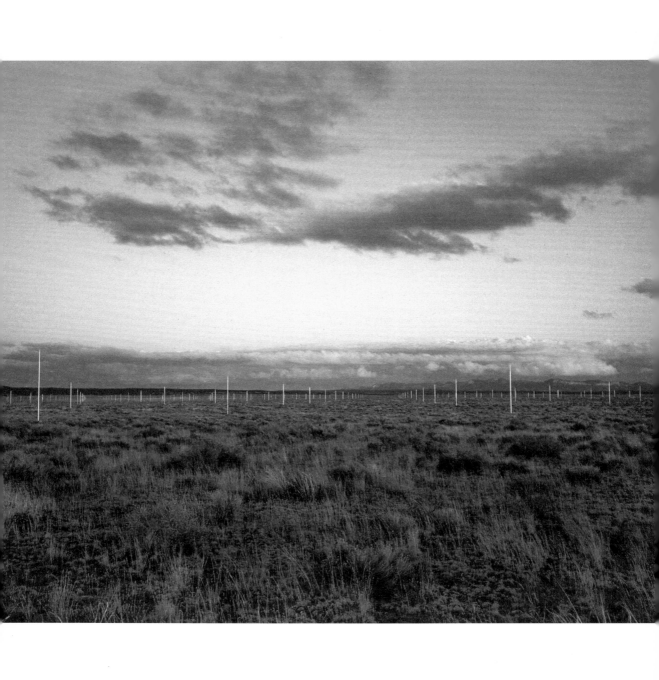

Kenneth Baker

Introduction

Two essays, written more than twenty-five years apart, make up this book. Although laced with argument and fitted with source notes, the book is a work of description and reflection, not of scholarship. And, although it refers to various works by Walter De Maria, the book is not a monographic treatment of this famously uncommunicative artist's career. It presents detailed accounts of *The Lightning Field* (1977), De Maria's greatest piece and one of the profoundest of American artworks, and tries to find words for the work's physical, situational poetics.

The Lightning Field is a philosophical sundial, telling the time of history,[1] as Theodor W. Adorno once said of lyric poetry. Its closest pop culture counterpart may be the Doomsday Clock, instituted by the *Bulletin of the Atomic Scientists*, which symbolizes the imminence of nuclear catastrophe as a countdown to midnight. In response to events, the board of the *Bulletin* has reset the clock eighteen times since 1947. At this writing, it stands at five minutes to midnight.[2]

In early 1978, Dia Art Foundation, which financed and owns *The Lightning Field*, commissioned me to write a study of the work. Although Dia decided against publishing the original text, new interest was expressed in 1994 in publishing the essay if it could be fleshed out to book length. By then, in my view, the 1978 text had already become a period artifact in its own right. (It appears here with only few and very minor revisions.) The longer part of the book recounts the thinking triggered by visiting *The Lightning Field* four more times, around the calendar, to experience a broad spectrum of the work's changes.

The terrorist massacres of September 11, 2001, occurred about two months after the second manuscript's initial completion, giving some of its themes an unanticipated currency. Those events forced upon Americans, at least upon those open to it, a new history-consciousness: to many that meant a wrenching

remapping or a first calibration of their own geopolitical position. For a short period, while Pentagon strategists plotted a military response but before they began to execute it, the mass media, especially radio, made space for an improbable diversity of voices and viewpoints. Some explained in detail the foreign policy roots of anti-American sentiment in various parts of the world and proposed constructive alternatives to the violent reprisals and imperialist opportunism that have followed. But soon an ill-defined, implicitly endless "war on terror" turned to a blank check for an assault on civil liberties at home, an explosion of military and "national security" spending, and a demonizing of dissent.

Abroad, American forces hammered Afghanistan, routing its Islamist Taliban leaders in failed pursuit of Osama bin Laden, the financier and mastermind of the September 11 atrocities. More than a year and a half later, after pridefully alienating much of world opinion, the Bush administration invaded Iraq, in an adventure that everywhere reawakened suspicions and fears of an American drive for world hegemony. With characteristic unself-consciousness, the Bush administration branded its aerial destruction of Baghdad "shock and awe," tacitly acknowledging the terroristic nature of warfare itself.

Manhattan being antipodal to *The Lightning Field*, it seems appropriate— indeed, irresistible—to quote here a prophetic passage from E. B. White cited often since September 11, 2001. The subtlest change in New York, White wrote in 1949, is something people don't speak much about but that is in everyone's mind. The city, for the first time in its long history, is destructible. A single flight of planes no bigger than a wedge of geese can quickly end this island fantasy, burn the towers, crumble the bridges, turn the underground passages into lethal chambers, cremate the millions. The intimation of mortality is part of New York now: in the sound of jets overhead, in the black headlines of the latest edition.

All dwellers in cities must live with the stubborn fact of annihilation; in New York the fact is somewhat more concentrated because of the concentration of the city itself, and because, of all targets, New York has a certain clear priority. In the

mind of whatever perverted dreamer might loose the lightning, New York must hold a steady, irresistible charm.[3]

From the moment of its completion in 1977, *The Lightning Field* has ranged itself against whatever background consciousness of the times that visitors bring to it. For most, this has meant a stirring, frequently troubling, disorientation. The terrorism of September 11 abruptly made that sort of disorientation real and immediate to almost every American.

In *After Progress* (2001), Norman Birnbaum nicely outlines the cultural situation in which most of this book was written. In no other industrial democracy are inequalities in wealth and income as pronounced as they are in the United States, Birnbaum writes. In no other, is an organized effort to overcome these, recently, so conspicuous by its absence. In no other is the withdrawal from the public sphere, with half the electorate abstaining from voting, so high. In no other, finally, are the citizenry's ideas of past and present so unconnected to the work of the nation's thinkers. The United States is a class society that dares not utter its own name, a good many of its citizens lost in historical time and social space. At the same time, it is a democracy of manners. Traditions of disrespect for authority and convention, of systematic idiosyncrasy, live on. Odd segments of the nation are often energized by projects of protest. The churches, and a spectrum of secular groups, propagate narratives of first and last things that contrast, often grotesquely, with the metahistorical flatness of the theologies of existence fabricated by the omnipresent industry of culture.

Does the conflict between modernity and antimodernity, in their American versions, explain as much, or more, of American existence as the conflict of classes? The politics of culture are too discordant, too jagged, to allow so easy an answer.[4] Since Birnbaum wrote, as the crude ideological profile of the American right has sharpened, the conflict between modernity and antimodernity seems to account for more and more of the politics of culture.

Among the gruesome ironies of the September 11 calamity was its reminder that contemporary technology makes colossal destructiveness potentially available

even to ideologues who claim to reject the world, and the world-picture, that advanced technology epitomizes.

Media pundits and politicians still have not tired of saying that September 11 "changed everything." They frequently use September 10 and September 12 as shorthand for the different sides of a watershed in popular consciousness.

But a half century ago, using very similar terms, Hannah Arendt pegged the epochal change in human consciousness to World War I, a change now nearly lost to living memory. September 11 must count as one of its latest reverberations and the one closest to home. The days before and the days after the first World War, Arendt wrote, are separated not like the end of an old and the beginning of a new period, but like the day before and the day after an explosion. Yet this figure of speech is as inaccurate as are all the others, because the quiet of sorrow which settles down after a catastrophe has never come to pass. The first explosion seems to have touched off a chain reaction in which we have been caught ever since and which nobody seems to be able to stop.[5] At this writing, a new cascade of threats and violent reprisals in the Middle East promises to amplify those reverberations yet again to global scale.

A spate of publications has flowed from every political direction, analyzing and rationalizing or condemning the invasion of Iraq as a response to Islamist terrorism as the new global threat to American interests. Probably no one has summed up the muddle of plausible motives behind the fateful digression into Iraq more concisely than Stephen Holmes, in a review of Michael Mann's book *Incoherent Empire.* Without trying to establish any particular hierarchy, Holmes wrote, we can safely say that the following jumble of motives, seizing different actors at different times, contributed to the decision. . . . The administration invaded Iraq to frighten any group or state that might feel emboldened to replicate 11 September; to offer solace to American voters traumatized by 11 September by letting them see U.S. military supremacy in action; to show that the U.S. was still responding aggressively to 11 September even after "running out of targets" in Afghanistan; to finish a job that George H. W. Bush had left undone; to avenge Saddam's 1993 attempt

to assassinate the first President Bush; to field-test Rumsfeld's proposals for military reform; to reduce U.S. dependency on the Saudis by securing some leverage over Iraqi oil supplies; to allow the U.S. to evacuate its troops from Saudi Arabia, thereby removing a focal point of anti-American rage; to destroy an important regional threat to Israel; to make sure that Saddam would not acquire the capacity for nuclear blackmail after France, Germany and other countries dismantled the UN embargo; to express America's self-love by offering to replicate American political institutions abroad; to counter "moral relativism" by revealing that the world really is divided between good and evil.[6]

The massacres of September 11 were a setback in many ways, including one seldom remarked: they turned back the clock of American mass psychology. As if the Cold War were again at its most perilous, we have reverted to daily mental life as a fraught process of waiting: waiting for "the other shoe to drop," as Art Spiegelman, a witness to the Twin Towers' collapse puts it, waiting for the next epochal atrocity, or the official pretext for unleashing it. Were terrorists to succeed in detonating a nuclear device in an American city—a most unlikely event according to expert opinion—it might easily trigger a nuclear exchange with Russia, merely out of panic and confusion. The former Cold War adversaries remain technologically in a hair-trigger nuclear standoff, as if no one had yet declared the Cold War ended. In a recent essay assessing "The New American Cold War," Russian studies scholar Stephen F. Cohen outlined the current peril. Experts differ, Cohen writes, as to which danger is the gravest—proliferation of Russia's enormous stockpile of nuclear, chemical and biological materials; ill-maintained nuclear reactors on land and on decommissioned submarines; an impaired early-warning system controlling missiles on hair-trigger alert; or the first-ever civil war in a shattered superpower, the terror-ridden Chechen conflict. But no one should doubt that together they constitute a much greater constant threat than any the United States faced during the Soviet era.[7]

Even before they have come into use again, nuclear weapons have once more extended the shadow they cast over the future, reasserted their dominance over

imagination on an unconscious level. Meanwhile intoxications of belief, of nationalistic sentiment and vengefulness, with or without historical foundation, continue to hold whole populations spellbound.

Behind the potentially paralyzing suspense of the new American war consciousness pulse denial and guilt: the guilt of all in the First World who understand that international peace must entail the globalization of minimal economic justice; the denial of those who understand this intuitively but refuse to acknowledge it. Demoralized by witnessing the spread of domestic political rot, Americans who take such things seriously feel disempowered to do anything about it.

Under such circumstances, many people conversant with the arts turn to them for consolation. *The Lightning Field* offers none. This confirms its importance. Artists cannot change or make history, John Berger wrote in 1979. The most they can do is to strip it of pretences.[8] *The Lightning Field* is a prime example of this sort of artistic success.

September 2006

1978

Walter De Maria's "Mile-Long Lightning Field," as he originally called it, is located at a remote spot on the North Plains of New Mexico. In New York, preparing to depart for *The Lightning Field*, I am told again and again that mud will be part of the trip. New York is so cold in late February, and so adamant in all seasons, that "mud" has no definite meaning there. Because snow still covers the Northeast, there is nothing strange about my wife and myself wearing the new waterproof boots we are too lazy to carry, as we board a plane for Albuquerque.

But after five hours' confinement in flight, the most reasonable provisions for ground conditions begin to look and feel out of touch. Before the flight ends, a tipsy Albuquerque lawyer has seated himself between us and is laughing at our spotless boots and our idea of conditions on the North Plains in spring, where he once hunted antelope. I retaliate soberly by telling him what I know of *The Lightning Field*: that it is a grid array of 400 stainless-steel poles, each two inches in diameter and sharpened to a point, covering a mile-by-kilometer area, and that it is the work of a living American artist whose name should be familiar to him. I try to make him feel that, as a trustee of the Albuquerque Museum, he should already be aware of such an outlandish-sounding contemporary art landmark in his own state, although I know it was completed less than six months before. But vodka and flight time have put him out of reach of my stabs at intimidation. While we land, he continues to laugh as he instructs us loudly to pronounce Quemado, "kwe-MAH-doh," after I mention it as the town nearest the site. (He is right about that.)

We are met at the airport by Helen Winkler, who has lived at *The Lightning Field* since the outset of its construction in June 1977. Helen, a lank, taciturn Texan, is on the advisory board of Dia Art Foundation, which has made *The Lightning Field* and our travel to it possible. She assumes the responsibilities of hospitality, which

intensify as we leave the city. But now it is already late evening and driving to the site is out of the question. Tonia and I are suffering the distortions of air travel, including its distortion of nourishment, and choose to retire to the hotel room already reserved for us. The room is of course equipped with color TV, to help keep travelers from sensing the immensity of the distances they consume. Weeks later, I will locate Ivan Illich's remarks, which elude me at the time: Beyond a certain speed, motorized vehicles create remoteness which only they can shrink. . . . The passenger who agrees to live in a world monopolized by transport becomes a harassed, overburdened consumer of distances whose shape and length he can no longer control.[1] Illich does not mention the feelings of isolation and futility that accompany individual resistance to mass institutions, such as transport and TV. In America, not to be aligned with mass institutions and services is not to be numbered among the atoms of official reality, and to find that obscurity perilous.

It has been two years since we last saw TV, and we unwisely prolong the dis-embodiment of flight with a soporific half hour of police action (in progress) and doze off amused at the rude graphics that illustrate the local weather report. The forecast for *The Lightning Field* area couldn't be more vague. Data from the vicinity must be scarce.

Daylight confirms that Albuquerque is America as we know it, with touches of Southwest flavor, such as adobe-style mobile homes and the coffee-shop place mat that describes "Indian Homelands" under my cup of Taster's Choice (I'm off caffeine). The roads are alive with customized cars and vans that say driving is taken seriously here as a mode of public appearance.

Helen drives an immaculate rented Ford, whose suspension idealizes the road. Its interior seems filled with the same processed air we breathed in the Pan Am 727 we rode from New York. Since childhood, that smell has struck me as futuristic, the atmosphere of a world in which life and technology have become confused, and speed has quantified the meaning of place. Illich has a similar idea of the present: With further acceleration, transportation began to dominate traffic, and speed

began to erect a hierarchy of destinations. By now, each set of destinations corresponds to a specific level of speed and defines a certain passenger class. . . . High speed capitalizes a few people's time at an enormous rate but, paradoxically, it does this at a high cost in time for all.[2]

Arriving at the Jeep dealer's garage, where Helen's four-wheel-drive vehicle has been fixed overnight, we have our first insight into mud. Sitting in a strangely spotless bay, Helen's Jeep, even its roof, is completely caked with hard, dried mud. I break off a clot the size of a walnut and know that our experience of distance will soon be less abstract. The Jeep is a new Cherokee Chief that spares us none of the inherent violence of motion at highway speed. Passing families of Indians in pickups on Route 40 West out of Albuquerque, I wonder how many Indians own Cherokee Chiefs—and whether they would endorse them. Signs of city life disappear alarmingly fast, giving way to expanses of open prairie, empty but for a few forlorn huts and trailers. Towering buttes and mesas soon frame a landscape in which most modern sculpture would look preposterous and puny. Here the landscape itself is a vast process work of nature that mocks the artist's arrogance of trying personally to originate forms. I wonder whether De Maria or any artist can surmount the problems posed by the scale and absoluteness of the natural setting.

The vista narrows to a canyon as we approach the last food and fuel stop before *The Lightning Field*. It is Stuckey's, famous for its pecan pie. I recall a bout of sickness induced by a piece of the legendary pie on a trip to Florida with my parents twenty-two years earlier. Stuckey's was then a restaurant chain local to the Deep South. I'm surprised to see one so far west, until I notice that Stuckey's is now owned by Pet Foods, Inc. We stop for gas and each wolf down a magenta hot dog. Inside, I paw nervously through a rack displaying photo-postcards of bristled tarantulas and evil-eyed rattlers as if these critters were objects of local pride. I'm relieved, though surprised, when Helen mentions that it's so cold now at *The Lightning Field*, most of the fauna there are dormant. Albuquerque was warm when we left, and it's only just become apparent that we've been gaining elevation.

Helen turns south off the highway onto a gravel road that shortly becomes rutted mud. Before long, it is clear how the Jeep's roof gets covered with mud. The road degenerates into a muddy trench, with deeper trenches to either side. Top speed is necessarily about fifteen miles per hour (Illich's idea of the optimum speed for human traffic). A few miles in, we come to a state highway-department truck, stuck crosswise in the road, spinning its wheels uselessly. The truck's function, Helen explains, is to spread its load of gravel over the road to keep it passable. After a moment's thought, she decides to leave the road and drive around the truck. (I can tell she is worried about how we are taking all this.) It is a rough detour, but she makes it back to the road, and a minute later we pass the last other vehicle we will see for days.

Though we're hardly ever on a perceptible slope, it is evident now that we're gaining elevation steadily. The air is cold enough to keep a thin layer of snow from dissipating, but too warm to freeze the mud beneath. The Jeep plunges through ponds of liquid mud that cascade in sheets the color of butterscotch down the windshield and over its flagging wipers. Helen is tense, but in control, as she eases out of slow spins, and attests her knowledge of the road by recalling harrowing mishaps of previous trips as we pass the points where they occurred.

Our isolation is frightening now, though I take some pleasure in feeling more remote from government than I have ever felt before. As I look out on miles of snowy, open plain, dotted with islands of rabbit brush, the idea that a road must lead somewhere loses its customary obviousness. I remember enough of the opening of Theodore Roethke's "The Far Field" to be glad the rest escapes me: I dream of journeys repeatedly: / Of flying like a bat deep into a narrowing tunnel / Of driving alone, without luggage, out a long peninsula, / The road lined with snow-laden second growth, / A fine dry snow ticking the windshield, / Alternate snow and sleet, no oncoming traffic, / And no lights behind, in the blurred side-mirror, / The road changing from glazed tarface to a rubble of stone, / Ending at last in a hopeless sand-rut, / Where the car stalls, / Churning in a snowdrift / Until the headlights darken.[3]

I cannot yet fathom this expedition as the approach to a contemporary art-work. Access to works of art usually involves no mystery as to destination. But *The Lightning Field* is still very distant from the mass institutions of publicity and transport with their means of structuring experience in advance. In the emptiness of the North Plains, it is easier than usual to distinguish between what happens and the logic you use in describing what happens, even when that leaves you with nothing to say. In everyday urban life, this distinction sounds pretentious or academic, for there the mass institutions of opinion formation are in force. The essence of their authority is to get people to behave so that nothing will appear to happen for which there is not a ready-made explanation. Out on the North Plains, that authority dissipates until it can almost be forgotten. I wonder if De Maria has chosen so remote a site believing that experience unconditioned by ideology is possible only in such isolation.

Another half hour and the cabin at *The Lightning Field* comes into view. We cross a fence line to which Helen has the gate key. The Jeep's windows are so mud-spattered that I can barely see several rows of poles glide by as the road curves toward the northeast corner of the *Field*. At this distance, the poles are fine gray filaments against a darkly clouded horizon. I can see only a few rows clearly, but they intimate an enormous presence, like an invisible city.

The cabin, built by a homesteader in 1918 and abandoned to the prairie animals some years later, has recently been refurbished and expanded. Inside, it is the stark, dusty setting of countless Western episodes dimly remembered from the black-and-white TV of my childhood. The sole amenities are a wood-burning stove and a comfortable bed. Helen introduces Robert Fosdick, who acted as engineer on *The Lightning Field* project and continues to supervise work on the cabin. She complains about the rigors of the trip, but more for our sake than on her own behalf, I think, as she seems to relish the ruggedness of life here.

Unable to contain my curiosity any longer, I excuse myself and head for *The Lightning Field*. I want to see the piece while still feeling vividly the danger and

difficulty of reaching it. I know from seeing other sculpture by De Maria that he thinks carefully about the approachability of his work. His Beds of Spikes (1968–69), for instance, pose a real danger of injury to anyone who gets near them. I remember the liability waiver that visitors were required to sign before entering the room in which the Beds sat at New York's Dwan Gallery. The total work comprises five "beds." Each is a rectangular slab of stainless steel bearing a regular array of square-shafted, vertical, sharpened steel spikes. A mathematical progression, subtle but decodable, determines the number of spikes on each bed. Falling onto any one of these objects could be fatal, so your approach to them is a serious matter. By providing the opportunity for accidents, the Beds of Spikes raises concretely the Freudian question whether there really are any accidents in human affairs. The danger you feel in their vicinity arises not only from the objects themselves but also from within. They confront your consciousness with its own belief in an unconscious capable of subverting, even of destroying, it. More than this, the Beds baits the unconscious by offering spikes as ideal conductors for the discharge (through an "accident") of repressed murderous or self-destructive impulses. And, as Franz Meyer has observed, by making you suspicious of anyone who enters the same space with you (will someone else's "accident" involve you?), the Beds of Spikes brings to light the suppressed antagonistic tenor of everyday social relations. Even when no accident occurs and conscious control prevails, you feel a danger in the very uncertainty of your relation to the sculpture from moment to moment. By keeping the possibility of irrevocable happenings before your mind, the work forces you to feel the irreversibility of time.

These aspects of the Beds of Spikes have their counterparts in *The Lightning Field*. But the formal affinity between the works is misleadingly direct. For the difference in one being an ensemble of objects, however provocative, and the other rooted in its site is more significant than their parallels.

At about four in the afternoon, I walk into *The Lightning Field*, the mud sucking at my boots. The dark overcast breaks now and then over the plain, but the Datil Mountains to the southeast will remain in shadow the rest of the day. I can tell

immediately that no description of the work is possible without mention of time of day, the season, the conditions of ground, light, and sky. As black clouds close again overhead, rent by weak light from the west, the poles to my left are a cool silver against the black mountains. Looking through the width of the *Field*, I seem to see the poles extend all the way to the foot of the Datils, which I know to be thirty-odd miles away. Attracted by this sublime illusion, I set off in the direction of the *Field*'s southeast corner, to see how distant the mountains will look from there.

When crossing the first row of poles, the sensation of passing into something is unmistakable, yet it is not the feeling of entering architecture. Although the *Field*'s grid structure is apparent from the outside, within it you sense the resonance, the rapport among 400 elements that allows you to feel connected to the entire expanse of space the work claims, even when its limits are visually elusive. (In ten days, I will never be sure of seeing the entire *Field* while inside it, and infer that this is impossible.) Each time I cross a row, I feel the inexorability of its sequence, of its simple additive logic, and for a moment feel added to it. This is one intuition of the poles' reference to the uprightness of the human figure. Perpendicular against the plain's horizon, they prodigally repeat the "+" form of De Maria's drawing *Number 13, June 5, 1969 Series* (1969). This occurs to me as I try to make a drawing of what I see on the *Field*.

Wherever I look, there are alignments of poles receding regularly, while others, more distant, fall into less recognizable patterns, like microtones, within the obvious intervals. Built into the work is the appearance that one part of it measures others as you pass among its perspectives. *The Lightning Field* has been realized with such precision that the distant poles look like hairline calibrations against the mountainous horizons. A step in any direction alters every configuration seen. The poles allow you to see your own movement (implicitly your perception itself) as an event in a field of shifting relations, which they make visible.

Once inside *The Lightning Field*, I realize part of the sense its remote site makes. Traveling here for the first time, you lose all familiar bearings and experience

yourself with unaccustomed immediacy as a tiny being adrift in an illimitable setting. This alone is enough to make you ask of what your normal feeling of being oriented in the world consists. *The Lightning Field* provides a surfeit of bearings to anyone within it, but the orientation it offers is at first only a sculptural feeling, for within the vastness of the plain, all sense of place arises in relation to the poles. I infer that De Maria must reckon anyone experiencing the disorientation of coming to the desert will compulsively try to reconstruct a feeling of familiarity with the world, using somehow the aesthetic phenomena abundantly provided by the sculpture's interaction with its setting.

I have been able to take only a few steps at a time, partly because of my fascination, and partly because of the mud underfoot. Trying to take a direct route to the *Field*'s southeast corner, I find that pools of mud and convenient atolls of vegetation force me to revise my path continually. Meanwhile, great braids of mud accumulate around the soles of my boots, making every step more difficult until they fall off of their own weight and new ones begin to form. I am surprised at how exhausting merely walking here is until I recall that the elevation is 7,200 feet higher above sea level than I have ever been on land before. After a few days of this, I will appreciate the quantities of coffee and Dr Pepper consumed at *The Lightning Field*; caffeine is the handy antidote to the continual mild exhaustion I will feel from the thinness of the air.

The rightness and importance of some of De Maria's decisions about structure are immediately clear. The decision that all the poles should rise to the same height above sea level, so their points define a level plane, was obviously crucial. (The lengths of the poles vary according to the ground level where each is located. Their average height is 20.62 feet.) The smooth visual recession that results allows you to see the poles imposing a framework of pictorial perspective on the terrain viewed through them. Wherever you stand or move within *The Lightning Field*, the ramifying alignment of poles defines wide boulevards and inviting avenues into the landscape. The rows tempt you to see the views they frame as destinations, a vision that dissolves as you follow any avenue to its end.

The grandeur of *The Lightning Field* and its being anchored to the landscape lead you to ponder the link between "destination" and "destiny." Looking down a long, beckoning channel of poles, you taste the feeling of believing your path into nature preordained. *The Lightning Field* is filled with prods to historical imagination, and this feeling is one of them. I understand it as evoking the arrogance and conviction implicit in both the exploration of the earth (and now of the solar system), and the operational penetration of nature by science. This feeling of the convertibility of destiny and destination is mocked by its very availability at *The Lightning Field*. After concentrating on one avenue that offers the feeling of being an ultimate path, you have only to glance aside to see another, another, and another that offer the same feeling just as readily. *The Lightning Field*'s reminders of pictorial perspective are more than fortuitous. They contribute to De Maria's effort to realize a historical vision in sculptural terms without representation.

William Ivins saw in the invention of perspective systems the beginning of the "rationalization of sight" that was to make modern science, and hence the modern world, possible. One of the poles' most replete aspects is their character as landmarks of rationality, something you sense in their rote framing of the landscape behind them. Many reasons are assigned, writes Ivins, for the mechanization of life and industry during the nineteenth century, but the mathematical development of perspective was absolutely pre-requisite to it. . . . Without the development of perspective into descriptive geometry by Monge and into perspective geometry by Poncelet and his successors, modern engineering and especially modern machinery could not exist.[4]

In Ivins's view, pictorial perspective made scientific classification practical by providing a logically consistent visual grammar conforming to the basic empirical assumptions of science. Either the exterior relations of objects, such as their forms for visual awareness, change with their shifts in location, or else their interior relations do. If the latter were the case there could be neither homogeneity of space nor uniformity of nature, and science and technology as now conceived would necessarily cease to exist. Thus perspective, because of its logical recognition of

internal invariances through all the transformations produced by changes in spatial location, may be regarded as the application to pictorial purposes of the two basic assumptions underlying all the great scientific generalizations, or laws of nature.[5] Because the poles of *The Lightning Field* present themselves so powerfully as objects from a world formed and informed by science, their reminiscences of pictorial perspective enhance their historicity.

The intervals within the *Field* seem right because they give the feeling of mediating between terrestrial and bodily scale. The distance separating successive poles (and adjacent rows) is 220 feet. This distance is great enough that you can hardly distinguish it from some of the long intervals between poles aligned diagonally (relative to the *Field*'s rectangle). Within any square of ground in the grid, the surrounding four poles always feel just close enough to mark tacit limits to your awareness of the local terrain.

The Lightning Field coordinatizes a part of the plain. (During construction, the rows were designated A through S, north to south, and 1 through 25, west to east. Each pole is named by its position: A3, G5, E10, etc.) A network of locations, *The Lightning Field* gives the impression that the natural reality of the plain has become observable in a new way, even in a sense for the first time, because the work's structure is present. This impression is confirmed for me when I spend some time on the open plain away from the poles. Without the fixed positions and scale provided by the *Field*, the terrain looks at once too undifferentiated, too detailed, and too immense ever to become familiar. In its broad effect on your perception and memory of the site, *The Lightning Field* conforms roughly to Alfred North Whitehead's notion of "field": the inter-weaving of the individual peculiarities of actual occasions upon the background of systematic geometry.[6]

When you feel the influence of the grid structure on your perception of events within it, you feel, too, the mathematical implication that the net it throws over appearances could in principle be woven ever finer to catch ever more elemental realities. The work does not disavow the positivistic assumption this mathematical

intuition entails: that "observation" has the same meaning regardless of the scale of phenomena. This discredited assumption is not only part of the popular authority of science, it used to be reflected in the theoretical ambitions of scientists themselves. Hermann Weyl recalls that, at a certain stage of the development, it did not seem preposterous to hope that all physical phenomena could be reduced to a single universal field law.[7] Weyl also remarks upon the importance of coordinate systems in science's effort at patterning knowledge of nature. Only after [the definition of coordinates] has been accomplished can one think of representing the spectacle of the actually given world by construction in a field of symbols. All knowledge, while it starts with intuitive description, tends toward symbolic construction. . . . A conceptual fixation of points by labels . . . that would enable one to reconstruct any point when it has been lost, is here possible only in relation to a *coordinate system*, or frame of reference, that has to be exhibited by an individual demonstrative act. It took a long time for mathematics before it had acquired the constructive tools to cope with . . . intuitively given figures. But once it had reached that stage, the superiority of its symbolic methods became evident.[8]

After an hour of walking and pausing, I find by counting poles that I am nearing the south side of the *Field*. I am already enthralled by the shifting inner harmonies of the work's geometry when the sun appears with full brightness for the first time. The poles to the east of me suddenly blaze with reflected sunlight, so bright that I can be sure of seeing the farthest row. (Those to the west are almost invisible, as I can see only their shadowed sides.) The radiant poles turn from solid objects into beams of dazzling light that pierce the air like tones. They lend themselves to light, which makes its appearance by intensifying theirs. The change suggests such an increase in energy around me that I can hardly believe it doesn't disturb the wide silence of the plain. I remember that my friend Bill Wilson once defined beauty as an increase in the available energy, as I feel suffused with the radiant energy I see. Now, with an idea of the spectacle the whole *Field* will offer, I head for the west end, hoping to see all the poles ablaze at sunset.[9]

Today, though, the sun will reappear only sporadically and set behind thick clouds. On subsequent days, under clearer conditions, I will see the incredible generosity of this work, as I view all the poles, down their mile's extent, under raking late-day light. One of the *Field*'s most amazing aspects is the way the poles amplify the light lingering after sunset. As dusk comes on, the poles take on a soft silver-whiteness that appears nowhere in the landscape except in the sky. They turn the color of the stars as the stars emerge. Finally they disappear in darkness with surprising suddenness. When I remember another of De Maria's sculptures, *Gold Meters* (1976–77) and *Silver Meters* (1976), I wonder whether he realized beforehand that the poles would tend to glow gold before sunset and silver at sunrise.

The perfection of the *Field*'s construction is never more evident nor more obviously crucial than at sunrise and sunset. At these times of day, under clear conditions, it is easiest to see that *The Lightning Field* is itself a number, though one of no particular mathematical interest: 400. At such moments, the work makes you feel the primitiveness of your number sense, for although 400 sounds like a familiar number, it is too large to recognize it when you see it. Facing the 400 poles, you feel they might be a thousand, and this feeling of having underestimated numbers generally intensifies the magnitudes of measure and energy already so immediate on the plain.

The Lightning Field's spectacle is so detailed and so disinterested in its existence as "art" that I know it will outstrip my ability to describe it. As a writer, I find this frustrating. But as the work's spectator, I sense a motive behind its inducement of speechlessness. To see *The Lightning Field* in its full efflorescence is to feel a primary wonder at the event before you and at the event of your seeing it. It seems unnecessary, as well as impossible, to articulate this wonder, as its essence is the immediate perception of your own experience as a transient event connected in wholly nonlinguistic ways to the phenomena you're witnessing. *The Lightning Field* accomplishes at least momentarily something modern artists and writers have tried to do in myriad ways for a century: it silences the incessant prattle of consciousness. (With

the ascendancy of mass media, the prattle of consciousness has increasingly taken on the idiom of "official consciousness," of ideology and publicity.) From the psychoanalytic perspective (which De Maria seems to have internalized), the story told by conscious awareness is always the "official" view in the hierarchy of the individual psyche and is always repressive for that reason. If consciousness is all words and no silence, writes Norman O. Brown, the unconscious remains unconscious.[10]

On *The Lightning Field*, I find myself thinking again and again, "Being here is like being on another planet!" Finally, I recognize that my exclamation really expresses an unaccustomed consciousness of being on *this* planet, of being on a planet at all. *The Lightning Field* focuses this awareness as does no other work of art I've seen. Its address to the sky, its constant visual linking of earth and sky (especially under low clouds), and its large scale all contribute to the sense that it is possibly an astronomical tool. The poles often wear the aspect of antennas, awaiting signals from beyond the earth. Yet in their perfect earthbound verticality, they remain tooled symbols, restating iconically the uprightness of your own body's orientation to the landscape.

The experience of being on a planet is powerful and immediate on *The Lightning Field*, but not wholly exhilarating. (Again, this sensation is implicit in the site itself, but intensified and focused by the work.) The sensuous immediacy of the experience is attenuated almost painfully by the knowledge, however vague, that science's authority has long since situated ultimate facts very remote from earthly reality. The initial exuberance of feeling yourself "on another planet" is soon deflated by the awareness that it's "just another planet" and in no way special because it is the site of your experience. On *The Lightning Field* you notice, for instance, that you feel no real conflict between the sense of the sun as "in the sky" and the sense of it as "in space."

I wonder whether this capacity to shift point of view imaginatively is not a common experience of science's infusion of its assumptions into everyday awareness, as Hannah Arendt suggests throughout *The Human Condition*. Here is

a characteristic passage: If scientists today point out that we may assume with equal validity that the earth turns around the sun or the sun turns around the earth, that both assumptions are in agreement with observed phenomena and the difference is only a difference of the chosen point of reference, it by no means indicates a return to Cardinal Bellarmine's or Copernicus's position, where astronomers dealt with mere hypotheses. It rather signifies that we have moved the Archimedean point one step farther away from the earth to a point in the universe where neither earth nor sun are centers of a universal system. It means we no longer feel bound even to the sun, that we move freely in the universe, choosing our point of reference wherever it may be convenient for a specific purpose. For the actual accomplishments of modern science this change from the earlier heliocentric system to a system without a fixed center is, no doubt, as important as the original shift from the geocentric to the heliocentric world view. Only now have we established ourselves as "universal" beings, as creatures who are terrestrial not by nature and essence, but only by the condition of being alive, and who therefore by virtue of reasoning can overcome this condition not in mere speculation but in actual fact. Yet the general relativism that results automatically from the shift from a heliocentric to a centerless world view—conceptualized in Einstein's theory of relativity with its denial that "at a definite instant all matter is simultaneously real" [A. N. Whitehead] and the concomitant, implied denial that Being which appears in time and space possesses an absolute reality—was already contained in, or at least preceded by, those seventeenth-century theories according to which blue is nothing but a "relation to a seeing eye" and heaviness nothing but a "relation of reciprocal acceleration" [Ernest Cassirer]. The parentage of modern relativism is not in Einstein but in Galileo and Newton.[11]

<p style="text-align:center">*　　*　　*</p>

I have been trying to suggest how convincingly *The Lightning Field* poles present themselves as objects peculiar to our time. As forms, their historicity is as precise as

their fabrication, and it should be, given that these are the objects chosen to evoke the world that is absent from the North Plains. This quality of historicity is the most immediate and persuasive justification any modern sculpture has presented for its industrial fabrication. Though they cannot be mistaken for objects of the past, the poles significantly suggest objects of the future.

Each pole is a length of stainless-steel tubing, two inches in diameter, seamlessly welded to a solid stainless tip. The tips taper to needle-sharp points with the arc of a curve six feet in diameter. Though the poles are elaborately anchored underground, they bear no obvious traces of the processes of fabrication and installation. They simply emerge from the ground as if growing there. After a week at the site, I have the intense desire to see trees again. The scrubby ground pines that lie to the east are not enough. I find myself thinking of the poles as the trees of America's future.

The aesthetics of the poles suggest that the mechanization of production has resulted in a mystified way of seeing objects that is obliquely a view of human reality and a tactic of power. The poles resemble the bulk of commodities produced by American industry only in bearing no recognizable traces of human labor. As the sometimes extraterrestrial atmosphere of *The Lightning Field* confirms, a world filled with objects having this quality is difficult to see as the crystallization of imaginable human actions. In such a world, the connections between the individual's own activity and the possibility of changed social reality must appear arbitrary, fanciful, or a matter of covert manipulations. In a manner that only sculpture could achieve, *The Lightning Field* discovers in the aesthetics of industrial fabrication at its most refined a repressed and repressive consciousness of power. Up close, the poles are compelling evocations of speed and force, though their fixity seems absolute. They display their formal affinities with weapons (the spear, the bullet, the missile) and with instruments (antennas, probes, needles).

Each pole also bears the memory of its artistic ancestors: Constantin Brancusi's *Bird in Space* (1923) and a whole family of vertical bronze figures by Alberto Giacometti. It is hard to guess whether *The Lightning Field* would make sense as sculpture without these precedents.

Commenting on De Maria's Beds of Spikes, Franz Meyer remarks that the analogy of the spikes to human figures evokes the war of each against all that is the economic reality of modern life. This identification of the human figure with a weaponlike form recurs, more elegantly, in *The Lightning Field*. The 400 poles are like a population, and their analogy to the human figure is more suggestive than that of the spikes of the Beds because the poles are "individuals" by virtue of the unique relations of length and position belonging to each one. (The spikes in the Beds are all of the same length and so are modular, as the poles are not.) In part because they are on the land, the poles are formally even more resourceful than the spikes. In spite of their resemblance, no pole represents another, because each is determined by its unique position in the array, and no position represents another. In this sense, the poles individually restate the argument of the whole work that there can be no mediated experience of it, that to say you've seen it, you must have been there. In the ideology of the world (and of the art world) that the poles imply, information increasingly counts as an adequate substitute for direct personal experience of something. The constant message of TV and of publicity generally is that vicarious experience is real experience. But reading this essay is not having an experience of *The Lightning Field*, nor is writing it.

<p style="text-align:center">* * *</p>

There is no way to avoid speaking of beauty when discussing *The Lightning Field*. One by one, the poles, whose complexion changes as conditions change, have a cold, almost brutal elegance. But it is their collective radiance under morning or evening sunlight that is transfixing. Registering the subtlest changes in conditions as changes in its own intensity of apparition, *The Lightning Field* may be seen as aligned with an ontological argument, the argument that being is a mode of appearance, not the reverse.[12] Seeing the work forces you to think about the double sense in which appearances depend upon light. Not only does light give definition to things and to our apprehension of them, it also sustains life on earth and makes our individual

historical appearance here possible. For all the care taken to realize the work perfectly, you see right away that the artist has no control whatsoever over the work's transient states. Like a scientific instrument, it permits fluctuations in conditions to be seen as events. It is a foothold in phenomena.

The conviction that *The Lightning Field* has been perfectly realized is most intense when it is ablaze with light. The work seems to demonstrate Hans-Georg Gadamer's argument that beauty has the mode of being of light. Radiance, writes Gadamer, is not only one of the qualities of what is beautiful, but constitutes its actual being. . . . But the beautiful is not limited to the sphere of the visible. It is, as we saw, the mode of appearance of the good in general, of being as it ought to be.[13] *The Lightning Field* makes you feel it could not be more perfectly what it is.

Part of the beauty of the work is its suffusion with mathematical feeling. There are not many works of sculpture that appeal to your number sense, but *The Lightning Field* takes advantage of mathematical facts in defining an aesthetic situation. In this situation, the simplest observations can correspond to primary mathematical statements, such as Weyl's remarks: Were I to name the most fundamental mathematical facts I should probably begin with the fact . . . that counting a set of elements leads to the same number in whichever order one picks up its elements, and mention as a second fact . . . that among the permutations of n(>2) things, one can distinguish the even and the odd ones.[14]

The number of parallels on *The Lightning Field* raises the question whether De Maria, in his conception of the work, was mindful of the pivotal place of Euclid's parallel postulate in the rise of modern mathematics. Ivins contrasted two perceptions of parallelness as they are contrasted throughout *The Lightning Field*: If we get our awareness of parallelism through touch, as by running our fingers along a simple molding [or along a vertical pole] there is no question of the sensuous return that parallel lines do not meet. If, however, we get our awareness of parallelism through sight, as when we look down a long colonnade, there is no doubt about the sensuous return that parallel lines do converge and will meet if they are far

enough extended. Although Euclid was well aware of this (see his *Optics*, Theorem VI) and was explicit about the fact that his famous fifth postulate was a postulate, it was not until the seventeenth century that for the first time a mathematician adopted convergence at infinity as the basis for a definition of parallel lines. And he adds: Where the dominant Greek and mediaeval idea of "matter" seems to have been based on tactile and muscular intuitions, the modern one to a very great extent is based upon visual habits and intuitions.[15]

Defined by a plain below, *The Lightning Field* defines a plane above. For this reason, an opposition between reality and ideality is one of the polarities I associate with the work's form. (Another is the polarity of electrostatic charges that makes lightning and, at a different level, the very structure of matter possible.) The plane above does not exist until it is seen to exist, and seeing that it exists means being able to get someone else to see it also. (The prairie animals, for whom the plain is a reality, do not seem to be aware of the plane, but how would we know?) It is a "focal" reality in Michael Polanyi's sense, and hence always out of literal reach, and never reducible simply to the "subsidiaries"—in this case the poles—that make it available to be seen.

* * *

Our seventh day at *The Lightning Field* is the only clear, dry day we will see here. It is mild. The bitter cold and relentless wind of earlier days are gone for a while. This is the one day when I will spend some time completely alone at the site. As usual under bright daylight, the poles are visually elusive. Being cylindrical mirrors, they reflect the dull yellow of the plain under the noonday light and tend to disappear against its background. Up close, they catch the blue of the sky, and flares of reflected light appear at their tips. Weather changes on the plain have been sudden and dramatic up to now, and every weather change means a change in the colors of the plain. Today it looks like desert, for the mud has finally dried hard enough to make normal walking possible. At midday, I set out again for the southeast corner, having a liking for its short poles. When you first enter *The Lightning Field*, all the poles

seem indistinguishable. But little by little, you get to know them individually, and to recognize them without counting. Some of De Maria's other sculptures, especially *The Equal Area Series* (1976–90), demand a similar exercise of slow perception.

Under high sunlight, I cannot tell how many poles I'm seeing. They recede out of sight faster now than when the light is low, and in this way affect my sense of the constancy of the distances they measure. Under such conditions, I think about the drier, more intellectual aspects of the work, as it looks more rigorous than spectacular. In my uncertainty about the lengths of the rows I see, I feel a reminiscence of the mathematical principle of induction, which I take to be another facet of the work's mathematical inklings. When the distant poles are too dim to be counted, the force of their progressions is still clearly felt. Later, I find the statement by Tobias Dantzig that gave rise to my thought about induction: The *general* principle of complete induction . . . is not content to say that a proposition true for the number one is true for all numbers, provided that if true for any number it is true for the successor of this number. *It tacitly asserts that any number has a successor.*[16] The receding poles can strain perception to the point where it cannot be distinguished, subjectively, from inference.

Repeatedly on earlier days, I've seen the poles against a background of dark clouds. At such times, even though I know this is not the lightning season, the poles take on the aspect of lightning rods. (In terms of manufacture, they are not lightning rods, though they are well grounded.) They can make the most harmless clouds look ominous, while the clouds bring out the poles' aspect of beckoning a response from the sky. In this way, the poles again suggest a fatal arrogance in science's probing of nature, or acting into nature, as Arendt puts it.

I have understood the work's beckoning of a response from nature as corresponding to its beckoning a response from the unconscious of the spectator, a bolt of repressed feeling or awareness. (Here is the real affinity of the poles with the earlier Beds of Spikes.) But it will take a stroke of luck to make clear to me what that feeling might be.

Standing on relatively high ground at the *Field*'s southeast corner, I am enjoying the immense stillness of the plain when an explosive, resounding crack splits the air, so loud I sense it with my whole body, not just my ears. It will take some time to recover the feeling that grips me in the moment before I hear the distant rasp of a jet and conclude that the big noise was a sonic boom (the only one in ten days).

A little later I will remember that, when I scanned the horizon after the sonic boom, I was looking for mushroom clouds. And I will then realize that since I first set foot on *The Lightning Field*, the work has been daring me to indulge the secret terror and thrill of isolation in these times: to imagine that the absent world has destroyed itself, to take seriously my flippant conviction that the world will destroy itself simply because this has become technically possible. In this way, the work forces the recognition that even deep in nature there can now be no escape from history. (Have you never asked yourself where you will be when the first "enemy" nuclear device detonates in the United States, whether you will watch it on TV, or feel a distant rumble, see the rising, toxic cloud, or be instantly consumed in the flare?) Walking among *The Lightning Field*'s coordinates often feels like being within a target area, but again, this releases you to acknowledge how much everyday life in today's world feels like being within a target area.

I have tried to show that the forms constituting *The Lightning Field* evoke the absent historical world so convincingly that they suggest themselves as emblematic relics of that world. The poles make you ponder the sadistic truth of science's applicability to domination. They dare you to think of them as all there is left of the world, and to discover whether you really find this cause for despair.

And so *The Lightning Field* poses the problem of how literally to take one's own wishes. To see the efflorescence of the work is to see the world in flames, metaphorically. It becomes the occasion for envisioning the world as a fire of appearances, the only love of which is the willingness to be "fire" oneself. Norman O. Brown expresses this way of seeing aphoristically in *Love's Body*: To find the true fire. Semele asked for the full presence of her divine lover, and received

the thunderbolt. *Hiroshima mon amour*. Save us from the literal fire. The literal-minded, the idolaters, receive the literal fire. The final judgment, the ever lasting bonfire, is here now. The apocalyptic fire burns up the reality of the material world.[17]

To put the matter more concretely, *The Lightning Field* may be seen as contrasting two senses of human "universality." One sense is that which science has established operationally. Philosophically, it seems that man's ability to take a cosmic, universal standpoint without changing his location is the clearest possible indication of his universal origin, as it were. It is as though we no longer needed theology to tell us that man is not, cannot possibly be, of this world even though he spends his life here; and we may one day be able to look upon the age-old enthusiasm of philosophers for the universal as an indication, as though they alone possessed a foreboding, that the time would come when men would have to live under the earth's conditions and at the same time be able to look upon and to act on her from a point outside. (. . . Instead of the old dichotomy of earth and sky we have a new one . . . between the capacities of the human mind for understanding and the universal laws which man can discover and handle without true comprehension.)[18]

The contrasting sense of universality, the more emotionally immediate in the experience and thought of the work, is the sense intended in this passage from early Karl Marx: The universality of man appears, in practice, in the universality which makes the whole of nature into his inorganic body: (1) as a direct means of life; and, equally (2) as the material object, and instrument of activity. Nature is the inorganic body of man; that is to say nature, excluding the human body itself. To say man *lives* from nature means that nature is his *body* with which he must remain in a continuous interchange in order not to die.[19]

*　*　*

My last glimpse of *The Lightning Field* comes as we pull away from the site in the Cherokee Chief. This time the Jeep is loaded only with luggage, and Robert is at

the wheel. All morning, snow squalls have been sweeping the plain. Each squall lasts only a few minutes, the winds within it one with the winds that carry it away. I see a squall begin to engulf the far end of the *Field* just as we leave.

Now the rows fly by, fine as wires, for the road mud has mostly turned to hard clay, and the trip to Albuquerque will take only two hours. As we come to the locked fence gate, Helen hands me her key (I'm sitting in front), and when I go to hand it back, tells me to keep it with a wry, but warm, "Y'all come back anytime."

We follow our previous route back to the city, and as its landmarks reappear in reverse, I ponder another experience on *The Lightning Field*. After a long, circuitous walk through the width of the field, I had looked back at my footprints and saw them appearing as random as an animal trail within the *Field*'s grid. (Outside the *Field*, trails look neither random nor not random.) I vividly remembered my path as a sequence of local decisions and responses to things seen, but these are utterly unrecoverable from the path itself. My trail might have been that of someone lost, sun-dazed, even blind. Against the symmetries of *The Lightning Field*, I saw the utter impossibility of symmetry in experience and still wonder whether the irreversibility of time is an ontological or a historical fact. Octavio Paz has one answer: Our age is distinguished from other epochs and other societies by the image we have made of time. For us time is the substance of history, time unfolds in history. The meaning of "the modern tradition" emerges more clearly: it is an expression of our historical consciousness. It is a criticism of the past, and it is an attempt . . . to found a tradition on the only principle immune to criticism, because it is the condition and consequence of criticism: change, history.[20]

After we've been on Route 40 East for a while, I notice passing trucks of a kind I've never seen in the Northeast. They have no markings, so I ask Robert about them. He explains that they are uranium-ore trucks that continually cruise Route 40. Conversation stops for a moment when he says blithely, "This road's radioactive by now."

Traveling alone, I make a second visit to *The Lightning Field* at the end of August. From Helen I learn right away that there has been virtually no lightning in the area of the *Field* all season. A photographer has been documenting the work for the past six weeks and has gotten almost no lightning shots. The Lightning Research Facility in Socorro has shut down early because of unfavorable conditions. My first half hour in the volatile atmosphere of the North Plains raises my hopes that meteorologically anything is possible here. The weather in Albuquerque seems domesticated by comparison. Soon after I arrive, in fact, a bolt strikes the mountains about fifteen miles to the west. Everyone at the cabin happens to see it, and for a while there is great anticipation of a spectacular event on the *Field*. But the weather neutralizes before long. Except for another bolt over the Datil Mountains that only I will see (and so wonder if I have merely imagined it), no lightning activity will occur near the *Field* during my stay. Anyway, I know that De Maria considers the occurrence of lightning on the site as an incidental and misleadingly climactic episode in the work's existence, and I can see his point. Still . . . The first change in the cabin I notice is the addition of real lightning rods along its roof ridges.

Very often the only sound on the plain in summer is the buzzing of flies and locusts. I am surprised to notice how much wilder these insects appear than those I'm used to seeing in populated areas. Here it is as if the flies and lizards have never seen a human being before. (This enhances your sense of being on "another" planet, of being an alien yourself.) They seem to have no stylized way of encountering human beings, as city insects apparently do.

The clear, dry summer weather produces sunsets and sunrises of fantastic intensity. The *Field* as a whole has a slightly different bearing than it did in March because the sun rises and sets a few degrees farther north on the horizon than before.

Walking in after a view of the whole *Field* under red, then golden light, I am suddenly struck by the fact that this work solves, almost offhand, a problem that has frustrated many modern sculptors at one time or another: the problem of how to

incorporate color into sculpture. De Maria's solution (though I doubt he even took this to be his problem) was simply to make sculpture indeterminate as to color and situate it where it will receive color through processes of nature. No one else who has tried to make colored sculpture has succeeded in letting color present itself. Conventional uses of color in sculpture, such as David Smith's or Anthony Caro's, tend to propose color as a static or at best "atmospheric" fact. *The Lightning Field* incorporates color by reflecting and intensifying it without misrepresenting its phenomenal nature. When the poles blaze rose or gold, you recognize color as an event in which your part as perceiver is definitive, though not personal.

The fact that I have returned to New Mexico, when I had not expected to, sets me thinking about returns and reversals again. Since I found Octavio Paz's remark about "the image we have made of time," I have become dissatisfied with his idea of why we experience time as pure irreversibility. I am aware that the physicists have their own elaborate answers to the question of the direction of time. But because De Maria's work, which I believe to be psychoanalytically informed, keeps prompting the question, I suspect it of having an unconscious or repressed significance.

If the obsession with time as irreversibility expressed a disguised awareness of a social fact, what would it be? The answer, I think, is a fact about money, or economic life. It is expressed by observing that, although a person can sell his living activity for money, he can never buy it back with money. It is understandable that we should want to unknow this fact, for to see it is to recognize the combative (though nevertheless abstract) character of everyday life, and to realize that such a form of life could not continue without the rule of force.

1994–2007

Isolation is the essence of Land Art. —Walter De Maria

Isolation is not what it used to be. The world—or should we say history?—began closing in on *The Lightning Field* as soon as it was built.

One of John Cliett's most dramatic 1978 photographs of *The Lightning Field* decorated the dust jacket of Robert Hughes's 1997 best-selling cultural history *American Visions*. A sharp spike in visitor inquiries followed, although Hughes devoted only two paragraphs to the work. The picture's use as a jacket illustration, he told me, merely answered the designer's need for an arresting, full-bleed image. Sometime earlier, the now-disbanded pop music group Soundgarden illicitly shot a music video at *The Lightning Field*, without acknowledgment, briefly drawing it to the uncomprehending attention of a whole new public. In 2001, the writer Dana Spiotta borrowed the title *Lightning Field*—with no telling what legal repercussions—for her first novel, a chronicle of contemporary Los Angeles anomie. A year later, poet Carol Moldaw won the FIELD Poetry Prize for a collection titled *The Lightning Field*.

The audience for De Maria's *Lightning Field* now divides into those lucky enough to have visited before it entered popular consciousness, when it really seemed to be off all the maps, and everyone who has visited since. Now that global positioning satellites can triangulate any point on earth, and anyone can buy a pocket navigation device, or rent a car that employs the system, or access its information online, no place may be off the map anymore. At this writing, government security zealots have begun to float the idea of implanting an RFID—radio frequency identity chip—under the skin of every citizen, which promises to make everyone locatable at every moment.

Meanwhile, climate change has begun to make obsolete the maps mountain climbers have relied on to guide them to the most challenging glacial slopes. Around the world, high-altitude regions are warming and melting, Katy Human reported in the *Denver Post*. Kilimanjaro's glaciers have all but disappeared. Glacier National Park's are melting so fast that federal computer models predict they'll be gone by 2030. . . . "Books are now obsolete," [Venezuelan climber Jose] Garcia explained. "Maps also." When considering a climb, he checks the Internet for new route descriptions and pictures, or he contacts colleagues who have been there recently.[1]

Even the assumption of the earth's singularity as an outpost of intelligent life has gone into eclipse during *The Lightning Field*'s brief history. Increasingly refined spectroscopic research has located hundreds of stars within our own galaxy—potential suns—with planets in orbit around them. And the concept of the quantum field has superseded in explanatory power the scalar and tensor fields of electromagnetism and relativity, which *The Lightning Field* evoked early on, giving the concept of "field" a new depth and sweep of generality.

Like *The Lightning Field*, De Maria's *Vertical Earth Kilometer* (1977) in Kassel, Germany, also split its public along lines of time and recall—in this case, between the locals who saw and heard *The Vertical Earth Kilometer*'s installation, and the rest of us, who can only see its top end: a brass disk embedded in a red granite plaque. Nearby residents are said to have been maddened by the months of noise caused by drilling and filling the kilometer-deep hole. The project thus embedded itself in civic memory as it sunk a sculpture into the ground. As firsthand witnesses to the *Kilometer*'s installation die off, its audience will divide ever more sharply into those willing and those unwilling to believe that a solid kilometer of brass, two inches in diameter, extends beneath the disk visible at ground level.

More than a dark joke about the modern world's rape of the earth, more than an inversion of traditionally protrusive public sculpture, *The Vertical Earth Kilometer* serves as a monument to the awe and incredulity that feats of engineering and technology provoke. It recalls the doubts that space exploration once stirred—

and still do—in some Americans: doubts not merely about its value, but about whether it has ever taken place as represented to us, or whether its portrayal in mass media constituted the sole authentic event, masquerading a colossal government scam.[2] In the German setting, whether or not De Maria intended it, *The Vertical Earth Kilometer*'s challenge to belief is more likely to sound echoes of the scandalous dispute over the historicity of the Holocaust, as the last witnesses to it die off.

The title *The Vertical Earth Kilometer*, with its hint of sky-high hierarchy, has an ironic ring. During the French Revolution, the metric system was seen as a progressive innovation. For centralizing elites, James C. Scott writes, the universal meter was to older, particularistic measurement practices as a national language was to the existing welter of dialects. Such quaint idioms would be replaced by a universal gold standard, just as the central banking of absolutism had swept away the local currencies of feudalism. The metric system was at once a means of administrative centralization, commercial reform, and cultural progress. The academicians of the revolutionary republic, like the royal academicians before them, saw the meter as one of the intellectual instruments that would make France "revenue-rich, militarily potent, and *easily administered*". . . . A rational unit of measurement would promote a rational citizenry. . . . The abstract grid of equal citizenship would create a new reality: the French citizen.[3]

In practice, of course, things did not unfold so simply. French citizenship would undergo many trials of redefinition, down to the present day. Most Americans still resist using the metric system. William S. Burroughs once wrote a little screed decrying it as an authoritarian scheme to recalibrate the space of informal, private experience. *The Lightning Field* mutely enshrines this conflict over measure in its mile-by-kilometer dimensions.

NUMBERS

The 400 poles of *The Lightning Field*, which had once seemed beyond number, appeared to have dwindled when my wife and I first glimpsed them again in

December 1994. A quick count of rows corrected this impression. (Strangely, a line in a piece of Dia's own publicity in the early 1990s misdescribed the *Field* as consisting of 384 poles, as if one short row had been removed.)

Perhaps the shriveling early winter cold contributed to our initial sense that everything there had shrunk. But we may also have brought with us some tacit awareness of our—that is, humankind's—proliferation in the intervening years. Meanwhile, the very ring of the phrase "revisiting the site" had also begun to change, as "site" turned to shorthand for "website," a structure implying no particular position or extension in physical space.

While this essay was in progress, world population surged past 6 billion. The Population Institute anticipates that by 2050 the number will grow by at least another two and a half billion—the equivalent of world population in 1950.[4] The larger the magnitudes we hear reported in world news, the further they recede from any tangible or picturable meaning. Number numbness, as Douglas R. Hofstadter calls it, set in long ago. His phrase is apt because ten, the base of our number system, literally is in, or on, our hands, the limbs of our grasp of the world. Multiples of ten we can envision as a show of hands, up to a point. But the powers of ten quickly outstrip physical imagination. George Steiner put the onset of number numbness almost a century in the past. Historians gauge at half a million the corpses left to rot or be pounded into mud in front of Verdun, he notes. Like the Weimar monetary collapse—a billion marks for a loaf of bread—the hecatombs of the First World War undermined the conceptual reality of large numbers.[5]

The crudeness of our number sense parallels the crudeness of our moral sense when it comes to extending sympathy, political will, or even the most rudimentary imagination to the tremendous number of people we are told exist but cannot begin to envision. Watching the everyday world thicken with strangers surely deepens rather than mitigates our sense of separateness—and possibly our desire for distinction—from them.

As this essay neared completion, an earthquake of cataclysmic intensity occurred beneath the Indian Ocean on December 26, 2004. It unleashed a tidal wave

of catastrophic dimensions across South Asia that reached even the east coast of Africa, killing many tens of thousands of people and jeopardizing the lives of unnumbered survivors. American citizens responded with a correlatively unprecedented outpouring of private charity. Yet every day, many of the same Americans walk or drive past "homeless" fellow citizens subsisting in misery on the streets where they conduct their own lives. No comparable groundswell of popular sympathy, political outrage, or private charity has arisen in response to the uncounted refugees from the American economy.

Is the difference simply a matter of suddenness, the increase in domestic refugees too gradual to elicit more than annoyance? Are the donors to victims of distant calamities acting out of unconscious superstition or guilt over the privilege they normally enjoy? Are they paying, along channels of magical thinking, to keep misfortune at a distance? Perhaps we must count the contradiction another example of what John Pilger describes as the division of the world into worthy and unworthy victims. The hypocrisy, narcissism and dissembling propaganda of the rulers of the world . . . are in full cry, Pilger wrote soon after the tidal-wave calamity. Superlatives abound as to their humanitarian intent while the division of humanity into worthy and unworthy victims dominates the news. The victims of a great natural disaster are worthy (though for how long is uncertain) while the victims of man-made imperial disasters are unworthy and very often unmentionable.[6]

The mass media have begun haltingly to register the fact that returning veterans of the Bush administration's invasion of Iraq have now turned up among the homeless on American city streets, like so many Vietnam veterans before them. Can popular consciousness simply not tolerate the contradictions that arise from the geopolitical structure of the world, or do the numbers themselves—more than 180,000 dead in a day—act as a moral shock to imagination, whereas face-to-face knowledge of individual strangers in jeopardy does not? Questions such as these run tangent to the experience of *The Lightning Field*, which reignites connections between one's quantitative sense and one's sense of moral linkage to the lives of others, familiars and strangers alike.

So many people, George W. S. Trow complained in *Within the Context of No Context* (1980), when urban America was perceptibly emptier than today. (Was he thinking of T. S. Eliot's lines, with their echo of Dante: A crowd flowed over London Bridge, so many, / I had not thought death had undone so many?) *Too many people*, Trow continued. More than two hundred million? How do you arrive at that figure? Do you go from house to house—houses formed into little units, constituting parts, then, of larger units, which are, in turn, parts of larger units, until you get to units large enough to count on the fingers of one hand? Or do you start instead with the two hundred million and slice it up? There's a difference. Taken from one direction, people have personal histories. Taken from the other, they have characteristics.[7] The computer revolution has since vitiated this methodological difference that then still seemed to matter: the universal solvent of digital information has begun to sluice away the last efficacious distinctions between statistical fact and personal history.

GHOSTS

Our December 1994 visit to *The Lightning Field* was too short—only two nights. It left few new impressions: the most vivid, a coyote—Trickster in the flesh—trotting at sunrise past the cabin to its daytime hideout through silver-green brush turned crystalline by predawn sleet.

A colony of rabbits had taken up residence beneath the cabin and each night raised a racket of thumping, like ghostly footfalls. Our sleep was shallow and troubled. The mention of ghosts that we happened to hear on our way to the *Field* played its part. Waiting to be met in Quemado by Robert Weathers, longtime caretaker of *The Lightning Field*, we hung out at Jimmy and Irene Jaramillo's Serape Cafe, the only place in town besides the post office that appeared hospitable to visitors. In the course of small talk, Jimmy mentioned that they had owned the cafe for only a short time and that he believed it to be haunted. Several times he had arrived to open for breakfast and found all the chairs in disarray, after having carefully

arranged them the night before. One day, while alone there, he saw an old Indian bow inexplicably "jump" across the room from the front window, where it hung. But what unnerved him most—and it had happened more than once—was finding the grill blisteringly hot when he arrived at dawn. Each night when leaving he double-checks to see that it is turned off.

Our 1994 trip was shorter in mileage than our first in 1978, but proportioned differently: less time in the air, much more on the road. We came by way of Phoenix from San Francisco, where we have lived since 1985, because United Airlines then flew from there to Phoenix nonstop (United began direct flights from San Francisco to Albuquerque in the late 1980s but had long since discontinued them). The second thing that dictated our route was frequent-flyer mileage, the currency of distance: all our mileage was already banked with United.

December daylight being so short, and the drive to the site from Phoenix so long—about three hundred miles as it turned out—we had booked in advance a motel room en route in the copper-mining town of Globe, Arizona.

Giant heaps of ore and mine tailings flank parts of Globe, looking like the forlorn fake mountains of an abandoned theme park. On an overcast night, they loom high as buildings, wide black cones against an even blacker sky, akin to those roadside lumps in the night—wind-gnawed buttes, as we discovered on our return by day—whose presences we had sensed along the lightless highway.

Globe seems more like Robert Smithson country than like De Maria's element (although De Maria set up a "test field," a sort of full-scale study for *The Lightning Field*, in Arizona before the New Mexico site was found). Smithson (1938–1973) would have felt as much at home among the slag heaps as among natural rock formations, for he viewed everything from critical debate to environmental activism in a vulcanological perspective both liberating and absurd. The smelting process that goes into the making of steel and other alloys separates "impurities" from an original ore, and extracts metal in order to make a more "ideal" product, Smithson wrote in 1968, belittling sculptors of his generation who used industrially produced

units of material, as if doing that offered a sufficient challenge to prevailing values. In Smithson's view, burnt-out ore or slag-like rust is as basic and primary as the material smelted from it.[8]

In the 1990s, mountains of slag brooding in darkness already had a futuristic look. They stirred a vague dread of seeing the urban landscape reshaped by the mountains of refuse that a world of 6 billion-odd humans generates. With every bag of trash I throw out, I have to put out of mind the fear that I may see it again when some great backwash of landfill engulfs the city, or that one day—the sort of turning-point day envisioned by Doris Lessing in *The Four-Gated City*—the trash, from then on, will simply fail to disappear.[9]

William Jordan gives unusually full-throated expression to this pessimism: The ultimate test of the human mind, he wrote, is salvation of the environment. Can homo sapiens survive itself? In light of its capacity for false illusion and its phenomenal capacity for denial, can it even conceive the issues?

The master switches are population growth and Western economics. There is no unified, enforceable, worldwide policy to deal with them, and they are diametrically opposed to long-term survival. Five billion people cannot help but poison the earth's physiology, because five billion mouths devour so much of the earth's biomass that the ecosystems are shorted, and five billion anuses produce so much feces that unless it is all recycled through the soil in which it originated, it accumulates in the water tables or in the offshore waters. Five billion people also desire the comfortable, easy, painless, narcotic lifestyle of the West, and that limbic desire foments Western industry. The living surface of the earth is a biological organ and cannot survive the caustic feces that industry for five billion produces. And Western economics, based on indefinite growth and driven by the self-interest of each individual, begets hysterical consumption of resources.

Yet at the present time, there is no political or religious movement with the remotest chance of defeating the illusions that be.[10] Add a billion and some to Jordan's figures to update his warnings.

Robert Smithson thought about a future in which art might help us digest socially the by-products of industry's plunder of the earth. It seems that the reclamation laws really don't deal with specific sites, he told an interviewer who asked him about strip mining, they deal with a general dream or an ideal world long gone. It's an attempt to recover a frontier or a wilderness that no longer exists. Here we have to accept the entropic situation and more or less learn how to reincorporate these things that seem ugly.[11]

His point about ecological nostalgia can stand. But Smithson died before nuclear-waste disposal became a defining issue of the age. Embrace entropy or not, radioactivity sets dire and inflexible limits to what we can learn to tolerate by a change of philosophical or political lenses, as proven by the underreported toxic aftermath of "depleted uranium" ammunition used in post–Cold War military actions in the Persian Gulf, the Balkans, Afghanistan, and Iraq.

The motel in Globe held a payoff for my long preoccupation with Minimalism: we were given a windowless room—A White Cube in Globe.[12] No window sashes for passing traffic to rattle, no daylight to shock the sleeper with time's flight, no air! This room was as good an antipode to *The Lightning Field* as Manhattan or San Francisco. We marveled at it briefly before demanding and getting a room with a window.

The thought of a cube within a globe reminded me of the famous unsigned print that illustrated Johannes Kepler's *Mysterium cosmographicum* (1596). It describes Kepler's vision of the orbits of all the planets then known as nested spheres separated by five regular polyhedrons, with the cube outermost.

In our era, not tiers of order but dislocations seem to be nested like Kepler's polyhedrons. *The Lightning Field* activates one's submerged sense of the philosophical dislocations the past millennium has effected. After Copernicus, Darwin, Marx, Nietzsche, Freud, and Einstein—and some might wish to add Heidegger, Foucault, and Derrida—humanity can no longer locate itself at the center of anything, except of the physical universe viewed as a structure of information, in which perspective the earth remains by far the densest point known.

Another art epiphany lay ahead the following day. The morning sky was cold, muffled by the sort of low, flannel-gray, quilted-looking winter clouds seen too seldom for my liking in northern California. My pleasure at waking to an overcast sky has increased since moving to the West, where TV weather forecasters denigrate everything but hammering sunlight and temperatures around 70 degrees Fahrenheit or higher.

Past Globe, the highway began a long, winding ascent that brought us to Salt River Canyon. Nothing prepared us for the scale and scenic drama of this vast, deep gorge. The clouds, which now seemed just overhead, had begun to break up, without apparently thinning. Here and there, blasts of sunlight slowly raked the canyon walls beneath the billowy graphite-gray overcast, awakening a mineral palette of raw umber, yellow, rose, and silver. We cruised right into the American sublime of Thomas Moran.

Moran's interest in Western landscape appears to have been sincerely awestruck, as well as commercial and official. He was a leading artist associated with the Great Surveys, the next wave after cavalry conquest, dispatched by the federal government to assay the American West's mining and other entrepreneurial prospects. Moran profited handsomely from paintings of Wyoming and Colorado and from mass-produced color prints based on them. His mountain landscapes carefully omitted real signs of human settlement that might have compromised their Turneresque sublimity. They are Edenic propaganda for a certain sense of American national destiny, yet are forbiddingly empty enough almost to have discouraged westward expansion. In fact, Moran's paintings of Wyoming stirred Congress to establish the National Park System. But from today's ecological perspective, even the National Parks have backfired, generating massive traffic problems on supposedly protected land.

Overlaid on my recollection of Moran was the memory of an annoying auto-maker's TV commercial. In it, a woman escapes a boring party by dreaming her way into an abstract painting on the wall. She ends up driving away, miniaturized, along a looping brushstroke through an impasto landscape: the last word in escapist art.

As it happens, the road through Salt River Canyon crosses Apache reservation land, which no white American of conscience can cross knowingly without an inner blush of shame. The only heartening thing about this passage is picking up indigenous language programs on a car radio. The language baffles white transients like ourselves, but we can hear at least that it endures: an irreplaceable way of sounding the world. Listening to it brought to mind one of my borrowed critical mottoes: Anne Stevenson's aptly fatalistic line, The way you say the world is what you get.

The ghost of Moran's aesthetic came as a reminder that there are neither unstructured views of nature nor disinterested modes of representation, hence, no natural language of appearances or of "the things themselves." This is one version of the postmodern "relativism" decried by fundamentalists of every stripe. Their animosity should come as no surprise. People who take to heart this so-called relativism will not be easily duped by anyone's claims to rightful, unassailable authority. They will regard every reported fact as the outcome of a skirmish of agendas and interpretations, hardly the same thing as the concept of truth discredited.

The question of who, if anyone, has the power to impose a definitive interpretation tacitly shadows all controversial matters of fact. But custom, practicality, or expedience—and acceptable evidence—settle most contests of interpretation before skepticism ever comes to life. The point is not to postpone indefinitely interpretation or action, but rather that inescapable ambiguities of experience should not remain unconscious—that is, unacknowledged for what they are.

Only when we claim ambiguity as our element, and let ourselves be openly delighted, fascinated, or beleaguered by it, can we accept our position: in the middle of nowhere, in the cosmological and philosophical senses (of being condemned to groundlessness), with only the makeshifts of observation, consensus, and responsibility as scaffolding for belief. To dwell zestfully in ambiguity and contingency, more or less as Nietzsche recommended, may be the only way to soften the defensive emotional brittleness of insular selfhood slyly objectified in the steely spines of *The Lightning Field.*

The social sanity of ordinary skepticism has been an ideological target of the new conservatism that swept into power almost everywhere in the West in the 1980s and 1990s. In such a climate, preoccupations like those of this book by themselves produce an intensifying sense of isolation.

WHEREABOUTS

The Lightning Field stirs in even the repeat visitor questions that sound almost comically simple: What and where is he? What time is it? Where does the art reside? Revisiting the site entails revisiting them.

I thought of how the work retunes such questions when I came across some musings on therapeutic technique by Rollo May. I have often found myself having the impulse to ask, May writes, when the patient comes in and sits down, not "*How* are you?" but "*Where* are you?" The contrast of these questions—neither of which I would probably actually ask aloud—highlights what is sought. I want to know . . . not just how he feels, but *where he is*, the "where" including his feelings but also a lot more—whether he is detached or fully present, whether his direction is toward me and toward his problems or away from both, whether he is running from anxiety, whether his special courtesy when he came in or appearance of eagerness to reveal things is really inviting me to overlook some evasion he is about to make . . . and so on. May hoped that rephrasing questions about the patient's condition into questions of orientation would bring the therapeutic process back to earth. If we assume, as we have reason for doing, he continues, that the fundamental neurotic process in our day is repression of the ontological sense—the loss of the sense of being, together with the truncation of awareness and the locking up of potentialities which are manifestations of this being—then we are playing directly into the patient's neurosis to the extent that we teach him new ways of thinking of himself as a mechanism. . . . The kind of cure that con- sists of adjustment, becoming able to fit the culture, can be obtained by technical emphases in therapy, for it is precisely the theme of the culture that one live in a

calculated, controlled, technically well-managed way. Then the patient accepts a confined world without conflict, for now his world is identical with the culture. . . . This is the way of being "cured" by giving up being, giving up existence.[13]

Another psychoanalyst, Christopher Bollas, recast primitive questions of self-awareness with a metaphor of wandering. "Where have you been?" "What have you been doing?" "What have you been up to?" Such interrogations betray the inquisitiveness of consciousness in the face of the dynamic and never-ending wanderings of the unconscious self, Bollas writes, which travels to worlds far from consciousness, encounters many a phantasm, gets up to many forms of mischief, and though always somewhere around, escapes location.[14]

Sometimes the virtual dimensions of artworks lend structure to the elaborate digressions of unconscious awareness from the conscious. *The Lightning Field* objectifies this fact at a scale and with a social and historical pertinence unprecedented in American art.

Readers of Heidegger's early work may think of the prepositional or adverbial character of the terms he uses in *Being and Time* in an effort to replace psychology and sociology with a lexicon of ontological relations: Being-in, Being-with, Being-towards-death, thrown-ness, even *Dasein*—his basic term for human reality—Being-there.

The parallel universe of cyberspace has given new inflections that May and Bollas never anticipated to the question "Where am I?" Weather, privacy, and gravity have no meaning in cyberspace, Allucquère Rosanne Stone observes, and the jury is still out on the persistence of location.[15] Is there an ontological novelty to being somewhere (somehow engaged) in cyberspace? Or is being online by definition merely an exercise in living in a calculated, controlled, technically well-managed way?[16]

NATURE

Surely the changed meaning of isolation in recent decades—if it has changed—relates also to what "nature" has undergone. In modernism . . . some residual zones

of "nature" or "being," of the old, the older, the archaic, still subsist, according to Fredric Jameson. Postmodernism is what you have when modernization is complete and nature is gone for good. It is a more fully human world than the older one, but one in which "culture" has become a veritable "second nature."[17]

Take a deep breath and Jameson's play with terminology sounds merely academic. If by "nature," we mean wilderness untainted by human projects, then it may indeed be gone for good, or at least for any future our culture envisions. Humankind has already strewn detritus as far away as Mars and Jupiter, and has yet more out there, still on the fly. We also have decades of intangible, uncontainable electromagnetic space pollution to answer for: the "Golden Age of Television," and much else, an expanding bubble of potential bafflement to extraterrestrial ethnologists.

But if by "nature" we mean the enveloping universe, in which we are recent arrivals, then no wrinkle of terrestrial culture seems likely to affect it. None except perhaps our utter self-destruction, which would blind the universe known to us. But then, the difference between a witnessed and an unwitnessed universe is literally, logically inconceivable, for any concept of an unwitnessed universe necessarily smuggles a witness—the thinker himself—into it.

WILDERNESS

N. Katherine Hayles reports that when asked for a definition of wilderness, Richard White offered the following ironic observation: wilderness is managed land, protected by three-hundred-page manuals specifying what can and cannot be done on it. . . . By the time it was named such, the "Wild West" had become a retrospective cultural construction that romanticized and mythologized firsthand experience in ways the original participants would no doubt have found amusing, if not incomprehensible. . . . Confronted with nature in the raw, people registered its impact on their bodies, as . . . White points out—calluses on hands and feet, sweat dripping off brows, muscles sore and aching after a day's battle with a river. When "nature" becomes an object for *visual* observation, to be appreciated by the

connoisseur's eye sweeping over the landscape, there is a good chance it has already left the realm of firsthand experience and entered the category of constructed experience we can appropriately call simulation.[18]

The transfiguration that Hayles (following Jean Baudrillard) calls simulation clearly impinges on the kind of experience we can have of *The Lightning Field* now. To say that the world is encroaching on *The Lightning Field* is to say, among other things, that the reign of simulations threatens to engulf it, or has already.[19]

Can we reckon where that process stands? Simulation as a cultural order may spell the end of *The Lightning Field*'s power to make isolation real to us, for simulation collapses or de-realizes distances. A crude example is the architecture of Las Vegas casino hotels, which plays at transplanting features of Manhattan, Paris, Cairo, and Venice with just enough detail to sap the originals of authenticity—that is, to put the notion of authenticity in quotes, even for people who have never heard of Baudrillard or Walter Benjamin. Perhaps, if we take Bollas's hint, what simulation cheapens, beyond the originals that give it traction, is unconscious fantasy—inner transports to Paris, Cairo, Manhattan, or wherever—whose psychic function depends on its being subjective rather than public.

Jameson puts the case against postmodernism in terms of the "autonomy" that gave modernist art, such as *The Lightning Field*, leverage to propose critical vantage points on social reality: A society of the image or the simulacrum and a transformation of the "real" into so many pseudoevents, Jameson writes, suggests that some of our most cherished . . . radical conceptions about the nature of cultural politics may thereby find themselves outmoded. Modernist cultural politics all shared a single, fundamentally spatial, presupposition, which may be resumed in the . . . formula of "critical distance." But lately the terms have changed so that distance in general (including "critical distance" in particular) has very precisely been abolished in the new space of postmodernism. We are submerged in its henceforth filled and suffused volumes to the point where our now postmodern bodies are bereft of spatial coordinates and practically (let alone theoretically)

incapable of distantiation.[20] Stranded mountain climbers and shipwreck survivors might disagree, but in the protected zones of everyday culture, we take the meaning of his overstatement.

The shift from modernism to postmodernism as Jameson understands it would critically defang *The Lightning Field*, rendering it a mere exotic outpost in the conglomerate culture that the editors of the *Nation* like to call "the National Entertainment State." Yet even if Jameson is right, *The Lightning Field* remains a philosophically primitive—or repriming—situation, for anyone lucky enough to stay there without other guests present.

Can we allow that an artwork might be subsumed in a system of spectacles designed to administrate imagination, yet lift or shred the veil over that system? If not, then we may neither credit nor experience *The Lightning Field* as the device De Maria intended it to be. By calling the work a philosophically repriming situation, I mean that, with company and other familiar distractions absent, the reflective visitor there can hardly evade thinking about relations among himself or herself, the world, and its representations. That, in Arthur C. Danto's view, is how the perennial concerns of philosophy are best understood.[21]

And what of Heidegger's idea that thinking draws near things only in their absence? If one wants to get close to a thing . . . through thinking, it must be far from immediate perception, Hannah Arendt explained. "Thinking," says Heidegger, "is the letting oneself into nearness." . . . We go on trips in order to see distant attractions up close; yet it is often only in retrospect, when the impression is no longer acting upon us, that the things we saw actually come close to us.[22] Any reader of Heidegger's text who has visited *The Lightning Field* may agree that something about his notion, as Arendt paraphrases it, seems right. It implies a historical dynamic very different from the cultural climate change that Jameson considers defining, one in which relations of distance and proximity pertain to existential facts more profound than the evolving capacities of transport, communication, and representation.

CABINS

"Crossing the Frontier," a 1996 exhibition at the San Francisco Museum of Modern Art, included photographs by John Divola from a series called *Houses: The High Desert*, begun in 1992. Each image is a long shot of a solitary desert dwelling. The houses are creepy monuments to the American myth of renegade individualism; their very singularity reads as a vague threat. Anyone would think twice before calling at one of these houses, even in extremis.

Divola's pictures gained ominousness following the arrest and indictment of a Montana misfit on suspicion of being the so-called Unabomber, and the publication of pictures of his mountain cabin. Theodore Kaczynski's dwelling was trucked all the way to the trial venue—Sacramento, California—to serve as evidence for a planned insanity defense that became unnecessary when he pleaded guilty to avert execution. Uprooted, the cabin looked like the stuff of art—an icon of isolation—the moment it appeared pictured in the media. The bomber, like his close colleague the aviator, Peter Conrad observes, is one of the twentieth century's symbolic protagonists.[23]

Soon Kaczynski's cabin itself cropped up in contemporary art. While on a brief teaching stint at Ohio State University in 1995, I saw an Ohio artist's video piece that looped news footage of the cabin being transported by night. In 1999, Bay Area photographer Richard Barnes exhibited in San Francisco huge color prints of the transplanted cabin sitting under sizzling fluorescents in the vacant corner of a Sacramento property warehouse. The government had commissioned Barnes to take pictures of the cabin for possible use as demonstrative evidence. He shrewdly saw artistic opportunity in the assignment.

The Lightning Field cabin, its prominent windows aside, might fit right into Divola's series of desert houses. It is like an anchorite's mask that each visitor tries on. Some find it a comfortable fit, others chafe under it. I can feel the pull of its implicit fantasy of self-sufficiency.

Locals like Robert and Karren Weathers, who look after *The Lightning Field*, must appear to many outsiders as autonomous, as the cabin hints it is possible to

be. Yet even more than city folks—because there are far fewer people thereabouts—rural New Mexicans like them rely daily on neighbors and nearby family, despite all they know of the land, weather, and equipment of life in the high desert.

My own most vivid image of rural autonomy comes from my first stay at *The Lightning Field*, when Helen Winkler took me to meet John Lehew, the rancher neighbor she regarded as a sort of local sage. The drive took about half an hour but the distance was impossible to estimate, so much time was spent maneuvering treacherous mud ruts. Lehew was out when we arrived, but we got a good look at his spread.

The house was an architectural cousin to *The Lightning Field* cabin, but larger, bulkier. For a good half acre in every direction stretched a sculpture garden of rusting tractors, trucks, appliances, and other scrap metal carcasses in every stage of dissection and decay. (The faintly tragic air of that landscape came back to me recently when I saw a photograph that Sebastião Salgado took in the famine-ridden Sahel desert region in 1984: it shows a makeshift cemetery in which destitute refugees marked grave sites with fragments of scrap metal.)

Lehew's kitchen door was unlocked, as Helen expected, so we stepped inside. There, a wealth of cooking clutter paralleled the riches of steel outside. Yet the psychological climate of the place was the opposite of disarray. One felt that what looked like disorder camouflaged the man's mindfulness of every object's whereabouts. The only hint of a system was the rows of large, rusting coffee cans that lined the uppermost kitchen shelves, those with labels almost all showing the same brand. Whether they served as storage or were merely being stored themselves was impossible to tell.

I thought of Steven Wright's line, You can't have everything—where would you put it? For John Lehew did seem to have everything and oceans of space left over.

Because of how much land he was believed to own, Lehew was regarded locally as a wealthy man. As Karren Weathers ferried us away from the *Field* in August 1995, I asked if she knew what had become of him or his son Jimmy, who had run

a long-defunct gas station in Pie Town. Careful to stress that some of what she told me might be no more than gossip, she explained that after the old man had died some years before, Jimmy had gambled his share of the estate on bitter, futile litigation with the other claimants to his father's assets. Rumor had it that Jimmy ended up driving a cab in Las Vegas, a fate to which it might take Joyce Carol Oates to do literary justice.

Soon after Karren finished the story, we came upon the most startling sign yet of the world's encroachment on *The Lightning Field*: State Highway 117 had been paved!

In 1978, it had been a measureless slough of mud; now it is a tidy rural artery. The area adjoining the Malpais lava fields near the highway's north end has been declared a National Monument. A paved parking lot and picnic tables await visitors at the base of the wind-eaten sandstone cliffs a few miles from the road's junction with U.S. Route 40. As yet, tourists were few, but their increase seems inevitable.

ISOLATION

Current thinking is that we have come a long way from the circumstances Clement Greenberg described in 1948, when he called isolation the natural condition of high art in America. Contrasting America favorably to Europe, Greenberg argued that it is precisely our more intimate and habitual acquaintance with isolation that gives us our advantage at this moment. Isolation, or rather the alienation that is its cause, is the truth—isolation, alienation, naked and revealed unto itself, is the condition under which the true reality of our age is experienced. And the experience of this true reality is indispensable to any ambitious art.[24]

Such sweeping statements make us uncomfortable today. Claims of access to "the truth" or "true reality" have an authoritarian ring—dictatorial, fundamentalist, or cultural imperialist. Perhaps we grant that sort of authority by default only to science, though in recent years the universality even of mathematical and scientific truth has come into question, except among working scientists.

But do we not still feel an emotional recognition of Greenberg's viewpoint that betrays something defensive in our nimble relativism? Does not an unchosen psychological or spiritual isolation pervade American life, whether it is a mark of our historical moment, of the nature of mass society, or of both? Marxian alienation may not be its cause, but then, alienation as Marx defined it has not abated merely because in the post–Cold War years people have learned to cringe at the mention of his name or because more workers today produce computer chips and data streams than pipe valves and wire. Could there be a better image of workers' estrangement from craft and the social value of their labor than employees in computer-chip makers' "clean rooms," clad in what looks like astronautical garb, as though working off-world?

Perhaps the social coldness we experience as isolation today is the cultural climate of the imminent collapse into solipsism that Louis Sass sees as a characteristically modern susceptibility. (Sass may have pinpointed here a continuity between modern and postmodern temperaments.) In his view, twentieth-century thought's obsessions with epistemology and selfhood are symptomatic of this condition.

In the 1990s came a new vogue for the idea that contemporary anomie springs from an erosion of civil society, that is, of citizens' disposition to organize themselves informally on the basis of trust and distributed responsibility. Some social scientists explained the breakdown of communist regimes by the State's (or the Party's) undermining of the mundane neighborly trust that makes civil society possible. By now it should be obvious that capitalism, untamed by the state and unopposed by any other ideology, has analogous corrosive effects.[25]

The Lightning Field enshrines the thought that isolation, tending toward solipsism, may be *the* defining sensation of subjectivity in our time. The experience of time spent there feels at first so incommunicable that the work itself can seem like an argument for the incommunicability of every experience. Further, it telescopes this self-perception and the highest achievement of *objectivity*: science's confirmation that we are the sole civilization in an unimaginably spacious universe, in fact if not in principle.

All of this leads to questions of how we delineate "our time" and with whom we share the sensation (or illusion) of being borne forward by it. Are there common markers of passage? Can any shared sense of the direction of history be the basis for solidarity now, or is that possibility a utopian delusion of the past?

I am more inclined to think of the present as a jumble of temporalities impinging on one another. What Peter Ackroyd writes of "London time" perhaps applies to the world at large: It seems not to be running continuously in one direction, but to fall backwards and to retire, it does not so much resemble a stream or a river as a lava flow from some unknown source of fire. Sometimes it moves steadily forward, before springing or leaping out; sometimes it slows down and, on occasions, it drifts and begins to stop altogether.[26] And when Arundhati Roy writes that India lives in several centuries at the same time. Sometimes we manage to progress and regress simultaneously, I wonder whether something similar might not be said of the United States.[27] The burgeoning homeless population of San Francisco, for example, seems much of the time to endure nineteenth-century conditions in a twenty-first-century setting. Even Robert Kagan, an apologist for the neoconservative imperial project, sees the United States and Europe as divided by the experience of living respectively in modern and postmodern zones of the new century, each with distinct political and ethical imperatives.

The Lightning Field evokes a specific sense of what defines "our time": the era of nuclear peril. The transition to a post–Cold War world has made this function of the work even clearer. *The Lightning Field* is a timepiece: should it ever seem to lose its apocalyptic tone, we will know that one or both of two changes has occurred. The age of nuclear threat will have ended, or humankind's assault on nature will have.

In post–Cold War times, the unlikelihood of a world war makes nuclear war improbable, Eric Hobsbawm speculates. However, the use of nuclear arms is, in my opinion, possible and not improbable, because technology has steadily increased their availability, made them more widely producible and more rapidly transportable.

Hence the exclusion of the risk of a world war does not eliminate the risk of wars in which nuclear arms could be used.[28]

PANIC

At dusk on the first day of our second 1990s visit to *The Lightning Field*, in April 1995, two jet fighters roared a few hundred feet above the plain, probably less than a quarter mile off the southernmost row. The first Gulf War (as related by CNN) was still fresh enough in memory to make this an electrifying moment, although it had more homely echoes to us who by then had already lived ten years in San Francisco.

For each year, as if in retribution for its reputed liberalism, San Francisco is treated to several days of rehearsal—followed by a full, skull-cracking performance —by the Blue Angels, the U. S. Navy's unmuffled precision flying team. A fraction of the population takes to the rooftops on these occasions, with binoculars and coolers of beer, to cheer on the pilots as if the military were America's ultimate sports team. But many of us register this martial entertainment viscerally as state terrorism, a thundering reminder of who's in charge. With gritted teeth we shudder to hear numberless tax dollars blasted into air and noise pollution. I find myself guiltily wishing that a small accident would put an end to these annual air assaults—just a wingtip clipping a bayside office tower, with plenty of property damage but no loss of life. If this is my fantasy, what incendiary dreams must these air spectacles trigger in those who identify with the pilots and their license to thrill?[29]

The fright I describe seems to me mere animal sanity, to borrow George Santayana's phrase. Any creature that has its bones shivered and ears hammered by the roar of a low-flying fighter plane knows itself to be under grave threat, unless benumbed by adrenaline or ideology. Birds and other sound-sensitive wildlife respond with unalloyed panic. My sense of being a target also springs from my awareness that, as Gabriel Kolko puts it, modern warfare has increasingly eliminated the distinction between combatants and others, as the invasion and occupation of Iraq have grimly confirmed.[30]

BOMB

Was it inevitable that the age of nuclear threat would also be the age of the computer? Hindsight makes it seem so, especially since the Internet, originally—and still, primarily —a military nexus, has been opened up to civilian and commercial use.

After the first bomb, the *atom bomb*, which was capable of using the energy of radioactivity to smash matter, according to Paul Virilio, the specter of a second bomb is looming at the end of the millennium. This is the information bomb, capable of using the interactivity of information to wreck the peace between nations. "On the Internet, there is a permanent temptation to engage in terrorism . . ." declared a one-time hacker who is now a company director, "and this danger grows with the arrival of new categories of Internet users. The worst are not, as is generally believed, the political activists, but *the unscrupulous little businessmen who will go to any lengths to do down a competitor who gets in their way*." Their preferred weapons? The new bulk-mailing software, invented by advertising people, which can submerge a particular server in a veritable "mail-bombing" campaign that enables anyone to become a "cyber-terrorist" at little risk to themselves.[31]

As any user of e-mail knows, renegades around the world intermittently unleash—usually for the hell of it—data-destroying viruses that wreak havoc on poorly defended computer systems.

An article in the September–October 2006 issue of the *Bulletin of the Atomic Scientists* notes that the Department of Defense Inspector General's office considers the Missile Defense Agency's communications network vulnerable to hacker attack. The ground-based midcourse defense system, cornerstone of an eleven-time-zone detection and communications network now under construction, was found to have serious vulnerability to potentially disastrous and undetectable hacker incursion. A perverse, ingenious "gamer" could touch off an international incident or even a nuclear catastrophe unless this vulnerability is corrected.[32]

BITS

Perhaps partly as a result of more than a generation's dependence on computers by practicing scientists, a new theory of reality gained ground in the 1990s: the physics of information, sloganized by cosmologist John Archibald Wheeler in the phrase *its [i.e., entities] from bits*. That is, tangible, indeed cosmic, entities are not only intelligible in terms of information but are products of it in an ontological sense.

It from bits symbolizes the idea that every item of the physical world has at bottom—at a very deep bottom, in most instances—an immaterial source and explanation, Wheeler wrote in a 1990 conference paper. *That which we call reality arises in the last analysis from the posing of yes-no questions and the registering of equipment-evoked responses.*[33] This is one way of expressing the fact that, from a quantum-theoretical viewpoint, everything we take to be real is founded on microphysical events in which some observer's decisions (or responses) are determinative, although from an everyday perspective this process is unconscious, if not unknowable.

A basic question, then, is what constitutes "an observer"? At another level, the same question is implicit in many works of modernist and postmodernist art, though few of them enrich it as *The Lightning Field* does. (A further parallel question arises when human events, rather than microphysical ones, are in dispute: who—or what—has standing as a witness?)

Do only self-conscious, deliberately communicative beings such as ourselves qualify as observers? Or does any entity capable of storing and processing information count, from computer-driven surveillance cameras down to, say, the self-replicating molecules and photosensitive amino acids in our remote biochemical ancestry? And where do we put creatures that survive by sensory modalities radically different from our own, such as deep-sea fish that comprehend their world through disturbances of the electromagnetic fields they emanate?

Wheeler speculates that we must ultimately understand time and space and all the other features that distinguish physics—and existence itself—as the . . .

self-generated organs of a self-synthesized information system, i.e., the known universe.[34] Eyes and minds would be prominent (to us) among these "self-generated organs." He appears untroubled by the gulf between science's equipment and methods—from which his cosmological vision derives—and the perceptual flow through which each of us seems both to make a world and find one already there. Objective reality, then, would be what "folk psychology" takes it to be: a broad, casual consensus about what there is, which science filters and formalizes. Wheeler borrows a philosopher's notion of "tangible meaning" as "the joint product of all the evidence that is available to those who communicate," and regards communication rather than consciousness, or even sentience, as what it takes to institute shareable realities.

Man has not yet learned how to communicate with an ant, Wheeler writes. But once we can, perhaps the questions put to the world around by the ant and the answers that he elicits [will] contribute their share too, to the establishment of meaning. Even what we call the past is built on bits, Wheeler argues, for the conundrums of probability and actuality in the quantum domain are unanchored in time and space as we experience them. His thinking on these matters carries the interesting requirement that we reject now-centeredness . . . as firmly as Copernicus rejected here-centeredness.[35]

Wheeler acknowledges the implausibility of the view he sketches. Enough bits to structure a universe so rich in features as we know this world to be? Preposterous! Mice and men and all on Earth who may ever come to rank as intercommunicating meaning-establishing observer-participants will never mount a bit-count sufficient to bear so great a burden. . . . We today, to be sure, through our registering devices, give a tangible meaning to the history of the photon that started on its way from a distant quasar long before there was any observer-participancy anywhere. However, the far more numerous establishers of meaning of time to come have a like inescapable part—by device-elicited question and registration of answer—in generating the "reality" of today. For this purpose, moreover, there are billions of years yet to come, billions on billions of sites of

observer-participancy yet to be occupied. How far foot and ferry have carried meaning-making communication in fifty thousand years gives faint feel for how far interstellar propagation is destined to carry it in fifty billion years.[36]

A first-time visitor to *The Lightning Field* today, properly prepared, may find mirrored in it some of the tension between Wheeler's post-humanist vantage point and the humanism still in the air of liberal, secular culture, well expressed by Erik Erikson, for example. Up to a point, Erikson wrote in 1960, the ego can be understood as a guardian of man's individuality, that is, his indivisibility. *The Lightning Field* poles suggest themselves nearly irresistibly as totems of that indivisibility. In the midst of other individualities, equally indivisible, Erikson continues, the ego must guard and does guard certain prerogatives which man cannot afford to be without and which he therefore will maintain both with secret delusions (such as are revealed by dreams and daydreams) and in those collective illusions which often guide his history. Some of these prerogatives are a sense of *wholeness*, a sense of *centrality* in time and space and a sense of *freedom of choice*. Man cannot tolerate to have these questioned beyond a certain point, either as an individual among fellow men, or as a member of a group among other groups. It is for this reason that in individual memories and in collective history man rearranges experience in order to restore himself as the cognitive center and source of events. Science might be described from one perspective as a systematic effort to break this compulsion.

He has crowned all-powerful kings and created all-knowing gods, Erikson writes of man, endowing them with all the ego-ism the individual cannot do without: a central position in violent events; . . . a certainty of being eternal and immortal; a conviction of being able to know the secret of life; the ability of being totally aware of goings-on everywhere and of influencing whatever one wishes to change.

But Erikson also warns of the danger inherent in the adaptations and illusions he describes, namely, the destructive rage which accompanies their failure.[37]

POSTMODERN

In a 1984 *Artforum* article regarding beauty, I proposed that the postmodern era began in August 1945, when American atomic bombs destroyed Hiroshima and Nagasaki. The bombs' detonation, irrevocable proof of their workability, permanently poisoned the future to which all utopian schemes and the modernist avant-garde had looked for vindication and space to flourish. From this perspective, *The Lightning Field* is centrally a work of the postmodern era, even though it is far from being an exercise in vogue postmodernism.

In 1978, a sonic boom broke the shell of denial over my fears about the nuclear future, fears that time alone at *The Lightning Field* had brought to an unconscious focus. To ascribe such an effect to this work—that of intensifying and releasing repressed apocalyptic dread—is to raise one of the peculiar critical problems it poses: Just what is the effective reality here? Is it the site, the poles, the cabin, the weather, the subjective context of one's responses to being there; the journey, the time, and attention spent at the site? This artwork, so much about boundaries, is itself hard to delineate. In a postmodern light, such quandaries are not supposed to matter much. The sole truth, the postmodern thinking goes, is the play of uncertainties, any resolution of which amounts to a bid for some sort of power.

In wearing its contradictions so openly, *The Lightning Field* appears to have been postmodernist from the beginning. It offers no resistance to changes brought by time, weather, or light, yet is carefully protected legally and carefully maintained physically. The work awakens whatever impulse the visitor may have toward critique of technology and its abuses, yet *The Lightning Field* owes its existence to the successful plunder of big oil and capital management. Then again, this work also insists—as postmodernist art does not—that there can be no substitute for direct experience of it, or of anything.

Appeals to experience in art interpretation are critically suspect now, when so much of our mundane experience appears to be subject to manipulation, maybe even a pure delusional product of it. For the first-time visitor, *The Lightning Field*

takes the equation of art and experience to extremes that would have made John Dewey swoon: under adverse conditions, it can be an ordeal. The uncertainty of the work's limits and its tendency to equate art content with experience keep open questions of how we can know, and whether it does us any good to know, how our experience has been culturally synthesized.

Social theories of experience such as Jean Baudrillard's or Paul Virilio's, descended from Guy Debord's vision of "the society of the spectacle," give the impression that every adventure of subjectivity is completely open to analysis because nothing outstrips the determining conditions these commentators discern.

The Lightning Field is, in one view, a monument to a different possibility, expressed decades ago by Iris Murdoch in an essay called "Nostalgia for the Particular." Why should there not be moments of significance, determinate though not necessarily recurrent? Murdoch asked. Surely, when we set aside the problems which arise from the attempt to bind language and experience rigidly together, we see there are such? Consider our enjoyment of the "language" of a Persian rug. Here there is not the thin light touch of recognition, but a deep gazing. . . . Here too we can *refine* our experience, making it more and more specific, seeing more and more deeply into the sense which is before us. What is required here is that an immediate experience should have an inner complexity and rigidity sufficient to enable it to withstand the flux of attention. The definiteness which we would find here is then not the definiteness which goes with verification . . . but an intense and experienced definiteness. . . . If indeed we consider how contemplation may discover (or create) an immediate form within its object we may even feel it possible to re-establish the significance of the world by turning all experience into contemplation.[38]

The Lightning Field is one of the rare contemporary artworks that can awaken, or reawaken, the hope of turning all experience into contemplation, not by aesthetic seduction, but by giving anchorage to the tension between contemplation and the mindfulness of history that always threatens to abolish it.

NOISE

Seemingly no place on earth is impervious to tourism any longer. While writing this essay, I came upon the fact that on May 10, 1996, there were 141 people—many of them amateur climbers—on Mount Everest, one of the most inclement, inaccessible places on the planet, if also one of the most storied. (Several of those climbers did not get off the mountain alive.)

I also happened on a telling essay in which filmmaker Stephen Mills laments having to falsify wildlife documentary footage to suit television conventions that curry public support for conservation. The commissioners of television programs believe that the public watch wildlife films because they wish to be reassured that there is an unspoilt earth out there, somewhere beyond the street lighting, Mills writes. But true wilderness . . . has mostly disappeared. . . . When we film lions gorging on a bloody zebra in the Serengeti, or a cheetah flat out after a bounding gazelle, we rarely turn our cameras on the dozen or so Hiace vans and land-rovers, packed with tourists sharing the wilderness experience with us. All over the world, we frame our pictures as carefully as the directors of costume dramas, to exclude telegraph poles and electricity pylons, cars, roads and people.[39]

Through most of the 1990s, *The Lightning Field* remained cut off from broad-cast media, although a satellite dish could have changed that overnight. The site has been plugged in since the cabin was electrified in mid-1978 and the refrigerator began its chronic hum. In 1994, a car radio still brought in nothing at *The Lightning Field*, but by 1997 it could pick up an Albuquerque AM station, when conditions were right. Probably by now the kind of experience that De Maria intended *The Lightning Field* to produce will depend on visitors surrendering their cell phones and other wireless devices, as well as their cameras, before arriving at the site.

Today only the privileged or the deafened manage to hear themselves be, Steiner complains, without explaining in what sense the deafened hear.[40] Aldous Huxley sounded the same complaint fifty years earlier. The twentieth century is, among other things, the Age of Noise, Huxley wrote. Physical noise, mental noise

and noise of desire—we hold history's record for all of them. And no wonder; for all the resources of our almost miraculous technology have been thrown into the current assault against silence.[41] For Huxley, noise was the signature of the modern world's ceaseless incitement of desire, to prevent the will from ever achieving silence and the desirelessness that is the condition of deliverance and illumination.[42]

"Deliverance" may be more than anyone (at least one who is not intoxicated with religious belief) can hope for today, but the intensity of light at *The Lightning Field* keeps alive the metaphor of "illumination" in the visitor's mind. The site is remote and quiet enough still to make the visiting city dweller wonder which aural experiences contribute most to his customary awareness of being. Does silence have some primacy in this regard, irrespective of where we experience it, or is the ontological report of incessant urban noise more truthful—because richer in historicity —in a mechanized, interconnected, overpopulated world, as John Cage implied?[43]

At times, *The Lightning Field* still offers the kind of silence Steiner pines for, a silence deeper than that of any town, which, as Alberto Moravia wrote, seems always somehow to retain wounds and aches from sounds already past.[44]

When the wind is calm, the site can be so quiet by day that all kinds of sounds register that we think of as inaudible: not only the buzz of flies and the whir of grasshoppers but the skittering of a startled lizard and the scratch of a stag beetle clawing its way across parched ground.

Yet no writer who has read William S. Burroughs can discuss silence without recalling such brilliant, pertinent flashes of paranoia as this one from *The Ticket That Exploded*: Modern man has lost the option of silence. Try halting your sub-vocal speech. Try to achieve even ten seconds of inner silence. You will encounter a resisting organism that *forces you to talk*. That organism is the word.[45]

BIRDSONG

The aural impressions most striking to the urban visitor at *The Lightning Field* may be the purity and detail of birdsong.

One reason . . . the wilderness feels liberating is that it allows us to enter an existence free of status, wrote the poet Jane Hirshfield. Whatever our encounter with a canyon wren, it will take place at another level . . . than that of rank. When we give our attention over to the non-human, self is released from self and into the ten thousand beings and things of the world.[46]

A pleasing thought, yet to the ornithologist, birdsong rings with meaning, and rank is one of its leitmotifs. Birdsong, John Terborgh explains, can communicate information about species, sex, territorial location, and individual identity, and, through its repertoire, it can provide clues to age and social status. Beyond that, song can communicate danger (through the sounding of alarm), sexual readiness, fear, hunger, aggression, scolding (particularly of predators), contentment, irritation, and location.[47] Science's disenchanting effect has typically been a matter of voiding meanings popularly ascribed to phenomena. In this case, disenchantment comes from recognitions of meaning.

On our fourth 1990s visit to *The Lightning Field*, in July 1997, we watched at length a family of flycatchers that had nested under the lip of the cabin's porch roof. The hungry nestlings' squeals could be heard throughout the day. Their parents, primarily the female, spent hours snatching insects from the air within a hundred-foot radius of the porch, bringing them back to feed the brood. At moments when I could see nothing moving against a blank, hot sky, she would swoop from under the shingles and, after a dither of wingbeats, return with live prey. (I was reminded of the old samurai taunt that an adept should be able to pick a fly from the air—alive—with chopsticks.)

My encounter with the flycatchers did take me out of myself, as Hirshfield promises, but it also stirred a futile wish that I could feel as perfectly adapted to my world as the birds apparently are to theirs. But what I wish for when I pine for perfect adaptation may merely be deliverance from the consciousness of history.

Recently, ecologists have pointed to an alarming decline in the populations of migrating songbirds in North America. They link the decline to human population

growth and, in particular, to the leveling of Caribbean and Latin American forests, the birds' age-old winter habitat.[48] Before long, unless things change, a generation may learn to think of all birdsong as cries for help.

Ironically, aircraft often make the calls and flight of birds inaudible at *The Lightning Field*. In 1978, I heard only a single jet pass overhead in more than a week at the site. Now aircraft are audible there frequently around midday and occasionally at other times, even after dark. Air traffic tends to be high flying and fast moving, but commercial flight paths now cobweb the sky above the region.

EXPOSURE

Contemporary sculpture can still afford us revealing experiences partly because of its soundlessness. (There are odd exceptions: Jean Tinguely, Edward Kienholz, Rebecca Horn.) Sculpture on remote, open land is particularly well-positioned to direct our attention to the contemporary world's systematic suppression of silence in technological consumer cultures as Steiner calls it.[49]

This thought was confirmed during a visit to Andy Goldsworthy's *Sheepfolds* project (1993–2003) in England in August 1996, a project strangely antipodal to *The Lightning Field*. In the rural British sheep farming district of Cumbria, Goldsworthy had been rebuilding traditional stone enclosures known as sheepfolds, making slight, odd alterations to them. Every inch of this landscape, Goldsworthy says, has been walked and worked by generations of people. The sculptures that constitute his vastly dispersed ensemble are all made of stones found on the land or salvaged from old, collapsed structures. Most are on private property. Goldsworthy took me to one of the more remote sites of the project, a high moor, a half-mile's walk from where vehicles are permitted, where the only signs of habitation are crumbling walls and a tumbledown stone cottage that he was hoping to annex for sculptural purposes. (The cottage brought to mind *The Lightning Field* cabin in the partially refurbished state in which I first saw it in 1978.) Gaps in the windowless hut's wood door let in just enough light to see a hole-in-the-wall fireplace and a clutter of timbers on the floor. As Goldsworthy finished telling me of his plan to put inside the cottage a

stone boulder too large to permit anyone to enter, a screaming of jet engines came across the sky.

Here, too, fighter planes—Royal Air Force? NATO?—were practicing maneuvers overhead. The pilots apparently took no notice of us on the ground, but their implicit threat mocked the stone cottage's promise of shelter. The jets screeching above helped me imagine the effect of what Goldsworthy proposed to do here: a boulder inside the cottage blocking entry would be a waking nightmare of shelterlessness—of exposure not only to the elements but to history. I envision it creating a bizarre collision of references: invoking René Magritte's conundrums of representation, in which boulders frequently figure, and turning inside out the Christian legend of the rock rolled away from Jesus's sepulcher.

VISITORS

In the Cold War years, the vapor trails of jet aircraft—visible on every clear day at *The Lightning Field*—were unnerving reminders of the Strategic Air Command's incessant patrol of the Northern Hemisphere. Today we may think first of commercial aircraft when we see vapor trails, but as reminders of global warming they are almost as ominous. (The September 11 massacres added a grim new note of foreboding.) In the mid-1990s, satellites began to detect a rise in sea level owing to the trapping of carbon dioxide and other "greenhouse gases" in the upper atmosphere. It being a parameter of *The Lightning Field*'s form, sea level is an abstraction never far out of mind there. I recall, too, a remark by Richard Diebenkorn about living landlocked in New Mexico after decades on the coasts. The sky, he said, eventually came to seem a surrogate sea.

In a secret Pentagon report on climate change leaked to the press in early 2004, ecological dread officially eclipsed Cold War paranoia, perhaps for the first time. The report mentions commercial air traffic as a major cause of the atmospheric breakdown that portends catastrophic worldwide social—and therefore national security—consequences.

High-altitude noise pollution was the first outward sign of the world's encroachment on *The Lightning Field* in the 1990s. Car headlights on the night horizon and the glint of sunlight on a far-off windshield, though still rare, were others. In the 1970s, a far-off flicker of traffic meant only one thing: that someone was headed for the cabin, someone with a reason to be there. Nowadays, distant headlights sometimes appear and disappear without anyone arriving. Passing traffic foreshadows the teeming of the world drawing closer and signals the disquieting possibility of surprise visitors.

At *The Lightning Field*, the very idea of surprise visitors brings trouble to mind: the proverbial escaped prisoners or inquisitive extraterrestrials reputed to prefer human contact in remote settings. I am not conversant with the literary tradition that, according to Steiner, gives an optimistic, even messianic coloration to the unanticipated visitor: There is a fundamental implication to the legends, numerous in the Bible, but also in Greek and other mythologies, of the stranger at the door, of the visitor who knocks at the gate at sundown after his or her journey. In fables, this knock is often that of a concealed god or divine emissary testing our welcome, Steiner writes. I would want to think of these visitors as the truly *human* beings we must try to become if we are to survive at all.[50] Such legendary visitors, Steiner suggests, also personify the way solitary reflection can cause us to seem even stranger to ourselves than others do.

In the city, I can accept the psychoanalytic view that the anxiety of physical isolation is that of feeling oneself sequestered with the unconscious, the alien within. When I sit in a cabin in the desert blackness, more outlandish mythologies gain ground.

Slipping off my zori to swing into bed one evening on our visit in July 1997, I noticed large, striped ants shuttling busily within a gap between the rough cabin floorboards. My thoughts raced to *Them!* the 1954 bomb-scare movie classic in which atomic tests at Alamogordo engender giant mutant ants. As a child, I was too terrified by the movie to catch its possible subtexts: that the bomb had broken the world anew into "Them!" and "Us!" and that it proved us to be nature's worst enemies.

Later I came upon Edward O. Wilson's advice, hardly reassuring, that to watch ants attentively may bring us as close as any person may ever come to seeing social life as it might evolve on another planet . . . [t]he evolutionary line that gave rise ultimately to ants and other social insects [having] separated more than 600 million years ago from the line that gave rise to human beings.[51] How relieved I was to find next morning that neither the bed nor my dreams had been invaded by ants of any description.

Marina Warner writes smartly about aliens as visitors from the shadow side of collective obsession. At the weird end of contemporary scariness, she observes, aliens who prey for ambiguous motives on human beings . . . communicate profoundly characteristic modern fears and reflect back our own sense of estrangement from ourselves. Aliens not only abduct their quarry, as did the fairies, but they also perform surgical operations, obstetrical in character, thus mimicking in phantasmagoric fashion the bewildering range of ethical issues raised by reproductive technologies and the new biogenetics.[52] In reality, the invaders that most threaten the world, ecologists say, are accidentally transplanted terrestrial species, like the "killer algae" in the Mediterranean, that burgeon unchecked in foreign but hospitable environments, creating ecological calamities by eliminating indigenous organisms.[53]

In his amusing novella of ideas, *Dark at the End of the Tunnel* (2004), Christopher Bollas has his psychoanalyst "comic hero" shock another character with the thought that space aliens may psychically represent aborted fetuses returning to reproach the living for thwarting their birth.

LIFE

Until the mid-1990s findings of evidence of pervasive ancient water on Mars and on Jupiter's moon Ganymede, the nearest thing we had to scientific evidence of extraterrestrial life were miniscule fossil structures, possibly of archaic bacteria, in a meteorite of Martian origin found in Antarctica in 1984. That the object is a

particle of Mars, apparently chipped off by the impact of an asteroid, is well accepted. It is thought to have fallen to earth as recently as 13,000 years ago. When it went adrift is anyone's guess. Few scientists persist in believing that the microbe-like forms embedded in it really are residue of early Martian life, "early" meaning more than three and a half billion years old. Surface observations of Mars have since found it chemically inhospitable to life as we understand it. More confirming to many astronomers interested in the prospects of life's cosmic dispersal was the 1969 descent to earth in Murchison, Australia, of a four-billion-year-old meteorite that proved to be two and a half percent organic matter.

Outweighing the Martian meteorite's value as scientific evidence was its utility as a lobbying tool for future space program funding. It occasioned a presidential press conference reaffirming a determination to search for further evidence of life on Mars, as if resolving that question were somehow crucial to life on Earth. Among scientists, historian Howard E. McCurdy writes, the merits of other alternatives were equal if not superior to the chances of locating life on nearby Mars. In the public mind, however, Mars possessed a special status.[54]

Its status was elevated further by transmissions from NASA's Sojourner vehicle, which was noodling around the Martian surface in July 1997, while Tonia and I were on our fifth visit together to *The Lightning Field*. The images from Mars, seen by countless people on the Internet, showed a landscape that looked startlingly like areas of New Mexico, apart from being barren of flora.

The reports of flooding and biological activity, no matter how ancient or tentative, electrified people who had been raised on reports of Martian canals and seasonal vegetation, according to McCurdy. The prospect of Martian life, a possibility that had thrilled the general public for more than a century, continued to be front-page news. Even as serious scientists raised doubts about the likelihood of Martian life, space advocates continued to dream about flotillas that would one day take human explorers to that familiar realm.[55]

Robert Zubrin, a former Lockheed Martin engineer who founded his own space exploration consulting business, has even revived "the Turner thesis" to argue

for human (read: American) colonization of Mars. As early as 1893, Frederick Jackson Turner proposed that confrontation with the frontier, which once meant much of the North American continent, had formed the pragmatic, individualist, innovative temperament that truly set Americans apart from the Old World. Zubrin reframes Turner's argument to suit present circumstances and entrepreneurial prospects: The creation of a new frontier presents itself as America's and humanity's greatest social need, Zubrin declaims. Apply what palliatives you will, but without a frontier to grow in, not only American society, but the entire global civilization based upon values of humanism, science, and progress will ultimately die.

Zubrin calls for an extraterrestrial restitution of the modern age, oblivious to the fact that the values of humanism, science, and progress have frequently been in conflict during the period. He dismisses the argument that undeveloped earthly regions, such as the poles or the ocean floor, are viable future frontiers. He never mentions cyberspace.

At this point in history such terrestrial developments cannot meet an essential requirement for a frontier, Zubrin writes, to wit, they are insufficiently remote to allow for the free development of a new society. In this day and age, with modern terrestrial communication and transportation systems, no matter how remote or hostile the spot on Earth, the cops are too close. If people are to have the dignity that comes with making their own world, they must be free of the old. . . . The fact that Mars can be settled and altered defines it as the New World that can create the basis for a positive future for terrestrial humanity for the next several centuries.[56] At least there appear to be no natives to extirpate.

Zubrin's voice belongs here partly because he takes world making so literally. The mind of anyone who spends enough time alone at *The Lightning Field* may drift to similar extremes, all the way to wondering how we ever make a world of what we experience. To what extent—if any—is it a solitary effort? Is it not always, necessarily, a social, if not a deliberative one: a matter of what John Searle calls collective intentionality?

DELIVERANCE

Since the debacle of the twentieth century's utopian social experiments and the recession of Cold War terrors, contact with extraterrestrial intelligence has become *the* popular image of deliverance from history, something of which I believe we are always dreaming, consciously or otherwise. We crave release from our own culture's way of living out time as the sheer, driving impossibility of repetition. That preclusion seems now to encompass the regenerative repetition of ritual and even the seasonal cycles on which humans have organized collective life for most of the species' existence. (Ecologists have begun to talk of "de-seasoning" as an upshot of global warming, a gradual leveling of once-pronounced distinctions among times of year.)

We have instead the shadow of cyclic realities: repetition as social control in the deadening rationalization of work and mass consumption. The institutions of capitalist society, threatening to become the only institutions there are, leave us to confront alone the raw contingency of events. The more we dwell on the unpredictability of those events, the less we apprehend time's cyclical aspects, the more acutely we experience time as a shredding differentiation of future occasions from past. As Louis Menand nicely formulates it, Modernity is the condition a society reaches when life is no longer conceived as cyclical. . . . Modern societies do not simply repeat and extend themselves; they change in unforeseeable directions, and the individual's contribution to these changes is unspecifiable in advance.[57]

Bollas reminds us that the *passing* of time is intrinsically traumatic.[58] And our culture's ways of conducting itself leave us defenseless against the trauma of time's passage. At *The Lightning Field*, these recognitions turn into an existential terror of exposure, which the sculptural nexus of the work shifts into an apocalyptic key specific to the nuclear age.

These thoughts come more sharply into focus at *The Lightning Field* the longer one stays there: they form in the tension between wheeling of days and nights and the irreversible one-way passage from unknown to known—or is it the reverse? —that the poles evoke so well. The poles give mute form to Umberto Saba's

observation that the twentieth century seems to know one desire only, to get to the twenty-first as soon as possible.[59]

Under the faith-based presidency of George W. Bush, another end-time mythology has come into its own: the evangelical Christian idea of the Rapture, the moment preceding Armageddon when God will waft all the chosen heavenward— no gravity-free vehicles needed, thank you—consigning the rest of us to the fires of the Final Conflict and eternal damnation. Perhaps all such end-time visions, including nuclear apocalypse, express a common resentment of mortality, gratifying in fantasy the wish that the world should end when one's own life on earth ends: a monstrous form of self-importance that the nameless faithful and the most hubristic potentates appear to share.

WAITING

In 1949, William Faulkner stated in his Nobel Prize acceptance speech: Our tragedy today is a general and universal physical fear so long sustained by now that we can even bear it. There are no longer problems of the spirit. There is only the question: When will I be blown up? Because of this, the young man or woman writing today has forgotten the problems of the human heart in conflict with itself which alone can make good writing because only that is worth writing about, worth the agony and the sweat.[60] Today Faulkner's literary pessimism seems excessive. About his historical pessimism we cannot be so sure.

I think of Richard Wilbur's lines from a 1961 poem called "Advice to a Prophet": Spare us all word of the weapons, their force and range, / The long numbers that rocket the mind[61]—"rocket" used in the double sense of making thoughts race and of annihilating thinking.

The equation of nuclear apocalypse with the end of history may seem like a symptom of Cold War–era dread, but the end of the habitable world by detonation may yet happen. The *Bulletin of the Atomic Scientists* reported recently that in spring 2004 the United States acknowledged having some 7,000 operational nuclear

weapons, by far the largest arsenal in the post–Cold War world, a small fraction of which could imperil life on earth as we know it.[62] Accounting of the former Soviet Union's weapon stockpiles is said to be far less reliable.

Meanwhile, India and Pakistan—and more recently North Korea—have announced themselves to the world as nuclear-armed antagonists, and the meaning of "nuclear proliferation" has expanded from the accumulation of bombs and warheads by the big powers to their development by nations of uncertain stability, with attendant criminal opportunities for brokering nuclear devices to terrorists or undeclared aggressors. The Bush administration's demonstrated proclivity for "preventive war" has made nuclear devices newly attractive to vulnerable nations as weapons of self-defense. From now on it is not dying we must fear, but living, Arundhati Roy wrote, echoing Faulkner, knowingly or not, soon after India's and Pakistan's detonations.[63] In the rarefied aesthetic dimension *The Lightning Field* opens up, the visitor tastes irrepressibly this air of the lived historical present as morbidity with no remit other than denial.

Russian and American military brass stood watch together, to prevent the worst from happening, as computer clocks rolled over to the year 2000. But the question remains why, under putatively post-confrontational circumstances, the decision times that follow missile system warnings on both sides remain as short as they were at the apex of the Cold War face-off.

An end-time scenario perhaps as probable as a hot World War III is an ultratoxic slow burn of nuclear accidents, mismanaged radioactive waste, and suicidal terrorism. (Michael Tobias gave one of his books about human ecological heedlessness the apt title *World War III.*) A northern hemispheric polar view of the earth, published in the May 2000 *Harper's*, makes this course of events appear already well advanced. The map is thickly speckled with dots and other symbols indicating waste dumps, known radioactive chemical deposits, and nuclear detonations that have occurred since 1949. Set aside battle sites, recent history has already given us a string of names permanently identified with disasters: Minamata, Three Mile Island, Bhopal, Chernobyl. Here we have the dark side of site-specificity.

Fresh information never comes as good news where the management of radioactive material is concerned. In 1997, the National Cancer Institute reluctantly disclosed its study reporting that much of America's population east of California between 1951 and 1962—about 160 million people, myself included—unknowingly suffered significant exposure to fallout from aboveground nuclear tests in Nevada. Government information made the average citizen's total exposure about equal to that of a chest X-ray; the National Cancer Institute study puts it between 200 and 3,000 times that amount.

Protests erupted in 1997 when it was reported that NASA planned to send its *Cassini* spacecraft to Saturn carrying more than seventy pounds of plutonium-238. Plutonium is so toxic, Helen Caldicott wrote at the time, that one pound distributed around the Earth in particles small enough to be inhaled could induce lung cancer in every person on the planet.[64] The mission went forward without mishap, but NASA has neither admitted nor explained the madness of the risk it entailed, which the space shuttle *Challenger* explosion had gruesomely illustrated not long before.

At this writing, an administration deaf to ideologically inconvenient scientific research has thrown its power behind a plan to bury vast quantities of nuclear waste beneath Yucca Mountain in Nevada, a plan that, even if it carried negligible risk of seismic and pollutant calamity, would mandate the routine transport of lethal nuclear material through many of the nation's densest population zones. The unrepentant insistence on jeopardizing life on earth for the sake of research or of ideology looks like another expression of the spite at the heart of the nuclear arms race: in my view, this spite is *the* problem of the human heart in conflict with itself.[65]

Perhaps Faulkner was half right in his critical pessimism, in that the ringing address to this conflict so far has been in nonfiction, prominently that of Jonathan Schell.

By the century's end, the web of arms control agreements that had been painstakingly woven during the last half century of the Cold War was tearing

apart, Schell wrote in a long essay for *Harper's*. The United States Senate voted down the Comprehensive Test Ban Treaty—an act that cut away the foundation of several decades of effort by the United States to halt the spread of nuclear weapons. . . . Interpretations of the real twentieth century now require not so much smarter interpreters as the world's decision whether, in the wake of the Cold War, it will reject nuclear weapons or once again embrace them. . . . How will we continue to believe that the democratic nations endured the risk of nuclear annihilation for the sake of human freedom when, with the threat to freedom gone, the threat of annihilation is preserved?

If Congress's rejection of the Test Ban Treaty and its enthusiasm for some version of the Reagan-era Star Wars system are true signs of the times, then a graver suspicion will be confirmed, Schell concludes that the United States and its nuclear allies did not build nuclear weapons chiefly in order to face extraordinary danger, whether from Germany, Japan, or the Soviet Union, but for more deep-seated, unarticulated reasons growing out of its own, freely chosen conceptions of national security. Nuclear arsenals will seem to have been less a response to any particular external threat than an intrinsic element of the dominant liberal civilization itself—an evil that first grew and still grows from within that civilization rather than being imposed from without. And then, recalling World War I, Schell writes, we will have to ask what it is in the makeup of liberalism that pushes it again and again, even at the moment of its greatest triumph, into an abyss of its own making.[66]

Schell did not raise in this context the possibility that *The Lightning Field* keeps before the visitor's mind—that the devil is in the technology, in the temptations and delusions of power implicit in it—power over the behavior of whole populations and the course of events, power over the forces of nature and the very terms of physical existence.

But perhaps neither technology nor the science behind it is "the dominant liberal civilization's" fatal internal flaw. Perhaps it is that evil can be systematized

but goodness cannot, whether in the name of justice, security, tradition, posterity, or any other value. This thought lies at the core of *Life and Fate*, Vasily Grossman's gripping novel of the Battle of Stalingrad. In a central chapter, one reads through the eyes of Mostovskoy, a contemptuous old Bolshevik, the jottings of a fellow war prisoner, an erstwhile Tolstoyan named Ikonnikov, who appears only briefly, seemingly to serve as Grossman's mouthpiece.

I have seen the unshakeable strength of the idea of social good that was born in my own country, Ikonnikov writes. This was something fine and noble— yet it killed some without mercy, crippled the lives of others, and separated wives from husbands and children from fathers. Now the horror of German fascism has arisen. The air is full of the groans and cries of the condemned. The sky has turned black; the sun has been extinguished by smoke of the gas ovens. And even these crimes, crimes never before seen in the Universe—even by Man on Earth—have been committed in the name of good.

The only value untrammeled by the march of great ideological schemes, according to this unhinged . . . feeble spirit (as Mostovskoy judges Ikonnikov) is the private kindness of one individual towards another; a petty, thoughtless kind-ness; an unwitnessed kindness. . . . A kindness outside any system of social or religious good.

This instinctive, blind kindness is indestructible only because it is powerless as dew, cannot be legislated, regimented, or made a weapon of social or military struggle. If Man tries to make a power of it, Ikonnikov concludes, it dims, fades away, loses itself, vanishes.[67]

Grossman filters Ikonnikov's reverie through Mostovskoy's cynicism, which the embittered Bolshevik regards as sober realism. And for jaded readers like ourselves, only a faint tarnish of resignation saves Ikonnikov's thoughts from sentimentality. Mostovskoy will not let Ikonnikov's thinking touch him. He ends the scene para-lyzed by depression, resenting his Nazi interrogator's summons to him, not to administer the torture through which Mostovskoy might demonstrate his courage

in a new way, but merely to hear him confirm the Nazi in his own opinion that Ikonnikov is an imbecile. Against the ignominy of their agreement, Mostovskoy finds himself defenseless.

TARGET AREA

After the end of the Cold War, Hollywood fantasies such as *Deep Impact* (1998) and *Armageddon* (1998) began to seem as plausible as any sociopolitical vision of history's end. Movies license the public expression of fears people already feel but dare not articulate or even acknowledge under other circumstances, which appear to leave those fears barren of context. Global-disaster epics may in fact have offered totalizing fantasies that served to perpetuate the Manichaean simplicity of the Cold War world-picture. That is, until radical Islamist terrorism lent credence to a morally shabby vision of a "clash of civilizations," and an American president professing evangelical Christian beliefs began to frame a shamelessly aggressive foreign policy in the language of good and evil.

Meanwhile the earth itself remains a target area in an astronomical as well as a geopolitical sense.

Not until the nineteen-seventies and eighties, when the Mariner spacecraft returned images of the pockmarked surfaces of Mars and Mercury and the Voyager mission to the outer planets took detailed pictures showing thousands of overlapping craters on satellites of Jupiter and Saturn, did scientists come to appreciate that the solar system's topography resembles that of an artillery range, wrote Timothy Ferris in a *New Yorker* article about the possibility of astrophysical calamity. Earth's relatively crater-free surface is the result of erosion: were it not for wind, rain, and geological upheavals Earth would be as pockmarked as the Moon.[68]

In the spring of 1996, the comet Hyakutake passed near enough to Earth to be visible late at night from our San Francisco apartment. My memory of the smudge of light it made in the night sky—from millions of miles away—was enough to

make Ferris's observations gripping. (How much brighter and nearer it must have appeared in the New Mexico desert!) That a meteoric calamity is always possible is just one more aspect of our defenseless condition as self-conscious creatures evolved by a temporarily lucky planet—the condition that every visitor to *The Lightning Field* experiences with unaccustomed intensity on a cloudless night. In the very long term, if civilisation is to survive on Earth it will have to find a way to protect itself from cosmic impacts, cosmologist John Gribbin confirms.[69]

From decades of NASA reconnaissance has evolved *a new and more sophisticated picture of the solar system as a unified entity with a common history*, according to Ferris. In this new picture, the planets owe their very existence to impacts. They are thought to have formed through the collisions of "planetesimals"—mile-wide objects, themselves built up from the dust grains and basketball-size clumps of material that orbited the infant sun in the early days. Earth, when young, was evidently hit by something as massive as Mars; the crash created a huge molten splash of mostly surface material, and that material coalesced to form the Moon. The Moon itself bears the scar of at least one nearly catastrophic impact, in the form of a gigantic ringed crater, Mare Orientale, an ash-gray bull's-eye bigger than Sri Lanka. (Mare Orientale happens to point ninety degrees away from the earth, so it remained undiscovered until it was photographed by lunar space probes. Had the Moon locked gravitationally to Earth a quarter of a turn later, so that Mare Orientale permanently faced us, we would have evolved looking not at the Man in the Moon but at a big, staring eye. How might that apparition have influenced the course of human history?) Eventually, the surviving planets emerged, having swept their orbits clear of everything massive enough to destroy them.[70]

DEVICE

The significant artworks of our era are devices in a double sense. First, they are things we use to attain to feelings, mental states, and pitches or transits of attention

that we might be unable to reach otherwise and may be unable to revisit even when we believe we can. Much depends on attunement and angle of approach. Artworks differ from other technics for affecting the self in being structured by communicative intent and by educated guesswork about how symbols, materials, allusions, expressive acts, and decisions will be deciphered. Regardless of how we use artworks, interpretation will be the upshot of our engagement with them. When we know ourselves and each other, we know styles and possibilities of construing what presents itself as real, both in our minds and independently of them. We dwell in our interpretations of the world and in the equipment—the language, images, and figures of thought—through which we apprehend it. Artworks mirror to us and let us feel our own interpretive reflexes. They acquaint us with the resistance offered by various levels of structure, visible and invisible, some intended to be "read," some not. *The Lightning Field* makes a superlative example of this sort of device.

Artworks are also devices in the heraldic sense. They serve as emblems of the ideas, emotions, or dilemmas that they help us bring into focus.

At one level, to experience *The Lightning Field* is simply to look receptively at earth and sky, in which the curious eye has its evolutionary roots and of which it therefore never tires. The sky, Ralph Waldo Emerson wrote, is the daily bread of the eyes. Even bereft of its Transcendentalist context, his observation stands.

Writing down this fact brings two things to mind. One is Clement Greenberg's formulation of avant-garde ambition in an early essay: The avant-garde poet or artist tries in effect to imitate God, Greenberg wrote, by creating something valid solely on its own terms, in the way nature itself is valid, in the way a landscape—not its picture—is aesthetically valid; something *given*, increate, independent of meanings, similars or originals.[71]

Here occurs a marker of a change that has taken hold in the past twenty-odd years: we find it hard now to believe that Greenberg's distinction between a landscape and its picture ever seemed a fundamental one, much less an ontological one, a distinction that might decide what is and is not "valid." In our lifetimes, images

have spread and coalesced into a network as compelling of fantasy, belief, and action as what it depicts. Nothing anymore, not even nature, seems independent of meanings, similars or originals.

The second passage that comes to mind is starkly different, and anachronistic in a different way. Lawrence Durrell argued that landscape subtends history in terms that read today more like a profession of faith than an account of experience. For to us it seems that *nothing* subtends history, whether we understand history as the churn of events or the precession of simulacra, as Baudrillard called it. The tendency to mark time's progress by the advance of ever more pervasive digital technology is the latest version of this unchosen faith, which may soon come to center instead on innovations in bioengineering.

I think some of the troubles which American artists talk about, Durrell wrote in 1960, are due not to "industrialization" or "technocracy," but something rather simpler—people not attending to what the land is saying, not conforming to the hidden magnetic fields which the landscape is trying to communicate to the personality. At a time when travel is packaged as tourism to an extent that would have sickened Durrell, *The Lightning Field* still serves as a device—even if only a commemorative one—for reawakening his idea of terrain-sensitive travel. The great thing is to try and travel with the eyes of the spirit wide open, and not too much factual information, Durrell wrote. To tune in, without reverence, idly—but with real inward attention. It is to be had for the feeling, that mysterious sense of *rapport*, of identity with the ground. You can extract the essence of a place if you know how. If you get still as a needle, you'll be there.[72]

TOUCH

The Lightning Field remains a useful tool of thought at the turn of the twenty-first century partly because, as enthralling as it is to the eye, it evokes *touch* as the sense our age is most bent on nullifying. Our eyes will continue to be overfed as the shift from analog to digital culture rolls on, but our imaginations grow less and less alive

to touch, the more we grow accustomed to the idea that everything that matters can be dematerialized in imagery with no loss of significance.

The thought of *The Lightning Field* as an expanded bed of spikes is a presentiment that the work is a monument to palpability. Its remoteness matters partly because its sculptural elements are most of the time far, far out of reach.

Might we not say the same of sculpture in a museum, though, of the David Smiths perennially on view at the National Gallery of Art, for example?

No. Because to see the Smiths is only one of countless reasons people visit the National Gallery, and to touch them is forbidden, except to certain staff and other art professionals.[73] But few people have visited *The Lightning Field* for any reason other than to experience the work or see to its maintenance. And unlike museum art, *The Lightning Field* poles can be touched: the physical feel of their improbable rootedness there, and their faint, deep thrumming in a stiff wind, are among the defining perceptions of this work. To grasp a pole is to feel that you know where you are, almost in Durrell's sense, or, even more, that you *are* irrefutably at the terrestrial spot you happen then to be knowing.

The memory of that sensation jolted me one day as I rode the New York subway, holding onto an upright stainless-steel pole that might almost have been a De Maria. The image of this pole racing forward belowground suddenly complemented my recollection of grasping poles at *The Lightning Field*. (Impinging from another angle was my memory of De Maria's *New York Earth Room* [1977], the almost 200-cubic-meter stratum of loam that stretches indoors—Magritte-esque—through an otherwise empty loft space one story above the Lower Manhattan streets.) Feeling firsthand the stasis of *The Lightning Field* poles reminds one sharply how physically particular place is, even in an age striving to persuade itself that, through speed, electronics, and illusion, it has finally transcended the ontological constraints of "meatspace," as opposed to cyberspace.

Heidegger, who famously defined the human mode of being as *Dasein*—"Being-there"—would probably have found in "being digital" (to borrow Nicholas

Negroponte's book title) final confirmation of his belief that technology has unmade ontology. *The Lightning Field* poles in their spearlikeness recall a remark of Heidegger's in *Parmenides*: The look of the modern subject is, as Spengler said, following Nietzsche, the look of the predatory animal: glaring. Through glaring, beings are, so to say, impaled and become first and foremost objects of conquest.[74] The glaring gaze itself was for Heidegger a marker of humankind's alienation from its erstwhile position of ontological privilege as the being that gives "the there" to what is. We might, then, take *The Lightning Field* as a monument to the "glaring" vision of human hostility to nature, although I see its incisive drive as more in line with William S. Burroughs's thought: when you cut into the present, the future leaks out.[75]

To quote Heidegger today feels very different from how it felt to cite him in the late 1970s. Irrebuttable evidence of his Nazi sympathies, widely translated and discussed in the past twenty years, has made vivid the antidemocratic temper of his thought and voided the moral force that once seemed implicit in his critique of the modern world.

The American appetite for depicted violence may be superstitious, like the hypochondriac's morbidity: a guilty dwelling on dreadful possibilities that dreams of redeeming itself by magically forfending them in reality. But the danger of feeding on violent imagery lies not only in its inflammation of anxiety and instinct but in the fact that images negate touch. We can enjoy the excitement of fantasizing violence only so long as it does not truly touch us.[76]

There is nothing that man fears more than the touch of the unknown, Elias Canetti reminds us. He wants to see what is reaching towards him, to be able to recognize or at least classify it. . . . All the distances which men create round themselves are dictated by this fear.[77] The new fictions and protocols of distance effected by the computer revolution have downgraded the tangible more than ever.

Some journalists who observed the 1991 Persian Gulf War remarked on the eerie detachment that new weapons make possible. The Gulf War was an

experience disconnected from itself, Michael Kelly concluded, conducted with such speed and at such distances and with so few witnesses that it was, even for many of the people involved, an abstraction. It was difficult for the Americans, who had done their killing almost entirely from afar, to feel a connection with those they killed, or with the act of killing. It was difficult for the Kuwaitis, coming out of seven months of hiding, to believe that their powerful tormentors had really been killed. The roads north filled these vacuums. They were, for miles and miles, rich with the physical realities of war, glutted with the evidence of slaughter and victory. They became the great circuit board of the Gulf War, where the disconnectedness stopped.[78] For us who were spared that sight, the episode's "disconnectedness" remains its signature in memory. Kelly was among the many journalist casualties of the second Gulf War.

PILGRIMAGE

Some people derisively liken a visit to *The Lightning Field* to a pilgrimage, supposing that reverence for De Maria's vision or for the wealth behind Dia's projects must be its point. (No doubt much awe and envy of wealth circulate on unconscious as well as conscious channels in American life.) But the rhyme of Land Art with traditional votive journeys is neither ironic nor sinister. It highlights another peculiarity of our historical position: that time-and-space-contracting technologies have made it imperative to rehabilitate our experience of distance. Perhaps the international vogue for hiking is symptomatic of this need.

Even medieval Christian pilgrimage, Gabriel Josipovici suggests, was not so much a passage from A to B as a journey into the experience of distance itself. When the pilgrim touched the shrine at the end of his or her long journey it was an attempt not so much to bridge the distance that separated him or her from the holy as an instinctive way of making that distance palpable.[79] But Josipovici may be projecting an aspect of our condition onto the past. For how could distance not have seemed palpable in premodern Europe, considering the peril and difficulty of

travel then? Did living in a world suffused with Christian belief predispose people to fantasies of intimacy with the divine that it took the pain of pilgrimage to dispel? For us, the experienced reality of distance promises to repair disconnection not from divinity but from the value of our own being.

I recall the chastised optimism of Eduardo Galeano's little prose poem "Window on Utopia": She's on the horizon, says Fernando Birri. I go two steps closer, she moves two steps away. I walk ten steps and the horizon runs ten steps ahead. No matter how much I walk, I'll never reach her. What good is utopia? That's what: it's good for walking.[80]

De Maria understood that one of contemporary sculpture's reasons for being is to make space physically real again to us who have grown so comfortable pretending to be—and so at some level truly becoming—disembodied by media and speed.[81] Perhaps no visitor to *The Lightning Field*, except someone local to the area, has deliberately walked there like a medieval pilgrim. Getting there and getting out again remain difficult enough to confound the urbanite's familiar sense of space, calibrated in terms of convenience.

CONTACT

Tonia and I intersected the invisible pop culture axis that now crosses *The Lightning Field* on our way there by way of Socorro in August 1996. We detoured briefly to the National Radio Astronomy Observatory (NRAO). Known as the Very Large Array (VLA), this colossal Y-shaped configuration of twenty-seven radio antennas ranges over the dry bed of an antediluvian inland sea: at highway speed, the Plains of San Agustin can still appear oceanic. As we neared the VLA, our friend and guest Robert Ecksel, seeing New Mexico for the first time on that trip, was startled to spot from the car window what looked like a distant schooner, as the landscape flashed between tall clumps of rabbit brush at the highway's edge. What he saw was a towering white radio antenna, far out on one of the VLA's tracks.

The VLA is *The Lightning Field*'s counterpart in aesthetic immensity and in its probing, defiant address to the sky. Both exemplify what David Nye calls the American technological sublime, though the VLA far outstrips De Maria's work in scale. Each antenna dish is eighty-two feet in diameter and stands about a hundred feet tall. Nine antenna units are positioned along each arm of the array. Each set of nine stretches more than 2,000 feet in the array's tightest configuration and thirteen miles at its most expanded.

The VLA was dedicated in 1980, about two years after *The Lightning Field* opened to visitors. It is a functioning example of what the *Field* evokes by sculptural means: the thrust of human curiosity beyond our planet and our innate sensory limits. The VLA literally scans great sectors of the sky as electromagnetic fields, mapping interstellar space and astronomical objects as sources of radiant energy at wavelengths far longer than those of visible light. *The Lightning Field* amplifies our awareness of visible light; the VLA is an amplifier of the electromagnetic spectrum's insensible upper reaches.

In 1986, the French astronomer Jean Heidmann found, to his great disappointment, that VLA data eliminated a prime candidate for extraterrestrial communication —a "nearby" radio source, mere hundreds of light-years away—whose emissions had appeared promisingly patterned.[82] How much meaning "communication" can have when such immense distances are involved is uncertain. An exchange of "messages" with an extraterrestrial civilization would take many generations, during which time the human—or extraterrestrial—resolve to make contact might well fail, reverse itself, or simply be forgotten.

VLA observations in pictorial form are always on view at the NRAO Visitor Center to affirm how much radioastronomy has enriched science's account of the physical universe. But the pictures attracting the most interest there during our visit showed Jodie Foster and other Hollywood luminaries and crew shooting parts of the movie *Contact* at the VLA a few months earlier.

Contact is based on a novel by the late Carl Sagan, the astronomer and science-popularizer who was passionately interested in the search for extraterrestrial

intelligence. In the movie, Foster plays an astronomer so bereft by the early death of her father that all other human relationships fail her: nothing less than extraterrestrial company will make the universe an unlonely place for her again. The film portrays her scientific ambition as a sublimation of her yearning to contact her father after his death. Although it hints at some cognitive and social quandaries that coherent signals from deep space might raise, *Contact* misrepresents the VLA as a listening device. But then, Hollywood valued the facility for its picturesqueness, not its true function.

The VLA or any instrument actually yielding evidence of extraterrestrial communication will depend on a fantastically lucky coincidence of the right signal, the right star, the right channel, [and] the right moment, Heidmann writes. We have to find the "right channel" among 100 billion; the "right star" among 100 billion for our galaxy alone; and as for the "right moment," our equipment must be operating when the waves of any possible signal actually reach the Earth. In an all-sky program taking several years, the listening time [for any target] will last only a minute. Finally, the "right signal" must be present because, despite the enormous effort that is involved, with current technology the only signals for which we can scan are a whistle or a "beep, beep," whereas far more complex signals are conceivable.[83]

Such facts can change the aspect under which one sees *The Lightning Field*, even in memory. Instead of looking like proud standards of humanity's aggressive drive to probe the universe, the poles can suddenly look instead like ciphers of science's incapacity to transcend limits it has already discovered. The poles stand no higher than twenty-six feet, after all, no matter how vividly at times they evoke the desire for cosmic reach.

Whether anthropocentrism might defeat efforts to contact or recognize intelligent life elsewhere is also a fair question. Consider the engraved metal plaque that Sagan designed to affix to the 1973 *Pioneer 10* spacecraft, now traversing the outer solar system. The inscriptions on the gold-anodized aluminum plaque include simple linear figures of an unclothed man and woman, on the chance that, should

intelligent beings elsewhere ever encounter it, their perceptual equipment and cultural background may have prepared them to comprehend the conventions of human self-depiction. The pair of naked figures adrift in space make an unself-conscious rhyme with the numerous images in European art of Adam and Eve's expulsion from paradise. Howard McCurdy notes that initial publication of the image outraged some prudish Americans who saw its transport as the interplanetary dissemination of pornography.[84]

Meanwhile some scientists wonder whether we have fully recognized intelligence on our own planet. Should the social behavior of ants or bees, already recognized as communicative, also be described as "intelligent"? An experimenter in Japan has shown that even slime mold, a simple, almost formless organism, can find its way out of a maze when food sources are placed at the maze's entrances.[85]

PATHS

Visitors to *The Lightning Field* can hardly avoid reflecting on where they happened to start out. Paleontologist Martin Lockley points out the humbling resemblance between the trails astronauts left on the moon and the fossilized tracks of foraging Cambrian worms.[86] A *Lightning Field* visitor who sees Lockley's comparative diagrams will be struck by their similarity to paths left by his or her own forays from the cabin. In the New Mexico desert, such recognitions strike deep, all the way down to one's beliefs about how our kind came to be here at all, of how life itself originated.

Most educated Westerners today accept some version of Darwinian evolution by natural selection. (The misconception of Darwin's thought persists, though, that species' survival depends more on predation and competition than on adaptation, symbiosis, and cooperation.) The past two decades have seen a groundswell of pop-ular interest in evolutionary biology, along with a religious counterthrust in public education known as "creationism," and its new, suave version, "intelligent design," which aims to demote evolution to the status of just another "theory," in the sense of an unconfirmed hypothesis. Courtesy of the faith-based Bush administration,

visitors to the Grand Canyon National Park can now buy at its gift shop a creationist tract titled "Grand Canyon: A Different View" that tries to put geological reality back on a biblical timeline.

Long after writing the previous paragraph for the first time, I came across the results of a 2004 CBS/*New York Times* poll on the subject of evolution. It recorded that just thirteen percent of respondents believe in evolution without God, in contrast to the fifty-five percent who say they believe God created humans in their present form.[87]

As the 2004 presidential election approached, Ron Rosenbaum introduced the useful distinction, which other observers quickly picked up, between "faith-based" and "reality-based" solidarity among citizens. The amoral trust in science that seemed to my generation a potential threat to the world's future looks sensible alongside the rejection of the very concept of verifiable evidence characteristic of "faith-based" viewpoints. Anatol Lieven of the Carnegie Endowment for International Peace took a detached look at the American clash of worldviews in an early 2005 op-ed piece in the *Financial Times*: For the past generation and more, Western democracies have been engaged in a great experiment, with unregulated television and the tabloid press as the chief instruments, Lieven wrote. We are testing how long liberal democracies can survive if their peoples, like so many hereditary monarchs in the past, become ever more lazy, ignorant and prone to irrational beliefs. Up to now, this has not mattered so much because material prosperity and physical safety have provided a cushion against political excess. But the results of the September 11 terrorist attacks should be an early warning in this regard. God help the political system in which a thoroughly addled sovereign is faced with a real crisis.[88]

Daniel Dennett has nominated Darwin's dangerous idea, as he calls it, the single greatest human insight in terms of explanatory power. If I were to give an award for the best single idea anyone has ever had, I'd give it to Darwin, ahead of Newton and Einstein and everyone else, Dennett writes. In a single stroke, the

idea of evolution by natural selection unifies the realm of life, meaning, and purpose with the realm of space and time, cause and effect, mechanism and physical law.[89] Part of what makes Darwin's conjecture so impressive is that he made it without knowing in detail how traits peculiar to species are transmitted genetically. His hunch was that natural selection is an algorithmic process, a slow tumult of life field-testing for durable traits over countless generations of all kinds of organisms, gradually resulting in the world of fauna and flora in which Darwin was astonished to find himself.

The notion that nothing describes change better than an algorithmic model has jumped from one academic field to another in recent years, probably accelerated by the fact that computers function algorithmically, by logical sorting through tiered chains of decision operations. Darwin's dangerous idea, as Dennett puts it, is that the algorithmic level *is* the level that best accounts for the speed of the antelope, the wing of the eagle, the shape of the orchid, the diversity of species, and all other occasions of wonder in the world of nature. No matter how impressive the products of an algorithm, the underlying process always consists of nothing but a set of individually mindless steps succeeding each other without the help of any intelligent supervision. . . . They feed on each other, or on blind chance—on coin-flips, if you like—and on nothing else. Most algorithms we are familiar with have rather modest products: they do long division or alphabetize lists or figure out the income of the Average Taxpayer. Fancier algorithms produce the dazzling computer-animated graphics we see every day on television, transforming faces, creating herds of imaginary ice-skating polar bears, simulating whole virtual worlds of entities never seen or imagined before.[90]

LIFE

The contrast between the inert, abstract order of *The Lightning Field* poles and the teeming of life on the desert floor remains inexpressibly vivid. The sculpture grid's framing of the desert ecosystem took on another association for me during my most

recent visit: to a simple mathematical entertainment with large implications—the Game of Life—devised by John Horton Conway in 1970. The Game of Life is the intellectual germ of what may be a new ontological plane, or merely a new feat of abstraction, known as artificial life.

Conway's "game" transpires in a grid homologous with that of *The Lightning Field*. Each square represents a "cell" that can have one of two states, on or off, i.e., "alive" or "dead." Imagine a grid of white squares in which a black checker, representing a living cell, appears wherever a cell is alive and is removed when it dies. Think of an arbitrary pattern of black checkers on white squares. A new "generation" is determined by a simple set of rules—an algorithm—applied to the present array. The rules determine which cells die, which survive, and which will be born in each generation (or calculation). In Conway's formulation, the rules are:
1. Survival: each piece with two or three neighbors survives in the next generation.
2. Death: each piece with four or more neighbors dies from overpopulation, and each piece with one or no neighbors dies of isolation. 3. Birth: each empty cell with precisely three inhabited neighbor cells is a birth cell, where a new piece is born in the next generation.[91]

Through successive applications of these rules, the configuration of black counters within the grid continually repatterns itself, as if spontaneously. Played on a computer, which can run the algorithm at high speed, the Game of Life will produce shape-shifting patterns that migrate around the screen. Some expire quickly, others sustain themselves indefinitely, as if they have learned the principles of survival in their world. Such patterns of recursive process are primitive examples of artificial life—a-life, for short.

Proponents of a-life see it as more than a model of the self-propagating character of biological entities, or b-life. The attempt to create artificial life, writes Claus Emmeche, an authority on the subject, is nothing less than an attempt to imitate nature's ability to create organic points in physical space; points where a purely physical description no longer captures the essence of the phenomenon, and

which must therefore be described with additional concepts and ideas. It is tempting here to view life as locations out of which emerge an autonomous perspective—the organism's own.[92]

Artificial life has always been tangent to another vision of machine autonomy, artificial intelligence. As a 2006 article that provides a sort of index of how fast the evolution of artificial intelligence has proceeded, Sherry Turkle published in the *London Review of Books* a troubling reflection on the already well-advanced passage from mere machine simulations of spontaneity to the interactivity of "relational artefacts," as she calls them, devices that reshape their responsiveness in certain respects according to the ways people interact with them. In the 1980s, according to Turkle, debates in artificial intelligence centered on the question of whether machines could "really" be intelligent. These debates were about the objects themselves and what they could and couldn't do. Now debates about relational and sociable machines are not about the machines' capabilities but about our own vulnerabilities. When we are asked to care for an object, when that object thrives and offers us attention and concern, we feel a new level of connection to it. The new questions have to do with what relational artefacts evoke in their users. . . . How will interacting with relational artefacts affect people's way of thinking about what, if anything, makes people special? The sight of children and the elderly exchanging tendernesses with robotic pets brings science fiction into everyday life and techno-philosophy down to earth. The question here is not whether children will love their robotic pets more than their real-life pets or even their parents, but what will "loving" come to mean?[93]

Turkle's remarks suggest odd parallels, in need of examination, between people's transactions with artworks and their interactions with the new manifestations of artificial intelligence. Coincidentally the French critic Nicolas Bourriaud, though not with "relational artefacts" in mind, introduced the term "relational aesthetics" into art nomenclature in an effort to capture the difference between art projects that demand or depend on behavioral involvement and those that merely anticipate passive reception.

DARKNESS

Most theorists concur that although it may support silicon-based life, a planet—indeed, a universe—like ours can spontaneously evolve only carbon-based life forms such as ourselves. The explanation is in—in the nature of—the stars.

The Lightning Field evokes the scientific "episteme" with uncanny aesthetic economy. It primes the visitor to intuit, if not to grasp, the historic weight of primitive questions and observations that force themselves upon him or her there. For example: Is space something or nothing? Does it have structure and orientation or is it their precondition?[94]

To watch night fall at The Lightning Field is to sense that, as Edward Harrison puts it, the most meaningful observation that can be made in astromony happens also to be the simplest: The sky at night is dark.[95] Darkness is inescapable at The Lightning Field, though it was even more dramatic before the cabin was electrified, when candles, flashlights, and the wood stove were the only rejoinders to the night. But even now, outer darkness so swamps the electric lights that they cannot provide unalloyed comfort. In fact, the interior lights heighten feelings of exposure that inevitably come of being alone in unlocked, uncurtained lodging. Only extinguishing all the lights and withdrawing into a darkness seemingly deeper than that of the night itself answers to that anxiety, and then only when the night sky is clear. Under heavy overcast, the lightlessness outside is total, except when snow falls and settles on the plain a faint, lusterless grayness, thin as a fog of breath on window glass.

In deepest darkness, the availability of light, and the certainty of its return, show themselves as unexpectedly entwined with the roots of fear. One feels in a homely way the truth of Samuel Beckett's remark, If there were only darkness, all would be clear. It is because there is not only darkness but also light that our situation becomes inexplicable.[96]

Whatever fear of the dark the visitor harbors will hunt him or her down here, possibly mitigated by the presence of other guests at the cabin. The truth is that the night contains whatever you care to put into it, according to A. Alvarez, and,

because you can't see, or can see very little, it gives your imagination unlimited space to work in. . . . Nothing is definite, nothing precise. Evil is a free-floating force and can inhabit the more commonplace objects. Fear of the dark is essentially unspecific; like darkness itself, it is formless, engulfing, full of menace, full of death. . . . Now we have light at our command, at the flick of a switch, we have become connoisseurs of nocturnal fear and keep it constantly on tap as entertainment: horror movies, pulp novels, shock comics tailored for all age groups. It is also out there on the streets every night: the freaks and muggers and addicts, the UFO visionaries, Satanists, religious fundamentalists and political crazies, the ghouls, the terrorists and perverts. The insomniac *passeggiata* of the modern city is a walking validation of our instinctive belief that night is the time when things go wrong and lurch out of proportion, the time when values get turned around and daylight rules no longer apply.[97]

STARLIGHT

Flaring slowly at sunset and then cooling, fading, and finally disappearing abruptly, the poles of *The Lightning Field* offer themselves as instruments for watching day shade into night. We note this process frequently in everyday life but seldom, if ever, take time to follow it. For following it requires slowing our attention (or so it seems at first) to the pace of the sun's transit. In high daylight that pace appears sluggish, almost imperceptible, opposite the pulse of life in society. We seem never to see the sun move overhead, only to notice it having moved, if we happen to catch sunlight jerking down the wall, as Edwin Honig says in a poem of childhood memory.[98]

To stand within *The Lightning Field* around the time of a cloudless sunset, as the poles blaze and your shadow cuts a deepening trough eastward into the rabbit brush, is to experience the earth as a careering vehicle, wheeling through space at the speed of life. At such moments, as at moonrise, the earth's rotation seems frightfully swift: the sweep of a gargantuan second hand. Yet as darkness and cold pool on the plain, you realize it is not so much the speed of the pivoting changes that spells

terror as their unstoppability. You feel viscerally the determinist intuition that must have underlaid seventeenth- and eighteenth-century visions of reality as a cosmic clockwork. Contemplate the turning earth hurtling you into planetary shadow, as the poles all around ring with icy twilight, and you wonder whether the striving for objectivity is not in part a craving for stability—the stability that certainty seems to promise—aroused by living in a realm of heedless forces.

During our 1997 visit, I decided that it was important really to witness day turning to night. At the end of a cloudless afternoon, I stood and ambled outside from just before sunset until the sky was black around the horizon and a bright half moon hung overhead.

As I watched the sun set and moon rise in tandem, a witty thought of Jean Cocteau's, which I found later, nearly formed in my mind: The moon is the sun of statues.[99] That is, the moon is the apogee of sculpture in being a likeness of the sun, the most exalted thing we know. On this view, the moon might be the apogee of Land Art, too: a likeness of the earth. Perhaps by speaking of the moon as a "statue," Cocteau also meant to mock sculpture's paltry limits, which must stop at mimicking the sun's shape, minus its brilliance and heat.

The Lightning Field uniquely links by sculptural means the sun's glory and all we have understood of our dependence on it. Meanwhile, De Maria and several other American artists of his generation completely revised the statuary conception of sculpture.

I also thought of Nelson Goodman's use of the stars to dramatize his thinking about our constraints and freedom as world makers. When a fellow philosopher objected that, whatever we may make of local realities we encounter, we cannot have made the stars, which predate our kind by eons, Goodman responded, I ask him which features of the stars we did not make and challenge him to state how these differ from features clearly dependent on discourse. For we unarguably have made the discourse of physics and astronomy, like that of astrology. Does he ask how we can have made anything older than we are? Goodman continues. Plainly, by

91

making a space and time that contains those stars. By means of science, that world (and many another) was made with great difficulty and is, like the several worlds of phenomena that also contain stars, a more or less right or real world. We can make the sun stand still, not in the manner of Joshua but in the manner of Bruno. We make a star as we make a constellation, by putting its parts together and marking off its boundaries. In short we do not make stars as we make bricks; not all making is a matter of molding mud. The worldmaking mainly in question here is making not with hands but with minds, or rather with languages or symbol systems.[100]

Cosmologist Eric J. Chaisson offers a definition that neatly condenses the star-making process as Goodman understands it: a star, Chaisson writes, is an open, coherent, spacetime structure maintained far from thermodynamic equilibrium by a flow of energy through it—a round, gaseous system so hot that its core can sustain thermonuclear fusion.[101]

In fact, the stars have been remade within my lifetime. From markers of the universe's merciless immensity, they have turned into beacons of the view that the evolution of life (though not necessarily as we know it) may have been inevitable, astrophysically speaking.

What is required of a universe so that large amounts of carbon, oxygen and other ingredients of life are plentifully produced? asks the physicist Lee Smolin. This question has a simple answer: the universe must contain stars. . . . Nothing can live in an environment of thermal equilibrium. If life is to exist, there must be regions of the universe that are kept far from thermal equilibrium for the billions of years it takes life to evolve. In short, There must be stars.[102]

We all know, but seldom see, that sunlight *is* starlight. Watching night fall at *The Lightning Field* makes it possible to see this—indeed, almost impossible not to—for the *Field* tilts aesthetic apprehension of the sky and land toward this recognition, as mere empty vistas do not. As the countless stars emerge overhead, blazing like algebra, as poet Ciaran Carson says, the afterglow of sunset turns

from an effect of mere aesthetic intensity to one of celestial proximity, a homely demonstration of astronomer Edwin Hubble's thought that the history of astronomy is a history of receding horizons.[103] Perhaps no more dramatic corroboration can be offered than the fact that a century ago, astronomers did not know whether more than one galaxy existed. Today they estimate the number of galaxies at about 120 billion.

For city dwellers like me, the clear night sky free of "light pollution" is a revelation and a confrontation. When the 1994 Los Angeles earthquake knocked out the power in the middle of the night, the science writer Wyn Wachhorst reports, Griffith Observatory received numerous calls asking whether the quake was responsible for the sky being "so weird." The city-bound callers had never seen a star-filled sky.[104]

TRANCE

A haunting speculation in Walter Benjamin's 1920s essay "One-Way Street" still makes it hard for me to clarify my own feelings about confrontation with the night sky. Nothing distinguishes the ancient from the modern man so much as the former's absorption in a cosmic experience scarcely known to later periods, Benjamin writes. Its waning is marked by the flowering of astronomy at the beginning of the modern age. Kepler, Copernicus, and Tycho Brahe were certainly not driven by scientific impulses alone. All the same, the exclusive emphasis on an optical connection to the universe, to which astronomy very quickly led, contained a portent of what was to come. The ancients' intercourse with the cosmos had been different: the ecstatic trance. For it is in this experience alone that we gain certain knowledge of what is nearest to us and what is remotest to us, and never one without the other. This means, however, that man can be in ecstatic contact with the cosmos only communally. It is the dangerous error of modern men to regard this experience as unimportant and avoidable, and to consign it to the individual as the poetic rapture of starry nights. It is not; its hour strikes again and again, and then neither nations nor generations can escape it, as was made

terribly clear by the last war, which was an attempt at a new and unprecedented commingling with the cosmic powers. Human multitudes, gases, electrical forces were hurled into the open country, high-frequency currents coursed through the landscape, new constellations rose in the sky, aerial space and ocean depths thundered with propellers, and everywhere sacrificial shafts were dug in Mother Earth. This immense wooing of the cosmos was enacted for the first time on a planetary scale, that is, in the spirit of technology. But because the lust for profit of the ruling class sought satisfaction through it, technology betrayed man and turned the bridal bed into a bloodbath.[105]

This passage gains pertinence as, at this writing, an extremist American administration eyes the ionosphere as a future field of battle. George W. Bush chose Cold Warrior Donald Rumsfeld, who was handily confirmed, as his Secretary of Defense. Upon his nomination, Rumsfeld resigned the chairmanship of the Commission to Assess United States National Security Space Management and Organization. The commission's report, issued in spring 2001, effectively redefines extraterrestrial space as a strategic domain. We know from history that every medium—air, land and sea—has seen conflict, the report concludes. Reality indicates that space will be no different. Given this virtual certainty, the U.S. must develop the means both to deter and to defend against hostile acts in and from space.[106]

WITNESS

The darkness of night strikes us as profound, Edward Harrison explains, not only because it portends danger but because of what it shows us of our situation: a universe cold enough to permit b-life to arise in orbital proximity to a star like the sun. A chain of relatively recent discoveries has led to this conclusion: that the universe originated with a primal event nicknamed the Big Bang and has been expanding and cooling since; that the heavier elements, which compose all possible planets and life forms, are incubated in the thermonuclear furnaces of stars and are dispersed through stars' eventual collapse and explosion. Every phase of this process (except its origin) appears in the sky we observe.

Some modern astronomers see the vastness of the Universe as persuasive testimony to the overwhelming probability that the Galaxy is teeming with other intelligent life-forms with which we might communicate, according to cosmologist John Barrow. But the universe needs to be as big as it is just to support one solitary outpost of life. It is a sobering thought that the global and possibly infinite structure of the universe is so linked to the conditions necessary for the evolution of life on a planet like Earth.[107]

Is this why awe always mingles with the terror of cosmic isolation that comes of gazing at the night sky? Because the cold and darkness of immeasurable interstellar space—the most inhospitable environment we can imagine—are necessary conditions of our own being?

At *The Lightning Field*, one's attention turns again and again to light as the precondition for life on earth and for the consciousness we call our own. According to Richard Dawkins, the paleontological record indicates that eyes have formed on earth some forty times on distinct evolutionary paths.[108] Living bathed in photons from a nearby star seems almost to have predestined us and other species to develop eyes, organs so refined that even Darwin thought them emblematic of natural selection's implausibility as a theory. It takes effort to resist the vanity that we occupy a privileged position in the universe as its articulate witnesses. Bring in quantum theory's notion that—at levels far beneath that of sensory awareness—observation makes things what they are, and it becomes yet harder to resist believing that the universe has grown us (and innumerable other sentient creatures) in a drive to make its own being explicit, though why a universe might encompass such a possibility remains a mystery.

The teleological appeal of this thought telescopes with that of another, which the twentieth century's calamities have imposed: that our witness to events is the ultimate argument for the value of participation in them. That is what history is in one sense: contests of witness, memory, and evidence. One of the modern era's great transformations of historical process has been in the technology of witness, with which interpretation of evidence struggles to keep pace.[109]

GUESSWORK

Scientists who ponder the prospects of detecting or contacting extraterrestrial intelligence sometimes refer to the so-called Drake equation. Devised in 1961 by astronomer Frank Drake, it estimates the number of detectable civilizations in our galaxy as a product of seven factors: the average rate of star formation; the fraction of stars that form planets; the number of planets in each system where life might originate; the fraction of those planets where life actually does arise; the fraction of life-supporting planets that evolve intelligent beings; the fraction of civilizations that develop means of interstellar communication; and the average lifetime of such a civilization.

The Drake equation's value is not the numerical figure it yields, which is necessarily speculative. (An optimistic figure for the number of our galactic neighbors— if we hope for cosmic company—is 10,000.) Rather, the equation serves to tease out scientists' assumptions and best guesses about such things as the inevitability of life evolving intelligence and of intelligence elsewhere developing along lines congruent with our own.

Drake's own, most striking assumption, David E. Fisher and Marshall Jon Fisher note, is that, as in our case, a civilization creates the means for . . . total suicide around the same time it develops a means of electromagnetic propagation that would permit us to detect it. Perhaps as a general rule, the Fishers suggest, self-destruction occurs soon after it becomes possible. On the other hand, life as we know it has shown nothing if not a remarkable tendency to survive and adapt. So it is also a considerable possibility that civilizations generally find a way to avoid nuclear holocaust—that they develop peace as a survival mechanism.[110] It would be consoling to believe that we have reached that stage, or soon will. But as Iris Murdoch observed, the twentieth century taught us to distrust anything that seems to offer consolation.

Was it Cold War thinking or cold-eyed maturity on Drake's part to assume that the discovery of nuclear fission must tempt any civilization to suicide? Was he

projecting humankind's spitefulness onto all possible worlds, guessing that some hidden self-destructive impulse, such as Freud's "death instinct," must inhere in any advanced social life form? Or is the survival factor in Drake's equation necessary merely to allow for the probability of accidental self-destruction, of any nuclear technology whatever fulfilling itself by destroying its fabricators? Perhaps a law of evolution is that intelligence usually extinguishes itself, Edward O. Wilson speculates bleakly: a remark that could serve as an epigraph to *The Lightning Field*.[111]

ROSWELL

Drake's assumption that any viably communicative civilization must have passed the test of its own discovery of nuclear fission finds an odd echo in New Mexico's most famous piece of modern folklore: the Roswell incident.

The story goes that in July 1947, one or more UFOs harrowing the Plains of San Agustin accidentally crashed near Roswell, New Mexico. Early accounts proposed lightning as a cause of the crash; all assume that extraterrestrials were aboard—whose remains the military found and promptly secreted—and that they were attracted to the area by atomic bomb tests made near Alamogordo, as if off-world visitors had regarded nuclear fission as a pivot point in *our* evolution. Ironically, the secret military operation, with pendant official denial, that precipitated the Roswell myth was a test of balloon-borne "radar reflectors" designed to detect aboveground Soviet bomb tests from afar. (The Russians happened to code-name their earliest atomic bomb test "First Lightning.")

Anthropologist Charles A. Ziegler sees in the Roswell incident the "hoarded-object" theme found in the myths of many cultures. The central motif of the Roswell myth, he posits, is that a malevolent monster (the government) has sequestered an item essential to humankind (wisdom of a transcendental nature, i.e., evidence-based knowledge that we are not alone in the universe). The culture hero (the ufologist) circumvents the monster and (by investigatory prowess) releases the essential item (wisdom) for humankind. . . . In the case of the Roswell myth, the hoarded-object theme clearly indicates anti-government sentiment.[112]

Ziegler notes that in 1947, the term "flying saucer" was newly minted and few people linked these terms to alien visitations, whereas by 1992 a majority of Americans considered the terms to be synonyms for "alien spaceship."[113]

Anyone who has read social historians of science such as Peter Galison and Andrew Pickering on the ways contemporary physical theory is constructed must wonder about the extent to which instruments and the social relations that inform their use condition science's view of ultimate realities. Suppose there are 10,000 civilizations in our galaxy with which communication is theoretically possible; we have no Drake equation for the probability that our concepts, our mathematical symbolism and its meanings, will be intelligible to minds evolved elsewhere in the universe. After all, some inscriptions from ancient *human* cultures remain undeciphered.[114] Nor is there even consensus on earth as to whether mathematics is the discovery of timeless, universal truths or an elaborate, historically contingent, bootstrapping of logical principles and symbolism.

Space aliens may do psychic duty as fantasies of the total otherness—beyond appeals for sympathy, beyond comprehension—that we fear (or perversely hope) to encounter in strangers, or even in the shadow sides of those close to us. Here I think of Proust: A pair of wings, a different respiratory system, which enabled us to travel through space, would in no way help us, for if we visited Mars or Venus while keeping the same senses, they would clothe everything we could see in the same aspect as the things of Earth. The only true voyage . . . would be not to visit strange lands but to possess other eyes, to see the universe through the eyes of another, of a hundred others, to see the hundred universes that each of them sees, that each of them is; and this we can do with an Elstir, with a Vinteuil; with men like these we really do fly from star to star.[115]

CAUSES

De Maria's masterpiece is an abstract vision of modern history as the drive of human curiosity into causally charged fields of our home planet and beyond. As

his epigraph implies, this vision draws some of its power from the physical isolation of those who experience it. *The Lightning Field*'s open structure is a void to which our overfed nervous systems and imaginations react with spasms: American culture does not tolerate a vacuum. The introspective visitor can get an uncommonly sharp view of his or her own world picture as it balloons to fill that void. As a tool of thought, *The Lightning Field* can prize into consciousness our unthought theories of why things happen, of what drives events in any domain. And by the precision and ingenuity of its form, the work confronts us bodily with our inherited confidence in science as the ultimate explanatory authority.

Into what sort of system do we play when we behave? Where does the causal interaction between ourselves and the world take hold? How does mental causation—the combustion of belief and emotion resulting in action, for example —connect with the physical causation we observe outside our minds, or the biochemical causation that researchers observe within the brain? Such unanswerable questions confront anyone who recognizes a vision of modern history in *The Lightning Field.*

Do the workings of the world seem hidden from us because they are too far-flung, too intricate, too intimately linked to hierarchies of power and access that exclude us? Or are the workings of change right there to descry in all our lives, if only we had the time, the focus, and preparation to read them? Perhaps only professional historians have the training and diligence to develop a sufficiently long, nuanced account of how things could have come to *this.*

There may be crude, deep reasons for the shortsightedness that seems to be our birthright. It was actually advantageous, Edward O. Wilson writes, during all but the last few millennia of the two million years of the existence of the genus Homo. The brain evolved into its present form during this long stretch of evolutionary time, during which people existed in small, preliterate hunter-gatherer bands. Life was precarious and short. A premium was placed on close attention to the near future and early reproduction, and little else. Disasters of a magnitude that

occurred only once every few centuries were forgotten or transmuted into myth. So today the mind still works comfortably backward and forward for only a few years, spanning a period not exceeding one or two generations.[116] Perhaps historical imagination, like peace, is still evolving as an aid to survival. A one- or two-generation purview may not be enough to get the historical drift, if there is one.

Our age fancies itself demythologized, as Iris Murdoch observed. That may merely mean that we have lost the knack of usefully transmuting into myth disasters such as the bombings of Hiroshima and Nagasaki, or the very invention of the bomb, and so always carry them buried inside, undigested, unexpiated. For visitors of my generation, *The Lightning Field* serves powerfully as a device for reawakening memories of nuclear fear. Whether it can function that way for people who did not live through World War II or the Cold War is a test of time to which few other twentieth-century artworks will be subject: sorry proof of their slightness.

LAWS

The Lightning Field sparks a modern philosophical reflex, exemplified by Hegel and diagnosed by Nietzsche: the desire to make a metaphysics of historical imagination. De Maria's great work of Land Art is an exoskeleton of the view that technology drives history and so will dictate the future, to the extent that we can discern anything doing so. This belief not only has survived the computer revolution but appears confirmed by it, there having been in the past twenty-five years no more conspicuous agent of change in most of our lives than the computer.

But it may be an illusion that the history of the scientific age is more scientific than that of any other era.[117] Perhaps no case is more emblematic of this fact than the controversy that raged, fifty years after the events, over the strategic necessity of dropping atomic bombs on Hiroshima and Nagasaki.

If we knew the laws which govern social or individual life, Isaiah Berlin observes, we could operate within them as we use others in conquering nature, by inventing methods that take full account of such forces—of their relationships and costly effects. This dependable social technology is precisely what we lack. . . .

When we speak of some process as inevitable, when we warn people not to pit their wills against the greater power of the historical situation, which they cannot alter, or cannot alter in the manner they desire, what we mean is not that we know facts and laws which we obey, but that we do not. . . . When we think of Utopians as pathetically attempting to overturn institutions or to alter the nature of individuals or of States, the pathos derives not from the fact that there are known laws which such men are blindly defying, but from the fact that they take their knowledge of a small portion of the scene to cover the entire scene; because instead of realizing and admitting how small our knowledge is, how even such knowledge as we could hope to possess of the relations of what is clearly visible and what is not cannot be formulated in the form of laws or generalizations, they pretend that all that need be known is known, that they are working with open eyes in a transparent medium, with facts and laws accurately laid out before them, instead of groping, as in fact they are doing, in a half-light where some may see a little further than others but where none sees beyond a certain point.[118]

Berlin's sobriety is hard to quarrel with, but at *The Lightning Field* one feels stirrings of historical curiosity in a more Emersonian key. Emerson the historicist saw individual life and past events and personages linked by something like the "self-similarity" by which mathematicians characterize fractals: they display the same structures at no matter what scale or extent of elaboration. Man is explicable by nothing less than all his history, Emerson writes. And if the whole of history is in one man, it is all to be explained by individual experience. There is a relation between the hours of our life and the centuries of time. As the air I breathe is drawn from the great repositories of nature, as the light on my book is yielded by a star a hundred millions of miles distant, as the poise of my body depends on the equilibrium of centrifugal and centripetal forces, so the hours should be instructed by the ages and the ages explained by the hours.[119] Part of what makes Emerson's viewpoint sound quaint is the cascade of technological innovations that began after his time.

A bolt of unwelcome recognition—or grandiose delusion—always threatens to strike at *The Lightning Field*: that we really *do* know the "laws" that steer the workings of history, at least we continually feel their force, for, more or less as Emerson and Freud maintained, they are the "laws" of our mental life.

Yet another possibility: our fixation on time as what withholds knowledge may be a kind of willful moral blindness to our position. John Berger raised this idea decades ago in a classic essay on portraiture: Prophecy now involves a geographical rather than historical projection: it is space not time that hides consequences from us, Berger wrote. To prophesy today it is only necessary to know men as they are throughout the whole world in all their inequality. Any contemporary narrative which ignores the urgency of this dimension is incomplete and acquires the oversimplified character of a fable.[120]

SHADOWING

The Lightning Field's isolation is an aspect of its form. The more the physical distance closes between the work and the world it evokes, the more the work is in danger of reduction to an upscale wilderness adventure, like one of the "dark parks" that now exist to reintroduce city dwellers to the night sky. When people who know *The Lightning Field* feel that it no longer functions as, or no longer is, what it was intended to be, they will know that another historical breaking point has passed.

Each visit to *The Lightning Field* makes it clearer that the work's force depends not only on its isolation but on the poles' and the grid's contrast to the ungoverned, ever-changing details of their setting.[121] Terms proposed by Michael André Bernstein in his book *Foregone Conclusions* suggest the weight of this point. Bernstein sees in contemporary culture a craving for the sense of superiority offered only by hindsight and by fantasies of predictive certainty. He sees determinist theories of history as constructions of the past or future corrupted by this yearning to be right. *The Lightning Field* coaxes into consciousness the impulses to "backshadowing" and "foreshadowing," as Bernstein calls them. To counter these predispositions, he

commends what he calls "sideshadowing," the widening of focus to encompass nonclimactic events and experiences that appear neither foreordained nor determinant of the future: details of life that do not compute (like the unaccountable, unwitnessed kindness that fascinated Grossman). Against foreshadowing, sideshadowing champions the incommensurability of the concrete moment and refuses the tyranny of all master-schemes, Bernstein writes. It rejects the conviction that a particular code, law, or pattern exists, waiting to be uncovered beneath the heterogeneity of human existence. . . . Sideshadowing stresses the significance of random, haphazard, and unassimilable contingencies, and instead of the power of a system to uncover an otherwise unfathomable truth, it expresses the ever-changing nature of that truth and the absence of any predictive certainties in human affairs.[122]

Literal shadows do obtrude in the leafless setting of *The Lightning Field* around sunrise and sunset. At such moments, snatches of Eliot's *The Waste Land* at its most Blakean eclipse in the mind Bernstein's metaphors of tendentious perspective: Your shadow at morning striding behind you/ Or your shadow at evening rising to meet you; / I will show you fear in a handful of dust . . .[123]

CALLS

Sitting in *The Lightning Field* cabin in April 1995, intermittently reading aloud to each other from two books—the then-new English translation of Robert Musil's *The Man without Qualities* and Carolyn See's *Golden Days*, both books about worlds ending—Tonia and I were stunned by a sound more shocking in that setting than a sonic boom: the ringing of a telephone.

It came from somewhere in the cabin, but where? Robert Weathers had showed us the shortwave radio to use in case of emergency, but had not mentioned a phone. The shock of its ringing momentarily paralyzed me. No one then had instructions on how to locate us except the people caring for my eighty-four-year-old mother outside Boston, and all they had was Dia's Albuquerque number. I remembered later Avital Ronell's likening of the telephone line to an umbilical cord.

This can only be an emergency, I thought—which is my response at heart to every unexpected phone call—as I fumbled for the neatly camouflaged door to the cabin's attic, where the sound appeared to originate. By the time I bounded gingerly up the dark stairs and grabbed the receiver, the caller had rung off. A little experimentation revealed that the cabin phone will forward only local calls—no toll-free links to long-distance networks—but presumably it might receive calls from anywhere: one more sign of the world's thickening around *The Lightning Field*.[124]

Later, I happened on the startling fact that fewer than one person in ten now living has ever made a phone call! (A slightly later account revised the world's caller population upward to thirty-five percent.) Countless people, even in the world's densest areas, then, must be isolated from the "communicative abundance" that we in the First World enjoy, if enjoy is the word.[125] Telephone technology began long ago to remake the meaning of "isolation," and it continues to do so with wireless technology and cyberspace, although Jasper Becker reports that as recently as the 1980s, citizens of Beijing who ordered home telephone service for the first time knew they could expect to wait up to sixteen years for its installation.

Weeks afterward, I located some pertinent passages in Ronell's dithyrambic *The Telephone Book*. America, she writes, operates according to the logic of interruption and emergency calling. It is the place from which Alexander Graham Bell tried to honor the contract he had signed with his brother. Whoever departed first was to try and contact the other through a medium demonstrably superior to the more traditional channel of spiritualism.[126]

Interruption by a phone call in the desert led me to rediscover how connected some of Ronell's ideas are to themes of my thinking about *The Lightning Field*. The telephone, she writes, destabilizes the identity of self and other, subject and thing, it abolishes the originariness of site; it undermines the authority of the Book and constantly menaces the existence of literature. It is itself unsure of its identity as object, thing, piece of equipment, perlocutionary intensity or artwork (the beginnings of telephony argue for its place as artwork); it offers itself as instrument of

the destinal alarm, and the disconnecting force of the telephone enables us to establish something like the maternal superego. . . . For Freud, the telephone, while exemplifying unconscious transmissions, set off the drama of an unprecedented long distance. There is always a child left behind, or the face of a distant friend translated sonically into a call.[127]

Freud had already found in the phone proof of the implacability of civilization's discontent. Most of the advantages we derive from technological progress, he complained in 1929, confer only "cheap enjoyment," like that of putting a bare leg from under the bedclothes on a cold winter night and drawing it in again—a cheap enjoyment readily available to an off-season visitor at *The Lightning Field*. If there had been no railway to conquer distances, Freud writes, my child would never have left his native town and I should need no telephone to hear his voice.[128]

Ronell views the telephone as a synecdoche for technology,[129] much as I see the poles of *The Lightning Field*. (To American ears, "poles" will always ring with a faint echo of "telephone poles.") Lodged somewhere among politics, poetry and science, between memory and hallucination, Ronell notes, the telephone necessarily touches the state, terrorism, psychoanalysis, language theory, and a number of death-support systems.[130] She sensibly wonders whether technology has instituted a form of social madness in democratizing magical communications such as only shamans and schizophrenics conducted formerly.

Thinking back to the connection between *The Lightning Field* and the Beds of Spikes, I realize that De Maria, too, may well understand artworks as "exemplifying unconscious transmissions." But it did not occur to me when the phone rang at *The Lightning Field* that the artist himself might be calling. He is not a person one expects to hear from.

The possibility might have crossed my mind had I known then of his 1967 proposal for the exhibition "Art by Telephone" at Chicago's Museum of Contemporary Art. (His piece was never done at the MCA, but was shown two years later in the epochal Kunsthalle Bern exhibition "When Attitudes Become Form.")

De Maria wanted a gallery empty of everything except a black telephone on the floor at the end of a very long cord. The phone would not have permitted outgoing calls. Instead, he proposed, the artist will . . . telephone into the exhibition and over the period of the month use $200 worth of telephone time in conversing with whichever visitors fate may have been placed near the telephone, about any subject at all. (The show's budget allotted each artist $200 to $300 in expenses.) A small sign on the floor was to read, If this telephone rings, you may answer it. Walter De Maria is on the line and would like to talk to you.

POSTHUMAN

The sense that geographic isolation is changing with time raises the question of how the isolation that seems independent of place—the solitariness of being uniquely oneself—has changed over the decades, not only on an axis of autobiography but in the kinds of self-experience possible to us. Can we distinguish what has changed *around* us from what has changed *in* us? What calibrates what? *The Lightning Field* objectifies this question for everyone who walks within it and watches its conjugation of frames.

For city dwellers, the outer world today is far more crowded than the inner, so the spatial sense of "isolation" may not be the first that comes to mind. We have trouble deciding whether the isolation most immediate to us is emotional or existential, legal or economic, whether it is fated, imposed, or unconsciously chosen. Perhaps subjectivity itself imposes a solitariness that solidarity can never dispel, but the weight given to the concept of subjectivity has definitely changed in recent decades. Psychopharmacology and biotechnology have posed and threaten to pose new challenges to old notions of self-knowledge and personal identity. These developments further threaten to dissolve concepts of human nature adequate to ground a definition of human rights. The term "posthuman" has recently begun to replace "postmodern," as if the stakes of historical change have been raised from a level of sensibility and social thought to one of ontology and bioethical quandary.

Fascination with the possibility of extraterrestrial intelligence is, among other things, displaced curiosity about what it means to be human. And how can we help wondering, in an era when genetically engineered strains of mice, grain, and vegetables are granted patents, when corporate technicians and financial strategists intervene in the biological meaning of something's being an animal, an ear of corn—and, soon enough, a person? Meanwhile, political philosophers debate whether ethnic, cultural, or political differences have, or ought to have, greater moral weight than a concept of humanity that comprehends everyone.

The deconstruction or "death" of the subject in all fields of critical thought—arguably a process begun by Darwin, Marx, and Freud—is thought to have culminated in the decades since *The Lightning Field* was made. Embodiment remains an inescapable condition of human life (despite Hans Moravec's dream of downloading human consciousness into a computer), but its meaning seems to need expanding.

The fashion in the past decade or so has been no longer to view the subject as a rational agent formed by what it experiences, wills, and believes but as a function of what a given society defines as thinkable.[131] The thoughts that an individual fancies originate in him or her, including thoughts about who he or she is, may merely be forming and dissipating like clouds in a society's climate of belief, language, and custom, their occurrence in any particular mind being purely contingent.

Today the very idea of the Self is under siege, wrote Connie Zweig, a representative voice, in 1995. In much the same way that Nietzsche's pronouncement that "God is Dead" reverberated through the hearts and minds of thoughtful people in the early decades of [the twentieth] century, Zweig continues, a parallel declaration of the death of the Self troubles our own time. The Self is being deconstructed, bit by bit, until it becomes transparent, like so many other beliefs in the postmodern age. . . . While the modern era was characterized by a war of paradigms, belief against belief, the postmodern era throws into question the nature of belief itself.[132]

But the subject may be as inescapable a term as the body. The notion that the subject is a figment whose time is passing may descend from Marx's idea that society's material transactions pattern people's mental lives, rather than the reverse. It reverberates, too, with recent world events that seem to spell the end of European Enlightenment ambitions, including Marx's. Perhaps liberal humanist selfhood is after all a figment of economic and geopolitical privilege. In that case, teasing ourselves with its dissolution may be an unseemly flirtation with repressed consciousness of the vast human majority for whom subjectivity primarily spells suffering and yearning for respite from it.

British political scientist John Gray argues that the dissolution of the Enlightenment project carries with it the ruin of the distinctive modern project of emancipation in a universal civilization.[133] In that case, postmodern military adventures such as the 1991 Gulf War and NATO's 1999 air war on the Balkans present—among other contradictions—the irony of up-to-the-minute weapons developed on universal principles of engineering used to impose an eclipsed ideal of "universal civilization." But then, "universal civilization" itself appears to have devolved to code for the erasure of constraints on the global movement of capital.

We live today among the dim ruins of the Enlightenment project, which was the ruling project of the modern period, Gray wrote in 1995. Contrary to the hopes which buoyed up Enlightenment thinkers throughout the modern period, we find at the close of the modern age a renaissance of particularisms, ethnic and religious. In the post-communist world, where the disintegration of the Soviet state has inaugurated a period of upheaval and convulsion fully comparable with that which followed the collapse of the Roman Empire, the collapse of the Enlightenment ideology of Marxism has not, as Western triumphalist conservatives and liberals supposed, issued in a globalization of Western civil society, but instead in a recurrence to pre-communist traditions, with all their historic enmities, and in varieties of anarchy and tyranny. . . . Within Western cultures, the Enlightenment project of promoting autonomous human reason and of according to science a privileged status in relation to all other forms of understanding has

successfully eroded and destroyed local and traditional forms of moral and social knowledge; it has not issued in anything resembling a new civilization, however, but instead in nihilism. Meanwhile, the market institutions through which the natural world is exploited, themselves increasingly disembedded from any community or cultural tradition, are ever more chaotic, and elude any form of human accountability or control. The legacy of the Enlightenment project—which is also the legacy of Westernization—is a world ruled by calculation and willfulness which is humanly unintelligible and destructively purposeless.[134]

The fate of the Enlightenment perhaps seems conceptually remote from *The Lightning Field*, but it is not. America and its constitution were after all exemplary Enlightenment projects, an attempt to found a nation on the abstract clarity of reason. *The Lightning Field* grid evokes quite directly the federal land survey that began in the late eighteenth century and rolled westward. The grid pattern of towns and cities facilitated the sale of property, geographer Yi-fu Tuan comments. Crass materialism, rather than any sort of geometric ideal, motivated its widespread adoption. Yet, there is no denying that it also promoted orderly process and efficiency of settlement and, moreover, projected an air of welcoming openness to strangers. A grid town is quickly known—a fact appreciated by people passing through. By the same token, it could quickly seem monotonous. . . . Rather than humdrum sameness, however, J. B. Jackson suggests that what American towns show is conformity to a distinctive American style. "Classical is the word for it. . . . Rhythmic repetition (not to say occasional monotony) is a Classical trait, the consequence of devotion to clarity and order."[135] The thought of classicism recalls one of the less obvious senses of isolation pertaining to *The Lightning Field*: its isolation from the artist who conceived it and oversaw its fabrication. Artistic self-effacement is the mark of classicism, and in his reticence De Maria has taken that to an extreme.

The Enlightenment also renovated metaphors linking light, rationality, and liberation, and *The Lightning Field*, under full, low-angled sunlight, can ignite nostalgia for the faith those metaphors express.[136] Under a bright moon, though, the visitor

may think instead of Sylvia Plath's line: This is the light of the mind, cold and planetary. Did she mean the light of the mind as such, the light of the female mind, the moon being a traditional female symbol, or merely the light of her own female mind? Her line calls attention to a clash of masculine and feminine symbols in the moonlit *Lightning Field* that probably goes unnoticed for the most part. De Maria himself might disavow it.

The faith in rationality as the faculty that could unify humanity—and perhaps even reconcile forms of intelligent life throughout the universe—is implicit in the scientific world-picture whose ruling influence on modern history *The Lightning Field* evokes with impressive aesthetic economy. The grid of poles may even appear under one aspect as a figure for equable solidarity, objectifying a dream of equality and autonomy for all and recalling the symmetry of everyone's relation to everyone else prescribed by John Rawls for his hypothetical just society. Yet that suggestion immediately brings a counterinterpretation to mind: *The Lightning Field* as an abstract figure for the "developed" world technologically armed against the "underdeveloped."

MIRAGE

Even if the subject is an ideological mirage, as Fredric Jameson says, it is not easily dispelled, since it can withstand the decompression of passage from everyday urban existence to the cultural thin air of *The Lightning Field*. The sudden, shocking dispersal of attention into quiet immensity structured only by a gleaming grid is this artwork's argument that if the individualist sense of self is a period artifact, then its moment must be the reign of science and technology, of which we can see no end except engineered or accidental catastrophe. This no doubt remains true despite the sudden change in ideological climate in recent years, with polarities of religious belief, or profession, supplanting or disguising political confrontation.

If Freeman Dyson is right, the great challenges to liberal humanist selfhood still lie ahead in the era of applied science, challenges that trivialize that of religious fundamentalism. After the Information Age, already arrived and here to stay,

driven by computers and digital memory, Dyson wrote in 1997, will come the Biotechnology Age . . . driven by DNA sequencing and genetic engineering. Third is the Neurotechnology Age, likely to arrive later in the next century, driven by neural sensors and exposing the inner workings of human emotion and personality to manipulation. These three new technologies are profoundly disruptive. They offer liberation from ancient drudgery in factory, farm, and office. They offer healing of ancient diseases of body and mind. They offer wealth and power to the people who possess the skills to understand and control them. They destroy industries based on older technologies and make people trained in older skills useless. They are likely to bypass the poor and reward the rich. They are likely, as Hardy said eighty years ago, to accentuate the inequalities in the existing distribution of wealth, even if they do not, like nuclear technology, more directly promote the destruction of human life.[137]

Subjectivity as an entwining of real and fantasized privacy has taken on an uncomfortable new depth for us citizens of the First World. We hide out in it, not only from one another, but from the awareness of our own relative privilege in the world context and its cost in global social injustice, which we know neither how to reckon properly nor how to redress.

SHARING

Changes in the climate of ideas over the past twenty years have made most commentators on art more mindful of their own demographics. Can I speak only for— or worse, only to—middle-aged white male heterosexual urbanites like myself? Do the words and concepts I use still extend the relevance of what I say beyond my own demographic circle? Is the wide pertinence of "speaker's meaning," as Owen Barfield calls it, a thing of the modernist past in matters of human concern? Perhaps only scientists (or their popular interpreters) speak for or to us all now, owing to the objective promise and menace of their professional activity.

The two and a half decades since I first wrote about *The Lightning Field* have inevitably heightened my sense of time running out. I have felt the weight of my life

shift slowly from an indeterminate future to a foreclosed past. If I feel more isolated now than before—can one really make such a comparison?—it may owe to a growing burden of past actions that I cannot adequately explain, justify, or even recall at will, though their drag on conscience and action feels real enough: my "shadow at evening rising to meet" me.

Diminished claims for the self chime neatly with the conservative agenda to abolish Americans' last protections against the profit system. Yet when Michel Foucault set down principles for antifascist living, he advised: Do not demand of politics that it restore the "rights" of the individual as philosophy has defined them. The individual is the product of power. What is needed is to "de-individualize" by means of multiplication and displacement, diverse combinations. The group must not be the organic bond uniting hierarchized individuals, but a constant generator of de-individualization.[138] But Foucault's nostrums will discomfit anyone who has read Canetti on the crowd. Nor can I forget Tzvetan Todorov's warning that it is not possible . . . to defend human rights with one hand and deconstruct humanity with the other.[139]

The Lightning Field's scale, classicism, and permanence seem to claim for it a universal significance. By its distance from the ordinary lives of most visitors and by its very openness—indeed, vulnerability—to interpretation, the work raises the ultimate critical quandary: What can be shared?

Perhaps more significant than the deconstruction of "the subject," and more pertinent to how we may respond to *The Lightning Field* today, is the rethinking of objectivity by Richard Rorty and other "neopragmatists." The poles of *The Lightning Field*, after all, can read as totems of objectivity or impersonality, each one standing definitively exterior to everything and everyone around it.

The desire for objectivity is not the desire to escape the limitations of one's community, Rorty states, thinking of the Enlightenment ambition to delocalize knowledge, but simply the desire for as much intersubjective agreement as possible, the desire to extend the reference of "us" as far as we can. Insofar

as pragmatists make a distinction between knowledge and opinion, it is simply the distinction between topics on which agreement is relatively easy to get and topics on which agreement is relatively hard to get. . . . My suggestion that the desire for objectivity is in part a disguised fear of the death of our community echoes Nietzsche's charge that the philosophical tradition which stems from Plato is an attempt to avoid facing up to contingency, to escape from time and chance.[140]

Rorty's effort to redefine objectivity in terms of solidarity, rather than as accurate mental representation of the nonhuman, has spurred some of his critics to accuse him of abetting the "relativist" and fundamentalist enemies of science and of the Enlightenment's liberating ideals. His real transgression, though, may be to have reconnected objectivity with social affiliations and put it back into history, unveiled as a function of "grammar" in Wittgenstein's sense. After Rorty, objectivity threatens to take on a new moral shading as a defensive symptom of privileged humanity's guilt-ridden incapacity to take responsibility for its own.

Think once more of *The Lightning Field* poles as totems of objectivity and suppose, worse, that Rorty has it backward: that the emotional appeal of objectivity is not its promise of agreements that evoke death-defying solidarity but its promise of justifying the social condition that Norman Geras calls the contract of mutual indifference.

Consider, as an "ideal type" or limit position, a world in which nobody ever comes to the aid of anyone else under grave assault or cognate misfortune, and in which there are plenty of instances of that, Geras posits. Even though no formal agreement had been made between the individuals of this world to the effect that they owed one another, under threat or misfortune, nothing in the way of aid or care, the case for imputing such an agreement to them would be compelling. . . . Now, this limit position of mutual indifference is not some *other*, temporally prior, state of being, nor is it a purely hypothetical construct set behind a "veil": behind a screen of abstraction that separates us from what we know or what we are. It is rather a model of the world which we really inhabit, although it is exaggerated—

or better perhaps, reduced—by omission of such mutually assisting behavior in dire misfortune as there is. Still, it is a model of our world. The state of affairs described by this contract of mutual indifference is close enough to the actual state of affairs in our world as to portray accurately the relations generally prevailing between most of the people in it.[141]

CITY

Does being at *The Lightning Field* correspond more closely now to the solitude of subjectivity than, say, being lost in the crowd of a city street? More closely than sitting incommunicado in a dark hotel room, or being adrift in a novel or in cyberspace's forest of lists?

Denis Donoghue views the experience of all-but-incommunicable inwardness as a spur to literary modernism, and associates it with the city. His view interests me because the experience of the city is *The Lightning Field*'s true antipode. And to be economic refugees in cities has been the fate of countless millions who, but for the grand schemes of capitalism and communism, might have visited cities seldom or never in their lives.

People who live in a city soon begin to feel that their apprehensions are private and can't easily be verified by being compared with someone else's, Donoghue writes of the urban subject. How much more true must that be for travelers or refugees excluded from the language and lifeways around them. The status of those apprehensions makes a problem in epistemology. Not in ontology. The existence of city streets need not be doubted, but what my mind, eyes, ears, and feet tell me of those streets emphasizes my privacy rather than my sociality or my citizenship. It is harder to conduct a dialogue of the mind with other minds than a dialogue of the mind with itself. My true life seems to be the one I live inside my head.[142] What he says appears to be as true of urban experience in so-called postmodern times as at the birth of modernism, no matter how we date it.

The power *The Lightning Field* draws from the ancient conflict of city and country may grow fainter as distinctions between centers and periphery grow more

notional. Today we all have reasons to chime in with John Ashbery's rejoinder to Yeats: Is anything central?[143]

CROWD

One discovers at *The Lightning Field* how inescapable the consciousness of living in an overcrowded world has become. Maurice Blanchot's phrase, the countless population of emptiness,[144] might come to mind when, upon arrival at the site, the urbanite experiences something like a kinesthetic afterimage of the crowding of everyday life.

Canetti reminds us in *Crowds and Power* that the invisible crowd throughout most of human history has meant the dead; he is tempted to call this humanity's oldest conception. This thought forms readily in those moments at *The Lightning Field* when the piece looks like a futuristic burial ground. Such moments can occur before or after a daytime storm passes, when the poles, with black clouds behind them, glow silver-white from brightness on the opposite horizon.

The feeling of posterity is as alive today as it ever was, Canetti claims, but the image of abundance has detached itself from our own progeny and transferred itself to humanity as a whole. For most of us, the hosts of the dead are an empty superstition, but we regard it as a noble and by no means fruitless endeavor to care for the future crowd of the unborn. . . . In the universal anxiety about the future of the earth, this feeling for the unborn is of the greatest importance. Disgust at the thought of their malformation, the thought of what they may look like if we continue to conduct our grotesque wars, may well do more than all our private fears for ourselves to lead to the abolition of these wars.

Canetti suggests that we have shifted to infectious microorganisms the ancient dread of invisible crowds of ghosts or demons. Instead of the souls, they now attack the bodies of men, he notes. Only a tiny minority of people have looked into a microscope and really seen them there. But everyone has heard of them and is continually aware of their presence and makes every effort not to come in contact with them.[145]

This observation from before the AIDS pandemic connects with another by contemporary social scientist Helen Epstein: Most books about rampaging microbes are written and sold in rich countries where infectious diseases now kill, relatively speaking, vastly fewer people than they did in the past. This is true, even in the age of AIDS. So why now? Why this resurgence of fear about germs? Perhaps AIDS roused us from complacency, reminding us how frightening infectious diseases are. But it may also be that along with our sense of relative well-being there is a growing apprehension that those remote places in this unequal world may be incubating their revenge.[146]

EXPERIENCE

The twentieth-century artworks that have kept their currency have presupposed the culture of cities as the inevitable form of modernity,[147] Donoghue says. And when George Trow speaks of "the national grid" to evoke the civic catatonia that television can induce, he acknowledges television's power to make urban anonymity feel like the normal condition of consciousness, a condition increasingly disconnected from place.

So what, if anything, can geographic remoteness reveal today to us, who are so reconciled to the seriality and false fellowship of being consumers, taxpayers, motorists, chat-roommates?

The late Edward Reed knew.

Billions of dollars are being spent to create continent-wide information super-highways along which will flow every kind of information except one, Reed wrote. The information being left out of these developments is, unfortunately, the most important kind: the information—termed ecological—that all human beings acquire from their environment by looking, listening, feeling, sniffing and tasting, the information, in other words, that allows us to experience things for ourselves.[148] If *The Lightning Field* still restores physical vividness to our increasingly abstract sense of isolation, it does so by framing onslaughts of "ecological information."

Every visitor discovers that *The Lightning Field* is a lesson in the inescapability of experience. By this I mean what Reed hints at in his book title, *The Necessity of Experience*, and something more. The contemporary developed world, Reed notes, conducts itself almost as if we had set about to root primary experience out of everyday life.[149] Unmediated experience of the world—of air and sunlight on your skin, of the ground underfoot, of sound and silence—ought to be touchstones of aliveness. But the postmodernist view of our condition sees unmediated reality as an anachronism: simulations have become so captivating and thickly layered that now only they and their cross-references are effectively real—in the sense that *they* are what people are willing to act upon. On this view, there is no bottom layer, no bedrock reality beneath all the facsimiles to keep the senses honest, because the senses themselves are culturally conditioned and instantly make tendentious representations of all that they take in. To be a media consumer in contemporary Western culture, then, is to internalize, consciously or unconsciously, all the tricks of illusion, elision, and self-reference by which the image industries make currency of the stuff of vision and memory.

The Lightning Field's counterpoise to this cultural situation is to focus the visitor's attention on phenomena that elude representation, that remind us viscerally why representations must tend to form a cross-referential system.

No medium can reproduce the softness of the late-summer air at *The Lightning Field*, or the knifing winds of December. No climate-control system simulates the changeability of the desert air temperature, nor can sonics properly mimic the wildlife there when they spontaneously fall silent in concert the moment a thunderhead blots out the sun. These sensations, playing against the poles as they go through their changes, make conscious being itself feel like a condition of privilege, at least to those visitors not narcotized by self-absorption or fanatical belief. Above all, nothing can depict the sensuous framelessness of the earth that *The Lightning Field* paradoxically brings to light by its very bracketing of the terrain.

Our December 1994 visit to *The Lightning Field* included what was for me one of the hardest moments of its appearance to describe. I decided to take a walk on the *Field* in late afternoon. The weather had been turbulent all day with bursts of sun and sudden squalls of wind and snow. Having warmed myself well at the wood stove, I donned almost all the clothes I had packed and set out due south from the cabin. About halfway through the *Field*, tiny pellets of snow began ticking at my right ear and face. Looking to the west, I saw a snow squall billowing my way like an atmospheric avalanche. The light behind it was strangely green. Soon I was engulfed in a fusillade of granular snow sent horizontal by a merciless wind. Behind me the cabin had disappeared. Murky green light enveloped what little I could see of the landscape, curtaining off horizons and sky. The few poles visible in each direction had turned to black silhouettes so fine that, blinking into the wind, I could not be sure how many I was seeing. Values seemed to reverse as if I were suddenly seeing the work in negative. I turned my back to the wind and waited, watched, and shivered as the squall finally withdrew eastward, the brightening sky behind it returning to the poles a silvery glow. But only for me, who experienced them, can words or images evoke the needlelike snow, the wind that blew through me as if I were a ghost, or the surprise of seeing the air turn green and the poles black.

MIRROR

Perhaps the oddest, least noticed views *The Lightning Field* offers are the poles' own reflections of oneself and the landscape. Yet those reflections, at once condensed and panoramic, are among *The Lightning Field*'s most suggestive figures. They marry the poles' spinal symbolism of the human individual—upright, singular, aloof from the nature in which it is rooted—to the metaphor of consciousness as a mirror, one of modern Western thought's ruling metaphors, according to Rorty. (Some visitors will also think of James Jesus Angleton's famous description of espionage as "a wilderness of mirrors.")

It is pictures rather than propositions, metaphors rather than statements, which determine most of our philosophical convictions, according to Rorty. The picture which holds traditional philosophy captive is that of the mind as a great mirror, containing various representations—some accurate, some not—and capable of being studied by pure, non-empirical methods. Without the notion of the mind as mirror, the notion of knowledge as accurate representation would not have suggested itself. Without this latter notion, the strategy common to Descartes and Kant [add Freud and Husserl]—getting more accurate representations by inspecting, repairing, and polishing the mirror, so to speak—would not have made sense.[150]

Rorty endorses instead John Dewey's dream of a culture no longer dominated by the ideal of objective cognition but by that of aesthetic enhancement.[151] We might even see this shift anticipated in *The Lightning Field*'s collision of technics and aesthetics. Since Rorty published *Philosophy and the Mirror of Nature* in 1979, the ideological atmosphere of popular culture has changed. A new mania for religion—or religious profession—has swept America, concurrent with a rising loss of confidence in "pure" science, though not in its offspring, technology. Meanwhile, with the postmodern turn to which Rorty contributed came a shift in critical attention away from representations available to introspection to the social traffic in representations—fabricated images—on which the profit system and governments rely with undisguised cynicism.

As Rorty hinted, part of the mirror's appeal as metaphor for the mind may be vulgarly narcissistic. The confidence that knowledge can accurately reflect what exists gives humanity—at least us secure and well fed enough to muse on such things—an inkling of metaphysical purpose and calling. The sense of ourselves as perfectible mirrors—science and technology demonstrating that very perfection by objective cognition—leads us to believe, Rorty argues, that our representations move progressively closer to the language of nature's self-presentation. Such beliefs can confer a sense of transcendental mission, even minus God.

BOUNDS

The Lightning Field remains literally open in all directions, consonant with its openness to interpretation. Now that it has existed for almost thirty years, the trick is not to bring meaning to it but to decide the bounds of interpretation. Here I recall James Elkins's warning about overinterpretation as a critical pathology of our historical moment. Where art interpretation is concerned, Elkins writes, we have inherited, or invented, a certain kind of complexity that cannot be described simply as the effect of the meanings of [artworks] in academic or intellectual late capitalist Western culture. . . . Which is more in need of explanation, the practice of interpretation or the culture in which it is embedded? What in culture, or cultural history, can be considered well enough understood so that it can serve as a starting point for explaining intensive interpretation?[152]

The complexion of the poles changes continually with light, weather, and time of day. At another level, their complexion of associations fluctuates against the changing background of events and beliefs. Where twenty-odd years before, the poles seemed to chime only with the neighboring ranchers' distant fence lines, in the 1990s, the poles—especially the rows that run east to west—irresistibly brought to mind the national border due south, a battle line between so-called First and Third Worlds, where border patrol officers try to thwart phalanxes of Mexican economic refugees who believe, perhaps correctly, that America is a better place to be poor than Mexico. The 1990s groundswell of anti-immigrant sentiment, and media attention to it, have brought the border with Mexico closer psychologically, helping to pivot the east-west symmetry of the Cold War toward a north-south axis. (In the fall of 2006, in a bizarre sort of post–Cold War resurrection of the Berlin Wall, the new xenophobia culminated in the passage and signing of unfunded legislation that ordains construction of 700 miles of fence along America's two-thousand mile southern border.)

Any history of the world in our century is of necessity a history in large measure of the things Europeans (and North Americans) did to themselves and to others, Tony Judt observes, and of how non-Europeans reacted to them

and were (usually adversely) affected. That, after all, is what is wrong with the twentieth century, seen from a "third world" perspective.[153]

The Lightning Field shows us where we stand—amid frames within frames, swept by change, bracketed by concepts and customs, by well-defined institutions and ill-articulated or unconscious beliefs. If others do not share our position—emotionally, intellectually, economically—amid the frames of reference and circumstances that we discern, what can we share with them?

In morally expansive moods, we may incline to believe that something connects us inherently with the rest of humankind: the concept of human rights rests on this assumption and attempts to give it moral and legal traction. But when we want to justify this belief, do we look to biology, psychology, mysticism, cosmology, ecology, political economy? The unprecedented complexity of our uncertainty on this point may be a true index of our historical position.

BOMB

At one level or another, everything changed between my visits to *The Lightning Field* in the late 1970s and the late 1990s. The Cold War, which seemed to me central to *The Lightning Field*'s meaning, ended with a seemingly sudden implosion of the Eastern bloc, beginning in 1989. Exactly how this came about may always be a matter of debate, but Thomas Powers almost persuades me when he describes the central paradox of the cold war as the fact that catastrophe was never far, and war was never close. In retrospect it seems clear that it was the political, not the military relations of the United States and the Soviet Union that were unstable. . . . But the face-to-face nuclear confrontation at ever higher levels of potential destructiveness was nevertheless astonishingly stable. . . . Throughout the cold war there were many occasions, especially in the early years, when the two sides might have gone to war. Just what stopped them can never be established with certainty, but one important factor surely was fear of the consequences. Hiroshima left no mystery about that.

Like Powers, I believed that the arms race itself, extended over decades, would make war inevitable, but that is not the way things turned out. Well, not yet. More than that, I believed that the modern technology of warfare would fulfill itself by starting a war on its own, and I still fear that it may. But then, I belong to an American generation that was taught to dive beneath desks in public school, hands over eyes, to avert injury by the flying window glass and blinding light that the bomb, dropped on the nearest city, would bring. How much of my own "nuclear fear" derives from these futile early lessons in "civil defense" I will never know.

Powers may be right when he says not the Americans, not the Russians won the Cold War, but the bomb. The bomb won.[154] The sinister hint of inanimate agency in his phrase is apt. The production of thousands of nuclear devices, and even their dismantling, as well as the "peaceful" use of nuclear power, have left the world a monumentally toxic and growing legacy of radioactive waste. The Cold War may have ended, but the bomb still flourishes. Nuclear weapons are still the foundation of a superpower. That will never change, as Deputy Secretary of Defense John Hamre put it in a little-reported statement in May 2000.[155]

Some political scientists argue that nuclear proliferation will guarantee world peace, that the weapons' effects are so horrific and the political cost of their tactical detonation so great as to render them unusable. But a glance at the history of wars in the twentieth century confirms that popular rage and the ambitions of leaders may overcome all normal revulsion at the prospect of mass carnage. Even if no hot war ever breaks out, the cost in environmental toxicity of living by deterrence may be too high for us—for the earth—to sustain.

During the writing of this essay, India and Pakistan exploded nuclear devices underground within days of each other, reminding us that the bomb is still out there, making history, that we may have passed from an era of global to one of regional Cold War.

Time is what the fear of nuclear war gave us, Powers concludes, time for the socialist economies to die of stagnation and mass discontent. Powers's statement may say more than he intends. It marks the distinctive aspect of historical

consciousness in the nuclear age, which *The Lightning Field* clarified for me: the sense that time is no longer an existential given but, as Faulkner said, a mere deferment of death by the inscrutable cunning of history—not just my death, but the death of humankind and of its habitat by nuclear calamity.

I think Powers underestimates the West's triumph of seduction, its success at projecting the image of a capitalist consumer utopia, a sideshow that stretched all the way back to Richard Nixon's "kitchen debate" with Nikita Khrushchev. The Cold War's end may have been primarily a triumph of capitalism, that is, of pent-up, advertising-inflamed envy and desire that makes social concern sound like a thin excuse for postponing private satisfactions. Cynics might even suggest that some of the recent revolutions in Eastern Europe had as their true goal not liberty and the right to vote but well-paying jobs and the right to shop, historian Benjamin Barber notes.[156] The logic of deterrence and that of consumerism dovetail nicely: as long as a balance of terror secures the future by continually threatening imminent doom, any indulgence may be justified in the name of probably dying tomorrow. This emotional logic certainly did not wither away with the Cold War.[157]

In a twisted replay of my generation's threat to bring the Vietnam War home, zealots of the right have since brought the Cold War home, relocating the enemy within American society. There is no "after the Cold War" for me, Irving Kristol declared. So far from having ended, my cold war has increased in intensity, as sector after sector of American life has been ruthlessly corrupted by the liberal ethos. . . . Now that the other "Cold War" has ended, the real cold war has begun.[158] Kristol's hankering for domestic enemies is an unusually open expression of the reactionary spleen to which conservatives feel entitled now that the Evil Empire no longer exists to shame them into a charade of benign political will.

For me there is no "after the Cold War" either, but my reasons differ from Kristol's. We may no longer live in the Cold War era, but it lives in us, in us who endured it. Consciously or not, our imaginations still refer everything to the bomb, and always will.

Defense experts provide some perspective. The arms race has not stopped, notes David Shukman, a journalist who specializes in military affairs. Instead, with the passing of the Cold War, it has lurched in new and potentially more dangerous directions. . . . Technologies of a bewildering variety—from nuclear energy to miniature computers to robotics to biological engineering to space flight—are suddenly on the loose and the competition to find new ways of putting them to military use is no longer the preserve of the most advanced industrial nations.[159]

In one of the most ominous speeches of his first administration, George W. Bush condemned as anachronistic the 1972 Anti-Ballistic Missile Treaty, a key factor in mitigating the world nuclear menace, and called for commitment of boundless resources to developing new missile systems to cope with a diffuse and inherently suicidal terrorist threat from designated "rogue states," prominently Iran and North Korea. (In 2002, chimerical weapons of mass destruction provided the pretext for invading and occupying Iraq. The vast expense of the ensuing calamity will provide pretexts in perpetuity for dismantling despised liberal social programs.)

The time has come to "rethink the unthinkable," Bush declared, seemingly deaf to his own call to make global catastrophe ponderable again.[160] Some critics of the plan and the not-yet-existing technology to make it feasible contend that, at best, it risks starting Cold War II, giving China and Russia license to arm or rearm themselves as aggressively as they please.

The Lightning Field's elements glimmer with yet another implication by the light of the "missile shield" fantasies of the Reagan and Bush II administrations: the poles now look like standards portending the militarization of space.

ACOMA

Nothing on American turf can throw into relief one's feelings about being among modern history's putative winners like a visit to the Acoma Pueblo. Because it lies between Albuquerque and *The Lightning Field*, many visitors to the *Field* add Acoma to their itinerary, as did we.

Standing atop the high butte on which the Acoma settlement has existed for 1,300 years, one can only marvel that gold-hungry Spaniards ever stumbled on this ill-starred people in the vastness of the desert. Rootedness in place certainly failed the Acoma as a defense against the spearhead of European expansion. Neither paved roads nor signage make it all that easy to find Acoma even today.

Watching the Acoma people desultorily shuttle white tourists through their everyday lives and listlessly replicate traditional artifacts to sell as souvenirs, I thought of Theodore Zeldin's remarks on Native American life (not the Acoma in particular). Zeldin sees the family and community harmony that Native Americans achieved as having cost them the ability to deal with the world beyond the tribe. His observations sound facile yet sadly plausible.

The price they paid for their easy-going attitudes, for their refusal to get angry, for their horror of face-to-face confrontation, Zeldin writes, was that they turned their anger against other tribes and destroyed themselves in war. War became their cure for grief; . . . Worshipping the equilibrium of natural forces, and denying the existence of evil, they found a superficial peace by always saying yes . . . refusing to coerce each other, regarding a hostile feeling in the same way as a physical illness. But on the other hand they were tormented by the fear of trickery; their endless, inconclusive discussions, and their factiousness, undermined their powers of resistance. Theirs was a civilization designed for wide open spaces, into which the dissatisfied could silently withdraw: 16,000 Cherokees had 100,000 square miles of Texas all to themselves. The ancient Amerindian civilizations collapsed—among other reasons—because although they had evolved impressive domestic policies, they had no foreign policy. They were puzzled by strangers. They accepted conflict as part of the natural order but could not cope with aggressors who had a completely different idea of what was natural.[161]

STORIES

The centripetal pull of each pole on the landscape, which it gathers up by reflection, can make an observer feel something that is supposed to be a benchmark of

postmodernism: a distrust of totalizing views or explanations of the world, perhaps mingled with nostalgia for them. The idea is that worldviews that explain too much express not comprehensive understanding but an encompassing ambition to dominate the world symbolically through narrative, as a step toward, or a technique of, dominating it operationally.

Jean-François Lyotard famously defined postmodernism as a loss of faith in "metanarratives," the big stories that swallow and reconcile, or blot out, the small stories of which lives and memory are made. This loss implies another: loss of the certainty that our own subjectivity can unify the world of our experience, by the ego's nimble, essentially conservative claims on psychic life, or by blurring or deferring uncertainties that might be bait for obsessive introspection. No wonder "the subject" had to go.[162]

Never have men been as conscious of their number, Jean-Marie Guéhenno wrote more than ten years ago, and never has the idea of the group been more problematic. We no longer believe in the nation, and now the universal republic is being unveiled [i.e., as a myth]. Stripped of the certainties of the age of nation-states, when civil society was a given—the legacy on which all sorts of political constructs could be built—we have no convenient formula for defining the scope of our solidarities.[163]

Seeking new metaphors for the changed world order, Guéhenno ventures an idea that might come easily to a visitor at *The Lightning Field*: weather as a model of history, perfectly rational yet nevertheless unpredictable . . . in which the infinitesimal modification of one variable can provoke a fundamental rupture; a world that defies the observer and the progress of observation to the extent that the pertinence of a variation has no bearing on its importance. This means that the ambition to control the system, and the equation of the political official with some great social clockmaker presiding over the . . . inner workings and regulating the whole machine within the confines of an equilibrium of controlled forces—

the "escapement" that clockmakers invented in the eighteenth century—these no longer make any sense. . . . In this world, power no longer resides in a prince capable of imposing his will on the social entity, but in the social entity itself; and the power of the social entity is not the appropriation by the collectivity of the powers of the prince—that was the illusion of the institutional age—but its capacity to exist as a social entity and not as a political body. It is a question of conveying information in all directions and, in doing so, to exist like a huge cybernetic machine.[164]

In its attunement to the historical vibrations of its time, *The Lightning Field* seems almost to have anticipated a shift in thinking like Guéhenno's. Especially so when he writes of the new condition as an age of mirrors . . . a play of reflections, a pale world, stalked at once by precariousness and by boredom, navigating between storms and utter calm, needing the imbalances without which no wind can come up, but fearing the unforeseeable ruptures that every disequilibrium threatens. And the very volatility of a world in which all the elements are holding each other in place, and which a mere nothing can set in vibration, is at the heart of modern angst.[165]

Yet in his embracing generalizations, Guéhenno still speaks the rhetoric of the "institutional world." Philosophical charades of self-dissolution—the "death of the subject"—may merely express the impossibility of identifying with people whose experience is too remote from our own: the peasant in rural China, the coffee picker in Chiapas, the Middle Eastern "guest worker" in Germany, the dispossessed living on the streets of every American city. What would their accounts of their historical situation be, if not their individual life stories?

Our amazing distance-shrinking technologies cannot close the gaps between individual life stories and narratives of collective history. Not only because our numbers are too great but because, as Arthur C. Danto puts it, we are by nature beings whose representations are properties of themselves, consciously or otherwise.[166]

REPORT

My 1978 nuclear epiphany at *The Lightning Field* occurred partly because, until that moment, in ten days at the site, I had heard no aircraft at all. The silence of the skies vouched for the remoteness of the place and made me wonder how the report of any epochal event might reach me there directly.

In June 1996, I inadvertently found one sort of answer in a remarkable document included in "Negotiating Rapture," the exhibition that inaugurated the Museum of Contemporary Art's new building in Chicago. The several nonart objects in that show included a 1942 "Official Road Map of New Mexico" that then MCA curator Richard Francis had found in the National Archives. At the bottom of the map the word "secret," written in red pencil, was overstruck in black, confirming just how casually this item had been declassified—in Francis's presence, as it happened—once the Cold War pressure was off. I thought of this map when I found Francis Stonor Saunders's reference in *The Cultural Cold War* to Congressman George Dondero's paranoid conviction that certain American abstract paintings encoded maps of missile sites in the American West.

The declassified New Mexico map features concentric circles drawn in different colors around black grease pencil dots that mark various rural town sites. (Similar concentric circles, still undeciphered, appear in petroglyphs made by the ancient Anasazi who lived in northeast New Mexico.)[167] A handwritten key on the map explains that the circles signify what official observers witnessed of the world's first man-made nuclear explosion, early on the morning of July 16, 1945. It took place at the Trinity test range near Alamogordo in southeast New Mexico. A red circle indicates that the explosion was audible to an observer, green that it was visible, and black that the air shock could be felt. Unsurprisingly, no observations from *The Lightning Field* area are recorded. But the nearest observers' notations suggest that the explosion's light might easily have been visible at the site, and the shock wave palpable.

Thunderstorms delayed the Trinity test and aroused concern that a lightning strike might cause premature ignition, the bomb's electrical detonator having been

an eleventh-hour makeshift. A navy captain who observed the test from twenty miles off was surprised by a sound like a "crack of thunder."[168] The yield of the Trinity explosion was a mere eighteen and a half kilotons of TNT: a firecracker by the megaton standards of the Cold War era.

I returned to *The Lightning Field* in the 1990s wondering whether a thunderbolt such as I had experienced in 1978 could still strike in the mid-1990s, with the Cold War officially behind us.

Cold War memoirs confirm that the years around 1980 were a period of high anxiety in the superpower face-off. We received a small insight into Soviet paranoia about the United States in mid-1980, former CIA director Robert M. Gates recalls in his book *From the Shadows*. On at least three occasions, there had been failures of the U.S. early warning computer system leading to combat alerts of U.S. strategic forces. CIA later learned that during the first half of June, 1980, the KGB had sent a message to all of their residencies reporting these failures and saying that they were not the result of failures but were deliberately initiated by the Defense Department for training. The KGB circular stated that the Soviet government believed that the United States was attempting to give the Soviet Union a false sense of security by giving the impression that such errors were possible, and thereby diminish Soviet concern over future alerts—thus providing a cover for possible surprise attack.

Gates acknowledges two occasions when World War III very nearly began by accident. In the first, senior military personnel detected computer misinformation just before it might have triggered an executive decision on armed response.

The second incident was even more dramatic, Gates reports. National Security Adviser Zbigniew Brzezinski was awakened at three in the morning by [military assistant Bill] Odom, who told him that some 220 Soviet missiles had been launched against the United States. Brzezinski knew that the President's decision time to order retaliation was from three to seven minutes after a Soviet launch. Thus he told Odom he would stand by for a further call to confirm a Soviet launch and the intended targets before calling the President. Brzezinski

was convinced we had to hit back and told Odom to confirm that the Strategic Air Command was launching its planes. When Odom called back, he reported that he had further confirmation, but that 2,200 missiles had been launched—it was an all-out attack. One minute before Brzezinski intended to telephone the President, Odom called a third time to say that other warning systems were not reporting Soviet launches. Sitting alone in the middle of the night, Brzezinski had not awakened his wife, reckoning that everyone would be dead in half an hour. It had been a false alarm. Someone had mistakenly put military exercise tapes into the computer system. . . . Such were the terrors and nightmares of the Cold War, now faded so far from memory.[169]

In that last line, Gates starts to sound like the propagandist one expects him to be, as if, thanks to the official end of great power confrontation, we have finally awakened from the nightmare of modern history.

Of course, we have not. In its evocation of Cold War–era anxiety, *The Lightning Field* redoubles the dread at not being able to go back that belongs to the trauma of time's passage. But at *The Lightning Field*, because of the presence of 400 sculptural elements that evoke a technologically sustained and menaced world, the existential frustration at being unable to go back in time turns to the dread of never being able to return to the world, because in one's absence it has destroyed itself as a human habitat.

The Cold War inspired images of apocalypse that were horrific but easily envisioned, as attested by countless editorial cartoons and movies such as *Dr. Strangelove* (1964) and *On the Beach* (1959). Since the end of the Cold War, mass media have offered no image of world crisis so picturable as nuclear standoff, except extraterrestrial invasion and the cosmic calamity of meteoric impact.

Stories about the growing perils of nuclear-waste disposal appeared frequently in the American press in the mid-1990s. An affecting one from 1994 reported that the Mescalero Apaches could find relief from economic hard times only by accepting payment for storage of spent reactor fuel rods on their southern New Mexico reservation land. More recently, the Russian parliament has moved to allow into

wilderness areas of their country highly toxic spent nuclear fuel from around the world, a scheme that promises as much as 20 billion dollars in revenues.[170] More ominous and less publicized is the reported breakdown of Russian security, storage, and tracking apparatus that keeps weapons and saleable weapons' materials from entering the black market.

To date, the ecological and social crisis of nuclear-waste disposal has generated no emblematic image to haunt the public mind as the mushroom cloud did. Protests from the Japanese government and sympathetic American public-interest groups were needed to keep the U.S. Postal Service from issuing a mushroom-cloud stamp to mark the fiftieth anniversary of World War II's end.

OKLAHOMA CITY

As Karren Weathers ferried us away from *The Lightning Field* in April 1995, taking the northern route, I asked her whether we had missed anything momentous in our several days' freedom from exposure to media.

"Well, you know about Oklahoma City, right?" she asked. "Uh . . . no," I said, fishing for associations to Oklahoma City, a place I had never visited, nor really even thought about before.

She provided sketchy details about the bombing of the Murrah Federal Building, which authorities and the media initially assumed to be the work of Middle Eastern terrorists.

It wasn't a nuclear exchange or accident, but the Oklahoma City incident radically redrew many Americans' world-pictures. It erased their assumption that American citizenship bespeaks a solidarity that no private resentment or ideological mania could unmake. Random school shootings and workplace mayhem are one thing. Organized mass murder of nameless strangers is another. Or so the emotional logic of public response seemed to go.

The misfit convicted of the Oklahoma City bombing, which killed 168, remorselessly welcomed his execution, to which, as a macabre courtesy, victims' surviving family members were invited. Opponents of capital punishment and

disinterested legal observers warned that execution would make Timothy McVeigh a martyr in the eyes of homegrown militias and other fringe groups united by rage at the coercive powers of federal government. The Oklahoma City massacre shined the wayward light of the media on the militant antigovernment underground only briefly, just long enough to insert "domestic terrorist" into the national vocabulary and raise once more the question of whether media attention magnifies social phenomena, illuminates them, or merely validates their existence.

Idly inspecting the contents of the kindling bucket beside the wood stove in the cabin during our April 1995 visit, Tonia fished out a back issue of a local weekly. Among its notices of livestock auctions, used truck sales, and church activities were opinion columns and letters from readers vehemently denouncing the government's—especially the Bureau of Land Management's—interference in ranchers' affairs. Grumblings against gun control were sounded as well.

Here were the voices of people to whom space and distance—distance from the geographic centers of power—were not abstract, but a calibration of prospective livelihood and continued independence. It was a little disconcerting to hear Karren chime in sweetly and unguardedly with the seditious sentiments expressed in the newspaper when our conversation turned to Robert's sideline of boarding Mexican cattle on his land.

Actor and painter Martin Mull later called my attention to a dialogue in Don DeLillo's 1991 novel *Mao II* about the terrorist, a new figure in American social mythology, supplanting the artist as the last man able to shock the public into unsought awareness of how things stand and where they are headed.

For some time now I've had the feeling that novelists and terrorists are playing a zero-sum game, DeLillo's character says. What terrorists gain, novelists lose. The degree to which they influence mass consciousness is the extent of our decline as shapers of sensibility and thought. The danger they represent equals our own failure to be dangerous. . . . Beckett is the last writer to shape the way we think and see. After him, the major work involves midair explosions and crumbled buildings.

DeLillo's bitter satire depends on the rattle of truth we can hear in his character's rant. As conventional people once secretly admired avant-garde artists for their indifference to society, he continues, people now admire the way terrorists live in the shadows, live willingly with death. The way they hate many of the things you hate. . . . In societies reduced to blur and glut, terror is the only meaningful act. There's too much everything, more things and messages and meanings than we can use in a thousand lifetimes. . . . Is history possible? Is anyone serious? Who do we take seriously? Only the lethal believer, the person who kills and dies for faith. Everything else is absorbed. The artist is absorbed, the madman in the street is absorbed and processed and incorporated. . . . Only the terrorist stands outside. The culture hasn't figured out how to assimilate him. It's confusing when they kill the innocent. But this is precisely the language of being noticed, the only language the West understands.[171]

LIGHTNING

The Lightning Field's name, and a few of John Cliett's photographs, give people who have not traveled there the impression that to attract lightning must be the point of the work. After four visits to the site, never having seen lightning strike closer than thirty-five miles from it, I began to crave confirmation of my intuition that thunderstorms at *The Lightning Field* are adventitious to its meaning.

Most of us seldom witness lightning up close, yet the earth suffers lightning strikes almost continually. Scientists estimate that worldwide, at any given moment, 2,000 thunderstorms are occurring, generating perhaps a hundred lightning strikes per second.

Convinced though I was that *The Lightning Field* ranks as a great artwork even if no thunderstorm ever approaches it again, my hopes rose when I saw lightning jump from an innocent-looking cloud to a rocky slope, while we snaked past the Datil Mountains to meet Robert Weathers at Quemado in July 1996.

I felt excitement and relief in equal measure at seeing lightning shoot to the ground not far from the cabin just as we arrived at the site on that visit. Dashing for

the cabin porch as rain began to fall, we might easily have been struck dead: several more bolts, ripping the air, soon hit nearby. Once the storm had passed, the afternoon weather settled down to a motionless overcast. The following morning not a cloud could be found. I was certain we had seen what lightning would occur during our stay.

Around midday, stepping from the porch to the boardwalk that skirts the cabin, Tonia heard a whirring sound and glanced down to find a family of rattlesnakes basking in a wedge of sunlight that fell between the boardwalk and the cabin wall. They appeared calm but wary, as were we. We stepped a little more carefully from then on and would encounter them once or twice more in the coming days, without mishap.

Over the years, I had been warned about rattlesnakes at *The Lightning Field* but had never seen one before. The coincidence of the snakes' and lightning's appearance at the *Field* did not strike me until much later, when I happened on a remarkable 1923 paper by Aby Warburg (1866–1929). More adventurous than his celebrated acolytes Erwin Panofsky and E. H. Gombrich, Warburg had traveled to New Mexico in 1896, searching for modern vestiges of the serpent cult he had already traced from pagan antiquity through Christian art. He took great trouble to observe the masked dances that Native Americans in New Mexico performed to bring rain. Integral to the dances were live rattlesnakes: tangible, animate symbols of lightning. Where helpless human suffering searches for redemption, Warburg concluded, the serpent as an image and explanation of causality cannot be far away.

Our own technological age has no need of the serpent in order to understand and control lightning, Warburg writes. Lightning no longer terrifies the city dweller, who no longer craves a benign storm as the only source of water. He has his water supply, and the lightning serpent is diverted straight to the ground by a lightning conductor. Scientific explanation has disposed of mythological causation. . . . Whether this liberation from the mythological world view is of genuine help in providing adequate answers to the enigmas of existence is quite another matter.[172]

Late in the morning of what had begun as a boundlessly clear day, white beads of cloud appeared on the southern horizon, many miles off. Within two hours, they had drawn close and swollen into high masses that filled half the sky. Thunder began to growl distantly, a little louder and nearer each time, while the sun still shined. Looking southeast, toward the Datil Mountains, we saw lightning jump from high within an oncoming thunderhead, arcing toward us down to the hills some miles off.

To sit on the cabin porch and see the plain fall suddenly into shadow, and hear the birds and insects promptly go silent, is thrillingly suspenseful. Finally, the poles seemed to come into their own as lightning rods, although we never did see a direct hit—indeed, lightning seemed to behave as if the poles weren't there. As the air cooled and the wind settled, space itself seemed to become electric. Soon the wind kicked up again, from the storm's direction. Thunder stretched itself in long, creaking arches overhead. The cabin porch's roof made it seem a safe enough place from which to observe the oncoming weather—probably a misleading impression. Lightning shot down, now here, now there, darting unpredictably closer to the cabin, sometimes forking from cloud to cloud, until intensifying rain and wind made being outside too uncomfortable to bear.

The closest lightning strike I saw occurred less than a hundred yards from the cabin window through which I watched the downpour. A crinkled blaze of violet-white light, it looked like a long crepe-paper streamer that vanished in ignition the instant it appeared, whipping out a crackling energy and sound that made me jump.

Searching for words to evoke thunder and lightning reminds me of the hundred-letter thunderclaps in *Finnegans Wake*, in which Eric McLuhan reads multilingual, onomatopoetic compressions of many of Joyce's themes. I cannot resist inserting one here (the fifth) just for the pleasure of copying it: Thingcrooklyexineverypasturesixdixlikencehimaroundhersthemaggerbykinkinkankanwithdownmindlookingated.

McLuhan argues that the ten thunderclaps record and replay by means of human speech the most profound effects of our technologies on shaping our

culture and sensibilities and that the last four thunders concern electric technologies.[173] Not the sound but the obscurity of Joyce's thunder words resonates with the discovery that thunder and lightning at *The Lightning Field* held for me: impressive, even frightening, as they can be, thunder and lightning seem barren of mythic and poetic reverberations, as Warburg noted. The lightning imprisoned in wire—captured electricity—has produced a culture with no use for paganism, he wrote, eighty years back. Natural forces are no longer seen in anthropomorphic or biomorphic guise, but rather as infinite waves obedient to the human touch. With these waves, the culture of the machine age destroys what the natural sciences, born of myth, so arduously achieved: the space for devotion, which evolved in turn into the space required for reflection. . . . Ominous destroyers of the sense of distance, . . . telegram and telephone destroy the cosmos. Mythical and symbolic thinking strive to form spiritual bonds between humanity and the surrounding world, shaping distance into the space required for devotion and reflection: the distance undone by the instantaneous electric connection.[174]

In *Finnegans Wake*, the thunderclaps fit Joyce's theme of history as a circuit of awakenings. His method of cobbling together composite "thunder" words from a score of languages suggests that recognitions once stabilized by myth have been pulverized in the modern age into shards dispersed throughout world culture.[175]

In place of mythic inklings such as the ancient belief that nature speaks thunder, we have lightning as the figure for a random blow of fate. (Though we may find an echo of the belief that nature speaks thunder in the scientific age's confidence that we can discover representations that perfectly match the terms of nature's self-disclosure.) Frida Kahlo compared the bus accident that crippled her in her teens to being struck by lightning.

Thinking back to lightning striking at the *Field* reminds me of the brilliant, though now discredited, conjecture that lightning might have sparked the catalytic processes that brought about life on earth. In 1953, Stanley Miller, a graduate student in chemistry at the University of Chicago, decided to test the hypothesis

that lightning was the crucial ingredient in fomenting life in the primordial environment. Miller passed electric currents through a mixture of methane, ammonia, hydrogen, and water vapor—a plausible approximation of the ancient atmosphere —and produced small residues of amino acids, including many of those fundamental to proteins. With changed understanding of conditions on the ancient earth, Miller's daring proposal has since been superseded, downgraded to a creation myth of the scientific age.

Recent speculation has suggested that "cosmic sugar" deposited by a passing comet or asteroid, might have supplied the critical ingredient. Clouds of molecular glycolaldehyde, a simple sugar, exist in the Milky Way galaxy and, recently discovered, on the outskirts of our solar system. Combined with carbon molecules or with other sugars, glycolaldehyde can form ribose, a chemical kernel of RNA and DNA, the foundations of all b-life.[176]

Perhaps the forking of lightning corresponds most directly in contemporary imagination to the dendritic paths along which electrical impulses link brain cells every moment of our lives.[177]

While reflecting on *The Lightning Field* as a setting for sudden, unbidden recognitions, I was startled to find the following passage in Roberto Calasso's *Ka*. In this retelling of Hindu mythology, Calasso has the Vedic sage Kasyapa explain that he and his kind are experts in the sensation of being alive. We are wakeful—or, if you like, we vegetate. *Vajra*, the lightning flower, the ultimate weapon of the gods, is connected with *vegeo*, "to be wakeful, vigilant," from which we have *wacker*, *wach* and *wake*, "awake." The lightning is the lightning flash of wakefulness. "Vegetation" and "wakefulness" share the same root. That which every instant implies, which every instant conceals, as the mind's mill grinds out its images, that was our place.[178]

No knowing how far from its sources Calasso's retelling is. But the passage evokes lightning as a figure for the condition of an observed universe. Thoughts about one's own implication in that cosmic condition can strike one speechless at

The Lightning Field. That which every instant implies, which every instant conceals is the apocalyptic sense laid bare in De Maria's masterpiece—the equation of the sun's thermonuclear glow and the light that took the snapshot of the world, as Irving Feldman calls it in a poem of the 1980s: The light that took the snapshot of the world / shows them—with a clarity not granted in / this life—poised in sober expectation at / the intersection of the ordinary and / of Something Very Important, which has stopped them / to ask the way, then turns back with a question, / What were you doing when the world ended?[179]

Lightning strikes witnessed at *The Lightning Field* seem to brand it once and for all a work of Romantic temperament. At those moments, the poles suggest themselves afresh as sleek monuments to light as the mediator between cosmos and earth, as well as symbolic conductors of superhuman forces into the human realm.

In the ultimate work of Land Art, lightning is climactic in one sense. It seals De Maria's insistence that reality as experienced inexorably surpasses any representation of it. The point might be trivial were not the postmodern age hell-bent on denying it. Staking itself on this unfashionable thought, *The Lightning Field* may be more isolated than ever, despite all the world's encroachments.

Notes

Introduction

1. Theodor W. Adorno, "On Lyric Poetry and Society," trans. Shierry Weber Nicholsen, in *Notes to Literature*, vol. 1 (New York: Columbia University Press, 1991), p. 46.

2. The recent groundswell of religiosity in America has promulgated a new apocalyptic timetable: the Rapture Index, which anyone can find with an Internet search engine. It marks the countdown to the moment when, according to Evangelical Christian belief, the faithful will ascend to the right hand of God, whence they will watch those "left behind" consumed in a final conflagration. On January 17, 2007, the *Bulletin of the Atomic Scientists* announced that it had moved the minute hand on the Doomsday Clock closer to midnight for the first time since 2002: It now stands at five minutes to midnight. http://www.thebulletin.org/media-center/announcements/20070117.html. In 2007, a spate of books appeared, led by evolutionary biologist Richard Dawkins's *The God Delusion*, that revived popular debate about the existence of God, spurred by anxiety over various forms of religious extremism. Reviewing an anthology of essays that react to Dawkins' militant atheism, philosopher Anthony Kenny, concurring with one of the book's contributors, wrote "[Dawkins's] recent crusade has done more harm to science than it has to religion. Most people have a greater intellectual and emotional investment in religion than in science, and if they are once convinced that they have to choose between religion and science and cannot have both, it will be science that they will renounce." *Times Literary Supplement*, August 17, 2007, pp. 26–27.

3. E. B. White, "Here Is New York," in *Writing New York: A Literary Anthology*, ed. Phillip Lopate (New York: Library of America, 1998), p. 710.

4. Norman Birnbaum, *After Progress: American Social Reform and European Socialism in the Twentieth Century* (Oxford: Oxford University Press, 2001), p. 329.

5. Hannah Arendt, *The Origins of Totalitarianism,* rev. ed. (New York: Schocken Books, 2004), p. 341.

6. Stephen Holmes, "No Grand Strategy and No Ultimate Aim," *London Review of Books* 26, no. 9 (May 2004), pp. 9–14.

7. Stephen F. Cohen, "The New American Cold War," *Nation*, July 10, 2006, pp. 9–17. The late philosopher Richard Rorty, in his last published interview, expressed the fear that most observers dread to speak. "I still think that the end of democracy is a likely consequence of nuclear terrorism," he told Danny Postel, "and I do not know how to guard against this

danger. Sooner or later some terrorist group will repeat 9/11 on a much grander scale. I doubt that democratic institutions will be resilient enough to stand the strain." Rorty, "Last Words from Richard Rorty," interview by Danny Postel, *The Progressive* 71, no. 8 (August 2007), p. 15. Available online at http://www.progressive.org/mag_postel0607.

8. John Berger, "The Hals Mystery," in *Selected Essays* (New York: Pantheon, 2001), p. 397.

1978

1. Ivan Illich, *Energy and Equity* (New York: Harper & Row, 1974), pp. 30, 45.

2. Ibid., pp. 29, 32.

3. Theodore Roethke, *The Far Field* (New York: Doubleday, 1964), p. 25.

4. William A. Ivins, Jr., *On the Rationalization of Sight* (New York: Da Capo Press, 1973), p. 12. Addendum, 2002: John Berger comments on perspective from a different philosophical angle in an essay on the Chauvet cave paintings. "Pictorial systems of perspective are architectural and urban," Berger writes, "depending on the window and the door. Nomadic 'perspective' is about co-existence, not about distance." Berger, *The Shape of a Pocket* (New York: Pantheon, 2001), p. 40.

5. Ivins, *On the Rationalization of Sight*, pp. 9–10.

6. Whitehead, summarized in Tobias Dantzig, *Number, the Language of Science: A Critical Survey for the Cultured Non-Mathematician*, 4th ed. (1930; repr. New York: MacMillan, 1943), p. 96.

7. Hermann Weyl, *Philosophy of Mathematics and Natural Science*, trans. Olaf Helmer (Princeton: Princeton University Press, 1949), p. 75.

8. Ibid., p. 84.

9. By 1989, when I wrote the following, the importance of beauty at *The Lightning Field* had become much clearer to me. "The work is a device for coaxing into consciousness one's worst fears about the present moment and direction of history. . . . [It] also serves as an instrument for intensifying one's grasp of the beauty of the earth. Emerging and disappearing from sight with the movements of the sun . . . *The Lightning Field* acquaints the visitor with the possibility that beauty may be the only conscionable and feasible refuge from history. That is, the apprehension of reality as everywhere *radiant with its being* may be the only bearable consciousness of life that does not entail repressing awareness of the horrors of our time. Beauty in this sense is just

what *The Lightning Field* makes available even as it gives sculptural anchorage to one's worst forebodings of the world's fate." Kenneth Baker, *Minimalism* (New York: Abbeville Press, 1988), p. 127.

10. Norman O. Brown, *Love's Body* (New York: Random House, 1966), p. 258.

11. Hannah Arendt, *The Human Condition* (Chicago: University of Chicago Press, 1958), pp. 263–64.

12. Arendt argues for a similar view in her last completed work, *The Life of the Mind* (New York: Harcourt Brace Jovanovich, 1978). See vol. 1, *Thinking*, pp. 19–53.

13. Hans-Georg Gadamer, *Truth and Method*, trans. Garrett Barden and John Cumming (New York: Seabury Press, 1975), p. 439.

14. Weyl, *Philosophy of Mathematics*, p. 84.

15. Ivins, *On the Rationalization of Sight*, pp. 8, 13.

16. Dantzig, *Number*, p. 75.

17. Brown, *Love's Body*, pp. 182–83, citing Blake.

18. Arendt, *The Human Condition*, p. 270.

19. Karl Marx, *Early Writings*, trans. and ed. T. B. Bottomore (New York: McGraw-Hill, 1963), pp. 126–27.

20. Octavio Paz, *Children of the Mire: Modern Poetry from Romanticism to the Avant-Garde*, trans. Rachel Phillips (Cambridge, Mass.: Harvard University Press, 1974), p. 9.

1994–2007

1. Katy Human, "Alpinists' Ice-Dreamy Mountains Melting Away," *Denver Post*, January 12, 2005, p. A01.

2. On February 19, 2000, I happened to hear two ironic public references to this skepticism, one by a panelist at a symposium on Internet art at the University of California, Berkeley, the other by a stand-up comedian on a cable-TV special. "Moon-landing denial, you should know, is a major cultural industry," science historian Steven Shapin wrote in a review of a book about American moonwalkers, "possibly with an even greater American following than Holocaust denial." Steven Shapin, "What did you expect," *London Review of Books* 27, no. 27 (September 1, 2005), p. 32. More recently, controversy erupted on the Internet over the authenticity of the first photograph of the moon's surface allegedly taken by China's first lunar probe, Chang-e 1. Skeptics accused the Chinese authorities of trying to pass off as their own a picture taken by an American lunar orbiter two years earlier. See, for example, Richard Spencer, "China Defends

Lunar Probe Pictures," *Telegraph*, June 12, 2007. http://www.telegraph.co.uk/news/main.jhtml?xml=/news/2007/12/03/wchina103.xml.

3. James C. Scott, *Seeing Like a State: How Certain Schemes to Improve the Human Condition Have Failed* (New Haven: Yale University Press, 1998), pp. 31–32.

4. "2.5 Billion More People by 2050, UNFPA Reports," *POPline*, no. 26 (November–December 2004), p. 1.

5. George Steiner, *Errata: An Examined Life* (New Haven: Yale University Press, 1998), p. 118.

6. John Pilger, "The Other Tsunami," *New Statesman*, January 10, 2005, p. 10.

7. George W. S. Trow, *Within the Context of No Context* (New York: Atlantic Monthly Press, 1980), p. 58.

8. Robert Smithson, "A Sedimentation of the Mind: Earth Projects" (1968), in *Robert Smithson: The Collected Writings*, ed. Jack Flam (Berkeley: University of California Press, 1996), p. 106.

9. The *San Francisco Chronicle* reports a potentially catastrophic trash crisis developing in California, which is widely known for its progressive and successful recycling programs. Vast desert landfills connected to urban areas by rail are envisioned, but plans for them are snared in lawsuits brought by residents' groups and conservationists. If those giant landfills open, "waste management board officials say, the state will have 35 years of 'capacity.' But if not: 17 years," the paper reported. "Government ideas about California's trash future imagine electric cars that use less oil, tires that last longer and Wall Street driving a larger, more aggressive recycling industry. But they also picture a skyrocketing poor population with a low priority on waste management alongside affluent 'super consumption' creating even more waste, including disposable cellular phones and other appliances already called 'e-waste.'" Jim Wasserman, "Growth Overwhelms California's Gains in Diversion, Recycling," *San Francisco Chronicle*, October 3, 2001. The trash crisis now exists offshore as well. A natural whirlpool of currents in the Pacific Ocean has consolidated a water-borne mass of refuse twice the size of Texas and eighty percent plastic that oceanographers now refer to as the Great Pacific Garbage Patch. Now estimated at more than 3.5 million tons, it has grown tenfold each decade since the 1950s, jeopardizing many forms of marine life that encounter it and showing no prospect of diminishing or dissipating in the foreseeable future. See Justin Berton, "Continent-Size Toxic Stew of Plastic Trash Fouling Swath of Pacific Ocean," *San Francisco Chronicle*, October 19, 2007, p. W8.

The *Bulletin of the Atomic Scientists* reported in October 2007 that the problem of human refuse even extends off-world. "Some 4,500 launches have taken place since Sputnik, and there are currently 850 active satellites in space, owned by some 50 countries," wrote David Wright, "as well as nearly 700,000 pieces of debris large enough to damage or destroy those satellites. . . . Space commerce generates more than $100 billion a year in revenue. In every region of the globe, many aspects of society are becoming increasingly dependent on the services satellites make possible, and militaries are becoming increasingly reliant on them for a range of uses, including communication, reconnaissance, navigation, and weather monitoring. . . . To preserve the long-term use of space, it's particularly important to address how to control the production of orbital debris. Due to their high speed in orbit, even small pieces of orbiting debris can damage or destroy a satellite." Wright, "Space Debris from Antisatellite Weapons," *Bulletin of the Atomic Scientists*, October 2, 2007,http://www.thebulletin.org/ columns/david-wright/20071002.html.

10. William Jordan, *Divorce Among the Gulls: An Uncommon Look at Human Nature* (New York: North Point Press, 1991), pp. 123–24.

11. Smithson, "Entropy Made Visible" (1973), in *Robert Smithson: The Collected Writings*, p. 307.

12. Brian O'Doherty, *Inside the White Cube: The Ideology of the Gallery Space* (1986; repr., Berkeley: University of California Press, 1999).

13. Rollo May, *The Discovery of Being: Writings in Existential Philosophy* (New York: W. W. Norton, 1983), pp. 163–65.

14. Christopher Bollas, *Cracking Up: The Work of Unconscious Experience* (New York: Hill and Wang, 1995), p. 150.

15. Allucquère Rosanne Stone, "In the Language of Vampire Speak: Overhearing Our Own Voices," in *The Eight Technologies of Otherness,* ed. Sue Golding (New York: Routledge, 1997), pp. 65–66.

16. Hannah Arendt uses the metaphor of a desert to evoke the modern deprivation of common ground—of politics in what she regards as a primal sense: "The modern growth of worldlessness, the withering away of everything *between* us," she writes, "can also be described as the spread of the desert. That we live more and more in a desert-like world was first recognized by Nietzsche, and it was also Nietzsche who made the first decisive mistake in diagnosing it. Like almost all who came after him, he believed that the desert is in ourselves, thereby revealing himself not only as one of the earliest conscious inhabitants of the desert, but also, by the same token, as the victim of its most terrible illusion. Modern psychology is desert psychology: when we lose the faculty to judge—to suffer and condemn—we begin to think that there is something wrong with us if we cannot live under the conditions of desert life. Insofar as psychology tries to 'help' us, it helps us adjust to those conditions, taking away our only hope, namely, that we who are not of the desert but live in it are able to transform it into a human world. Psychology turns everything topsy-turvy: precisely because we suffer under desert conditions we are still human and still intact; the danger lies in becoming true inhabitants of the desert and feeling at home in it." Hannah Arendt, *The Promise of Politics* (New York: Schocken, 2005), p. 201.

17. Fredric Jameson, *Postmodernism, or, The Cultural Logic of Late Capitalism* (Durham: Duke University Press, 1991), p. ix.

18. N. Katherine Hayles, "Simulated Nature and Natural Simulations," in *Uncommon Ground: Toward Reinventing Nature*, ed. William Cronon (New York: W. W. Norton, 1995), pp. 410–11.

19. "Today in the system's spectacle, [the struggle with necessity] exists no more," John Berger wrote in 1995. "Consequently no experience is communicated. All that is left to share is the spectacle, the game that nobody plays and everybody can watch. As has never happened before, people have to try to place their own existence and their own pains single-handed in the vast arena of time and the universe." Berger, "Steps Towards a Small Theory of the Visible (for Yves)," in *The Shape of a Pocket* (New York: Pantheon, 2001), p. 13.

20. Jameson, *Postmodernism*, pp. 48–49.

21. Arthur C. Danto, *Connections to the World: The Basic Concepts of Philosophy* (1989; repr. Berkeley: University of California Press, 1997), p. xviii.

22. Hannah Arendt and Martin Heidegger, *Letters, 1925–1975*, ed. Ursula Ludz, trans. Andrew Shields (Orlando, Fla.: Harcourt, 2004), p. 157; Arendt's paraphrase of Heidegger from Heidegger's *Discourse on Thinking* (originally published in 1959 under the title *Gelassenheit*), trans. John M. Anderson and E. Hans Freund (New York: Harper & Row, 1969), p. 89.

23. Peter Conrad, *Modern Times, Modern Places* (New York: Knopf, 1999), p. 220.

24. Clement Greenberg, "The Situation at the Moment," in *Clement Greenberg: The Collected Essays and Criticism,*

vol. 2, ed. John O'Brian (Chicago: University of Chicago Press, 1986–93), p. 193.

25. With characteristic acuity, John Berger links the experience of isolation with the "spectacular" tactics of globalization. "Today images abound everywhere," Berger wrote in 1995. "Never has so much been depicted and watched. We have glimpses at any moment of what things look like on the other side of the planet, or the other side of the moon. Appearances are registered, and transmitted with lightning speed. Yet with this, something has innocently changed. They used to be called *physical* appearances because they belonged to solid bodies. Now appearances are volatile. Technological innovation has made it easy to separate the apparent from the existent. And this is precisely what the present system's mythology continually needs to exploit. It turns appearances into refractions not of light but of appetite, in fact a single appetite, the appetite for more. Consequently—and oddly, considering the physical implications of the notion of appetite—the existent, the body, disappears. . . . Consider any newsreader on any television channel in any country. These speakers are the mechanical epitome of the *disembodied*. . . . No bodies and no Necessity —for Necessity is the condition of the existent. It is what makes reality real. And the system's mythology requires only the not-yet-real, the virtual, the next purchase. This produces in the spectator, not, as claimed, a sense of freedom (the so-called freedom of choice) but a profound isolation." Berger, "Steps Towards a Small Theory of the Visible," in *The Shape of a Pocket*, pp. 11–12.

26. Peter Ackroyd, *London: The Biography* (London: Chatto & Windus, 2000), p. 661.

27. Arundhati Roy, *Power Politics*, 2nd ed. (Cambridge, Mass.: South End Press, 2001), p. 1.

28. Eric Hobsbawm, *On the Edge of the New Century: A Conversation with Antonio Polito*, trans. Allan Cameron (New York: New Press, 2000), p. 8.

29. It took nothing less than the massacres of September 11, 2001—my fantasy of an aerial accident horrifically twisted and magnified—to suspend this annual spectacle of military-industrial pride. It resumed in 2003.

30. Gabriel Kolko, *Century of War: Politics, Conflict, and Society since 1914* (New York: New Press, 1994), p. 470.

31. Paul Virilio, *The Information Bomb*, trans. Chris Turner (New York: Verso, 2000), p. 63.

32. See Victoria Samson, "Hacker's Delight," *Bulletin of the Atomic Scientists* 62, no. 5 (September–October 2006), pp. 64–65.

33. John Archibald Wheeler, "Information, Physics, Quantum: The Search for Links," in *Complexity, Entropy and the Physics of Information*, ed. Wojciech H. Zurek (Redwood City, Calif.: Addison-Wesley Publishing, 1990), p. 5.

34. Ibid., p. 16.

35. Ibid., p. 13.

36. Ibid., p. 14.

37. Erik Erikson, "Human Strength and the Cycle of Generations" (1960), in *The Erik Erikson Reader*, ed. Robert Coles (New York: W. W. Norton, 2000), pp. 218–19.

38. Iris Murdoch, *Existentialists and Mystics: Writings on Philosophy and Literature* (London: Chatto & Windus, 1997), pp. 55–56.

39. Stephen Mills, "Pocket Tigers: The Sad Unseen Reality Behind the Wildlife Film," *Times Literary Supplement*, February 21, 1997, p. 6.

40. Steiner, *Errata*, pp. 160–61.

41. Aldous Huxley, "Silence" (1945), in *The Perennial Philosophy* (London: Chatto & Windus, 1946), p. 250.

42. Ibid., p. 250. The American composer Andrew Waggoner picked up Aldous Huxley's theme in a recent essay on the website *New Music Box*. "The colonization of silence is complete." Waggoner writes. "Its progress was so gradual that even those who watched it with alarm have only now begun to take stock of the losses. Reflection, discernment, a sustainable sense of tranquility, of knowing where and how to find oneself—these are only the most obvious casualties of marauding noise's march to the sea. Much more insidious has been the loss of music itself"—that is, music encountered against a background of sonic openness rather than within the present enveloping cacophony of audible culture. "In losing silence, and the corresponding potential for musical discernment that silence engenders," Waggoner argues, "we lose ourselves, our native sense of our motion through life." Waggoner, "The Colonization of Silence," *New Music Box*, August 8, 2007, http://www.newmusicbox.org/article.nmbx?id=5188.

43. Curiously, the clearest precursor of *The Lightning Field* in De Maria's oeuvre may be his 1965 *Cage*, which he wryly characterized as a portrait of John Cage: a tight but tall cage of vertical stainless-steel bars, perhaps just large enough to have contained the composer himself, though not at all comfortably. The emptiness of *Cage* may ironically celebrate the composer's liberating influence. John Cage was much on the minds of New York artists in the 1960s. Yoko Ono made

a piece with him in mind that seems to foreshadow forms and themes of *The Lightning Field*. Her *Forget It* (1966) is a needle fixed vertically, point upward, atop a Plexiglas base. In hindsight it reads like a model for a single pole of *The Lightning Field*. "Didn't Christ say that it was like a camel trying to pass through a needle hole, for John Cage to go to heaven?" Ono wrote at the time. "I think it is nice to abandon what you have as much as possible, as many mental possessions as the physical ones, as they clutter your mind. . . . It is nice to keep oneself small, like a grain of rice, instead of expanding." *Yes Yoko Ono* (New York: Japan Society, in association with Abrams, New York, 2000), pp. 118–19.

44. Alberto Moravia, *Contempt* (first published in Italy as *Il disprezzo* in 1954), trans. Angus Davidson (New York: New York Review Books, 1999), p. 235.

45. William S. Burroughs, *The Ticket That Exploded* (New York: Grove Press, 1967), pp. 49–50.

46. Jane Hirshfield, "Komachi at the stoop: Writing and the threshold of life," *American Poetry Review*, no. 25 (September–October 1966), p. 29.

47. John Terborgh, "Cracking the Bird Code," *New York Review of Books*, January 11, 1996, p. 44.

48. "But It's Not Just the Birds," *POPline*, no. 23 (May–June 2001), p. 1.

49. George Steiner, prologue to *No Passion Spent: Essays 1978–1995* (New Haven: Yale University Press, 1996), p. x.

50. Steiner, *Errata*, p. 56.

51. Edward O. Wilson, *In Search of Nature* (Washington, D.C.: Island Press, 1996), p. 47. Paul Davies discussed in a recent *Scientific American* article the possibility, now under investigation, that forms of alien life, or traces of their remains, have long existed on earth unnoticed as a kind of "shadow biosphere." Davies, "Are Aliens Among Us?" *Scientific American* 297, no. 6 (December 2007), pp. 62–69. Available online at http://www.sciam.com/article.cfm?id= are-aliens-among-us.

52. Marina Warner, *No Go the Bogeyman: Scaring, Lulling, and Making Mock* (New York: Farrar, Straus and Giroux, 1998), p. 383.

53. An article in *Popular Science* gave a feel for the questions that a true discovery of extraterrestrial life forms might raise. In 2001, an unexplained red rain fell on the Indian state of Kerala. A scientist at Mahatma Gandhi University named Godfrey Louis analyzed samples of the rainfall and discovered miniscule cell-like structures that reproduce despite

lacking DNA and that can withstand extremes of temperature intolerable to every known terrestrial life form. Louis and his fellow researchers published an article in the journal *Astrophysics and Space Science*, speculating that the entities might be bacteria or other primitive life forms that had evolved so as to survive the conditions of interplanetary space, entities perhaps swept off of a life-bearing planet by a passing comet. Other scientists have undertaken to reproduce the experiments Louis and his team performed before advancing their hypothesis. (See Jebediah Reed, "Is It Raining Aliens?" *Popular Science* [2005], http://www.popsci.com/printerfriendly/science/2c21c0f98d07b010vgvcm 1000004eecbccdrcrd.html.)

54. Howard E. McCurdy, *Space and the American Imagination* (Washington, D.C.: Smithsonian Institution Press, 1997), p. 156.

55. Ibid., p. 137.

56. Robert Zubrin, *The Case for Mars: The Plan to Settle the Red Planet and Why We Must* (New York: Free Press, 1996), pp. 297–98.

57. Louis Menand, *The Metaphysical Club* (New York: Farrar, Straus and Giroux, 2001), p. 399.

58. Bollas, *Cracking Up*, p. 119. Simone Weil puts the point a little more colorfully: "All the tragedies which we can imagine return in the end to the one and only tragedy, the passage of time." Weil, quoted in Joshua Foa Dienstag's *Pessimism: Philosophy, Ethic, Spirit* (Princeton: Princeton University Press, 2006).

59. Umberto Saba, quoted in David Lehman, *The Last Avant-Garde: The Making of the New York School of Poets* (New York: Doubleday, 1998), p. 284.

60. William Faulkner, Nobel Prize Acceptance Speech at City Hall, Stockholm, December 10, 1950, http://nobelprize.org/literature/laureates/1949/faulkner-speech.html.

61. Richard Wilbur, *Advice to a Prophet and Other Poems* (New York: Harcourt Brace & World, 1961.) p. 12.

62. Robert S. Norris and Hans M. Kristensen, "U.S. Nuclear Forces, 2004," *Bulletin of the Atomic Scientists* 60, no. 3 (May–June 2004), p. 68.

63. Arundhati Roy, "The End of Imagination," *Nation*, September 28, 1998, p. 12. Several years later, Jonathan Schell added an essential postscript to Roy's reflections on the new South Asian arms race. "In a world whose great powers were committed to nuclear disarmament, the decision by other nations to forgo these weapons would be consistent with national self-respect. But in a world in which one

self-designated enforcer of a two-tier nuclear system [i.e., the U.S.] sits atop a mountain of nuclear bombs and threatens destruction of any regime that itself seeks to acquire them, such forbearance becomes national humiliation—a continuation of the hated colonial system of the past, or 'nuclear apartheid,' as the Indian government put it." Jonathan Schell, "The Growing Nuclear Peril," *Nation*, June 24, 2002, p. 14.

64. Helen Caldicott, "NASA Nuclear Roulette," *Nation*, September 29, 1997, p. 29.

65. Aikido has a moral pertinence to my thinking about *The Lightning Field* that I never suspected when I began to practice it. The physical practice of aikido teaches anyone engaged in it—at an extraconscious level—to prefer yielding and trust to rigidity and stubbornness. Aikido is the only means known to me to unlearn spite—the desire to win a perverse victory by the exertion of will for its own sake, a desire whose most intense expression may be gratuitous self-destruction. Spite is the dynamic behind nuclear weapons, terrorism, and the nest-fouling shortsightedness of a profit system wreaking planetary ecological havoc.

66. Jonathan Schell, "The Unfinished Twentieth Century: What We Have Forgotten About Nuclear Weapons," *Harper's* 300, no. 1796 (January 2000), pp. 54–56.

67. Vasily Grossman, *Life and Fate* (New York: Harper & Row, 1986), pp. 406–10.

68. Timothy Ferris, "Is This the End?" *New Yorker*, January 27, 1997, pp. 44–45.

69. John Gribbin with Mary Gribbin, *Almost Everyone's Guide to Science: The Universe, Life, and Everything* (New Haven: Yale University Press, 1999), p. 178.

70. Ferris, "Is This the End?" p. 47.

71. Greenberg, "Avant-Garde and Kitsch" (1939), in Greenberg, *Clement Greenberg: The Collected Essays and Criticism*, vol. 1, p. 8.

72. Lawrence Durrell, *Spirit of Place: Letters and Essays on Travel* (New York: Dutton, 1969), p. 162.

73. Thinking about David Smith's work while going through the Solomon R. Guggenheim Museum's superb 2006 Smith retrospective, I suddenly saw in *The Lightning Field* a merciless revision of Smith's famous informal array of his work on his property at Bolton Landing, New York. *The Lightning Field* repudiates everything scenic in the rural New York landscape, and in the sculpture's picturesque interplay with it. In the process, of course, De Maria also rejects the championing of personal expression in Smith's art. De Maria leaves us to speculate about how conscious this repudiation was.

74. Martin Heidegger, *Parmenides*, trans. André Schuwer and Richard Rojcewicz (Bloomington: Indiana University Press, 1992), p. 108.

75. William S. Burroughs, "Origin and Theory of the Tape Cut-ups" (lecture, Jack Kerouac School of Disembodied Poetics, Naropa Institute, Boulder, Colo., April 20, 1976).

76. In one of his penetrating commentaries on the destruction of the World Trade Center, Jonathan Schell wrote, "As so many have observed, it was, probably by evil design, a disaster film—even a comic book or video game—brought sickeningly to life: horrific 'infotainment' or 'reality TV.' The use of real life and real lives to enact a plot lifted out of the trashiest entertainments was an element of the peculiar debasement of the event." Schell, "Letter from Ground Zero: The Power of the Powerful," *Nation*, October 15, 2001. p. 32.

77. Elias Canetti, *Crowds and Power* (New York: Farrar, Straus and Giroux, 1984), p. 15.

78. Michael Kelly, *Martyrs' Day: Chronicle of a Small War* (New York: Random House, 1993), p. 229.

79. Gabriel Josipovici, *Touch* (New Haven: Yale University Press, 1996), p. 68.

80. Eduardo Galeano, *Walking Words* (New York: W. W. Norton, 1995), p. 326.

81. Another of De Maria's indoor urban pieces, *The Broken Kilometer* (1979) in Manhattan, demonstrates the eye's undependable sense of measure. A kilometer of brass rod broken into five parallel rows of two-meter units, viewed end-on under intense overhead lights, *The Broken Kilometer* confounds one's bodily estimate of its extension in space. The eye quickly succumbs to the dazzle of the brass finish and the illusion that the rows rise as they recede.

82. Jean Heidmann, *Extraterrestrial Intelligence*, trans. Storm Dunlop (Cambridge: Cambridge University Press, 1995), p. 155.

83. Ibid., p. 141. The BBC reported online in October 2007 that Microsoft cofounder Paul Allen has bankrolled a new facility, the Allen Telescope Array, under construction about three hundred miles north of San Francisco, that promises to survey an area of sky seventeen times larger than what the Very Large Array can take in. "Skies to Be Swept for Alien Life," *BBC News*, October 12, 2007. http://news.bbc.co.uk/2/hi/ technology/7041183.stm.

84. McCurdy, *Space and the American Imagination*, p. 127.

85. Toshiyuki Nakagaki et al., "Maze-Solving by an Amoeboid Organism," *Nature*, no. 407 (September 28, 2000), p. 470.

86. Martin Lockley, *The Eternal Trail: A Tracker Looks at Evolution* (Reading, Mass.: Perseus, 1999), p. 285.

87. Michelle Goldberg, "The New Monkey Trial," *Salon*, January 10, 2005. http://dir.salon.com/story/news/feature/2005/01/10/evolution/index.html

88. Anatol Lieven, "The Modern Limits of Democracy," *Financial Times*, January 12, 2005, p. 17.

89. Daniel C. Dennett, *Darwin's Dangerous Idea: Evolution and the Meanings of Life* (New York: Simon & Schuster, 1995), p. 21.

90. Ibid., p. 59.

91. John Horton Conway, "The Game of Life" (1970), quoted in Claus Emmeche, *The Garden in the Machine: The Emerging Science of Artificial Life*, trans. Steven Sampson (Princeton: Princeton University Press, 1994), pp. 6–7.

92. Claus Emmeche, *The Garden in the Machine* pp. 23–24. Recent breakthroughs in the synthesis of DNA promise to upset the distinctions between a- and b-life in new ways. "Scientists in Maryland have already built the world's first entirely handcrafted chromosome—a looping strand of DNA made from scratch in a laboratory, containing all the instructions a microbe needs to live and reproduce. In the coming year, they hope to transplant it into a cell, where it is expected to "boot itself up," like software downloaded from the Internet, and cajole the waiting cell to do its bidding. And while the first synthetic chromosome is a plagiarized version of a natural one, others that code for life-forms that have never existed before are already under construction. . . . Already a few scientists have made viruses from scratch. The pending ability to make bacteria—which, unlike viruses, can live and reproduce outside of a living body—raises new concerns about contamination, contagion and mischief." Rick Weiss, "Creation 2.0," *Philadelphia Inquirer*, December 31, 2007. http://www.philly.com/inquirer/magazine/20071231_creation_2.0.html.

93. Sherry Turkle, "Tamagotchi Love," *London Review of Books* 28, no. 8 (April 20, 2006), p. 37.

94. A startling new sort of answer appears in Christopher Alexander's breathtaking four-volume study *The Nature of Order*. Alexander argues that "space itself carries the attribute of life." He develops, empirically and mathematically, the idea that "centers," both perceived and unperceived, in regions of space bootstrap themselves into "living structures," which cut across familiar distinctions between the organic and inorganic. "If we understand the idea of the field of centers well," Alexander writes, "we shall have a picture of the universe as made of stuff—space/matter—which is potentially living stuff. It is a material in which the occurrence of centers produces more and more intensity of centers. The material actually transforms, comes to life . . . 'blazes' one might even say, as this field of centers is created within it. . . . [We] need to understand space as a material which is *capable* of awakening. This is what I . . . refer to as 'the ground.' The ground is just that 'something' in the fabric of space which is capable of awakening. We may imagine it as lying behind the space or in the space or under the space conceptually. Or we may imagine it is *the* space itself, but then recognize space itself as something immeasurably deeper than the way we used to think about space in 20th century physics" (Alexander, *The Nature of Order. Book One: The Phenomenology of Life*, vol. 1 [(Berkeley: Center for Environmental Structure, 2002–6], pp. 426, 428, 439). There occur moments at *The Lightning Field* when one feels poised at the threshold of Alexander's intuitions.

95. Edward Harrison, *Darkness at Night: A Riddle of the Universe* (Cambridge, Mass.: Harvard University Press, 1987), p. 4.

96. Samuel Beckett, quoted in Marjorie Perloff, *Wittgenstein's Ladder: Poetic Language and the Strangeness of the Ordinary* (Chicago: University of Chicago Press, 1996), p. 88, n220.

97. A. Alvarez, *Night: An Exploration of Night Life, Night Language and Dreams* (New York: W. W. Norton, 1995), pp. 35–37.

98. Edwin Honig, *Four Springs* (Chicago: Swallow Press, 1972), p. 23.

99. Jean Cocteau, quoted in Michel Tournier, *The Mirror of Ideas*, trans. Jonathan F. Krell (Lincoln: University of Nebraska Press, 1998), p. 91.

100. Nelson Goodman, "On Starmaking," in *Starmaking: Realism, Anti-Realism and Irrealism*, ed. Peter J. McCormick (Cambridge, Mass.: MIT Press, 1996), p. 145.

101. Eric J. Chaisson, *Cosmic Evolution: The Rise of Complexity in Nature* (Cambridge, Mass.: Harvard University Press, 2001), p. 237.

102. Lee Smolin, *The Life of the Cosmos* (New York: Oxford University Press, 1997), pp. 27–29.

103. Edwin Hubble, quoted in Richard Panek, *Seeing and Believing: The Story of the Telescope, or, How We Found Our Place in the Universe* (London: Fourth Estate, 2000), p. 173.

104. Wyn Wachhorst, *The Dream of Spaceflight: Essays on the Near Edge of Infinity* (New York: Basic Books, 2000), p. 133.

105. Walter Benjamin, "One-Way Street," in *Reflections: Essays, Aphorisms, Autobiographical Writings*, trans. Edmund Jephcott (New York: Harcourt Brace Jovanovich, 1978), pp. 92–93.

106. "U. S. Objectives for Space," *Report of the Commission to Assess United States National Security Space Management and Orientation* (January 11, 2001), p. 28. Also available online at http://space.au.af.mil/space_commission/. One of the masterminds of the Bush administration's Iraq invasion and occupation, Donald Rumsfeld has since resigned in disgrace from his position as Secretary of Defense, to be succeeded by Robert M. Gates, a Cold War "realist," who has so far tempered to some extent the recklessness of Bush/Cheney loyalists.

107. John D. Barrow, *The Universe That Discovered Itself* (Oxford: Oxford University Press, 2000), p. 397.

108. See Richard Dawkins, *Climbing Mount Improbable* (New York: W. W. Norton, 1996), p. 139.

109. William H. Gass makes a nice analogy of the night sky to the difficulty of historical sophistication. "Our world resembles the night sky," he writes, "since all those stars we see shining together, and which seem to exist in the same plane as though painted on a plate, actually bring us their light from far different times—a few are thousands of light-years away, some are nearer, perhaps half a century off—and when we, often awestruck, gaze at them, we see this mottled past, and if we are wise, we try to correct for and understand the differences: not always easy, since the spangle of the skies does resemble, in its simultaneity and dazzling presence, Las Vegas' seductive signs. But the stars (or the light we admire in the stars' stead) do not constitute a community." William H. Gass, *Tests of Time* (New York: Knopf, 2002), pp. 175–76.

110. David E. Fisher and Marshall Jon Fisher, *Strangers in the Night: A Brief History of Life and Other Worlds* (Washington, D.C.: Counterpoint, 1998), pp. 190–91.

111. Edward O. Wilson, "Is Humanity Suicidal?" *New York Times Magazine*, May 30, 1993, p. 24.

112. Charles A. Ziegler, "Analysis of the Roswell Myth: A Traditional Folk Motif Clothed in Modern Garb," in *UFO Crash at Roswell: The Genesis of a Modern Myth* (Washington, D.C.: Smithsonian Institution Press, 1997), pp. 51, 68.

113. Ibid., p. 13.

114. Recent research encourages a more optimistic view of the possibility of interplanetary communication. Scientists at the California Institute of Technology subjected more than a hundred writing systems to topological analysis and found a startling consistency underlying their apparent diversity. They inferred that these consistencies relate to features of the physical world in which human beings have had a vital—adaptive—interest for thousands of years. One of the researchers speculates that if denizens of an extraterrestrial civilization live under conditions of light and shade similar to those on earth and "among opaque macroscopic objects strewn about," such creatures might indeed develop writing systems with characteristics similar, at least topologically, to ours. See Roger Highfield, "Alphabets are as simple as . . ." *Telegraph*, 18 April, 2006.

115. Marcel Proust, quoted in Malcolm Bowie, *Proust among the Stars* (New York: Columbia University Press, 1998), p. 19.

116. Wilson, "Is Humanity Suicidal?" p. 26.

117. As Bryan Magee humblingly notes, "Whitehead . . . once remarked that it is possible to be provincial in time as well as in place; and the uncomfortable truth is that all but a handful of people are narrowly provincial in time." Magee, "My Introduction to Academic Philosophy," in *Confessions of a Philosopher* (London: Weidenfeld & Nicolson, 1997), p. 26.

118. Isaiah Berlin, *The Sense of Reality: Studies in Ideas and Their History* (New York: Farrar, Straus and Giroux, 1996), pp. 36–37.

119. Ralph Waldo Emerson, *Essays and Journals*, selected and with an introduction by Lewis Mumford (Garden City, N.Y.: Doubleday, 1968), pp. 69–70.

120. John Berger, "The Changing View of Man in the Portrait," in *Selected Essays and Articles: The Look of Things*, ed. Nikos Stangos (Middlesex: Penguin, 1972), p. 40.

121. William Gass writes: "Transcendence is not what masterworks teach me: they teach me immersion. They teach me that the trivial is as important as the important when looked at importantly." Gass, *Tests of Time*, p. 118.

122. Michael André Bernstein, *Foregone Conclusions: Against Apocalyptic History* (Berkeley: University of California Press, 1994), p. 4. Bernstein's suggestion chimes by chance with some of Christopher Bollas's remarks on the psycho-analyst's approach to the history personified by a patient. "The momentous facts of life, or the dramatic things done," according to Bollas, "are the entrance of the real into the life of the subject—creating a momentary caesura or blankness—

and they stand in isolation, as markers of the subject's history, notations of trauma and subjective absence. They tell nothing, or tell of the presence of nothing. It is only in the displaced mutation of the subject, in his asides, his sotto voce mumblings—in the details of the seeming trivia of his life—that one can discover the true response to the deeds done." Bollas, *Cracking Up*, p. 140.

123. T. S. Eliot, "The Waste Land," in *The Waste Land and Other Poems* (New York: Harcourt, Brace and World, 1962), p. 30.

124. Years afterward, I came across Primo Levi's remark that "a book has to be a telephone that works," incidentally an offhand slur on Italian technology. See *The Voice of Memory: Interviews, 1961–1987*, ed. Marco Belpoliti and Robert Gordon (New York: New Press, 2001), p. xix. I had also forgotten John Cage's admonition to "beware of that which is breathtakingly beautiful, for at any moment the telephone may ring or the airplane come down in a vacant lot." John Cage, *Silence* (Middletown, Conn.: Wesleyan University Press, 1961), p. 111.

125. See John Keane, "The Humbling of the Intellectuals: Public Life in the Era of Communicative Abandonce," *Times Literary Supplement*, August 28, 1998, pp. 14–16. Andrew O'Hagan has drawn out satirically the dark consequences of "communicative abundance": "Nowadays, being unavailable is understood to be an act of aggression. . . . To fail to answer your mobile phone, or to turn it off completely, is merely to announce that you are deep in the throes of a secret life. You don't care, you're not reliable, you've got something to hide, you're screening. . . . Answer or you're evil. Answer or you're dead. The telecommunications industry has been hard at work in recent years to wipe unavailability from the face of the planet." O'Hagan, *London Review of Books*, October 4, 2007, p. 22.

Around the same time, Mairéad Byrne put similar thoughts in prose poem form, writing in part: "Cell phones are a new dimension. They have revolutionized the concepts of out & in. You're never really out. Unless you're comatose. And when you're in, you're often out. . . . A cell phone is a stun gun of the in between while simultaneously allowing no other state." Byrne, *American Poetry Review* 36, no. 5 (September/October 2007), p. 61.

126. Avital Ronell, *The Telephone Book: Technology— Schizophrenia—Electric Speech* (Lincoln: University of Nebraska Press, 1989), p. 4.

127. Ibid., p. 9.

128. Sigmund Freud, *Civilization and Its Discontents*, trans. James Stachey (New York: W. W. Norton, 1961), p. 35.

129. Ronell, *The Telephone Book*, p. 20.

130. Ibid., p. 3.

131. Barbara Johnson, introduction to *Freedom and Interpretation: The Oxford Amnesty Lectures, 1992* (New York: Basic Books, 1993), p. 6.

132. Connie Zweig, "The Death of the Self in the Postmodern World," in *The Truth about the Truth: De-Confusing and Re-Constructing the Postmodern World*, ed. Walter Truett Anderson (New York: G. P. Putnam's Sons, 1995), pp. 146, 149.

133. John Gray, *Enlightenment's Wake: Politics and Culture at the Close of the Modern Age* (New York: Routledge, 1995), p. 147.

134. Ibid., pp. 145–46.

135. Yi-fu Tuan, *Cosmos and Hearth: A Cosmopolite's Viewpoint* (Minneapolis: University of Minnesota Press, 1996), p. 88.

136. Natural light as a metaphor for the streaming of attention has ancient roots in Asian as well as Western thought. "Turning the light around for an instant / routs becoming, abiding, and decay," wrote the seventh-century Chan Buddhist sage Seng-ts'an. A modern commentator notes that "turning back the light" is a common expression in Chan (*Zen* in Japanese) texts for attention seeking its own source as a corrective to helplessly finding mental categories reified in things. To this way of thinking, dualities are illusory, including the division of oneself from the external world, and light merely intensifies them, causing us to become absorbed in them unless and until we meditate sufficiently on its source.

137. Freeman Dyson, "Can Science Be Ethical?" *New York Review of Books*, April 10, 1997, p. 48.

138. Michel Foucault, *Essential Works, vol. 3: Power*, ed. James D. Faubion (New York; The New Press, 2000), p. 109.

139. Tzvetan Todorov, quoted in Johnson, *Freedom and Interpretation*, p. 7.

140. Richard Rorty, "Solidarity or Objectivity?" in *Philosophical Papers: Objectivity, Relativism, and Truth*, vol. 1 (Cambridge: Cambridge University Press, 1991), p. 23.

141. Norman Geras, *The Contract of Mutual Indifference: Political Philosophy after the Holocaust* (New York: Verso, 1998), pp. 28–29.

142. Denis Donoghue, *The Old Moderns: Essays on Literature and Theory* (New York: Knopf, 1994), p. xi.

143. John Ashbery, "The One Thing That Can Save America" (1975), in *The New York Poets: An Anthology*, ed. Mark Ford (Manchester: Carcanet, 2004), p. 78.

144. Maurice Blanchot, *Awaiting Oblivion*, trans. John Gregg (Lincoln: University of Nebraska, 1997), p. 26.

145. Canetti, *Crowds and Power*, pp. 46–47.

146. Helen Epstein, "An Infectious Sense of Danger," *Times Literary Supplement*, August 15, 1997, p. 25.

147. Donoghue, *The Old Moderns*, p. 29.

148. Edward S. Reed, *The Necessity of Experience* (New Haven, Conn.: Yale University Press, 1996), pp. 2–3.

149. Ibid., p. 4.

150. Richard Rorty, *Philosophy and the Mirror of Nature* (Princeton: Princeton University Press, 1979), p. 12.

151. Ibid., p. 13.

152. James Elkins, *Why Are Our Pictures Puzzles? On the Modern Origins of Pictorial Complexity* (New York: Routledge, 1999), p. 32.

153. Tony Judt, "Downhill All the Way," *New York Review of Books*, May 25, 1995, p. 21, n2.

154. Thomas Powers, "Who Won the Cold War?" *New York Review of Books*, June 20, 1996, p. 27.

155. John Hamre, quoted in Jonathan Schell, "Nuclear Madness," *Nation*, May 29, 2000, p. 5.

156. Benjamin R. Barber, *Jihad vs. McWorld* (New York: Times Books, 1995), p. 17.

157. Eric J. Hobsbawm recapitulates the period handily: "Governments of the ideological right, committed to an extreme form of business egoism and *laissez-faire*, came to power in several countries around 1980. Among these Reagan and the confident and formidable Mrs. Thatcher in Britain (1979–90) were the most prominent. For this new Right, the state-sponsored welfare capitalism of the 1950s and 1960s, no longer buttressed, since 1973, by economic success, had always looked like a sub-variety of that social-ism . . . of which they saw the USSR as the logical end-product. The Reaganite Cold War was directed not only against the 'evil empire' abroad, but against the memory of Franklin D. Roosevelt at home: against the Welfare State as well as any other intrusive state. Its enemy was liberalism . . . as much as communism." Hobsbawm, *Age of Extremes: The Short Twentieth Century, 1914–1991* (New York: Pantheon, 1994), pp. 248–49.

158. Irving Kristol, quoted in Michael S. Sherry, "Patriotic Orthodoxy and American Decline," in *History Wars: The Enola Gay and Other Battles for the American Past*, ed. Edward T. Linenthal and Tom Engelhardt (New York: Metropolitan Books, 1996), p. 107.

159. David Shukman, *Tomorrow's War: The Threat of High-Technology Weapons* (New York: Harcourt Brace, 1996), p. xiii.

160. The Bush II administration has followed through on this threat. A classified Pentagon document uncovered by jour-nalists in March 2002 outlines plans for possible nuclear attack on seven nations, including China, Iran, Iraq, and North Korea, and for the development of smaller nuclear devices, less dangerous to neighboring friendly populations than many-kiloton Cold War models. See Paul Richter, "Pentagon Broadens Nuclear Strategy," *San Francisco Chronicle*, March 9, 2002, pp. A1, A14.

161. Theodore Zeldin, *An Intimate History of Humanity* (London: Sinclair-Stevenson, 1994), p. 383.

162. The collapse of the communist world and the old Cold War ideological antipodes suggest that Lyotard might be right. Yet the metanarrative of conservative social and economic ideology gained more ground in the 1990s than anyone but zealots would have thought possible. Geoffrey Galt Harpham nicely unmasked the reactionary face of post-modernism in a notice of Fredric Jameson's book on the subject. "Postmodernism," Harpham wrote, "deploys and inverts the central categories of Marxist thought: it stands for materiality without substance, totality without community, homogeneity without equality, economics without class, populism without humanity, dynamism without aspiration or hope, and liberation without justice" (Harpham, "Postmodernism's Discontents," *Times Literary Supplement*, June 28, 1991, p. 6). At the twentieth century's end, many of us tasted something that to progressives seemed inconceiv-able in the 1970s: nostalgia for the state, for a government adept and activist enough to protect the populace from the racketeering of global capitalism.

163. Jean-Marie Guéhenno, *The End of the Nation-State*, trans. Victoria Elliot (Minneapolis: University of Minnesota Press, 1995), p. 48.

164. Ibid., pp. 78–79. Louis Menand traces the weather as a metaphor for evolutionary and historical process to the nineteenth-century American mentor of the pragmatists Chauncey Wright. See Menand, *The Metaphysical Club*, pp. 207ff.

165. Guéhenno, *The End of the Nation-State*, p. 83. Political commentator Brendan O'Neill brought Guéhenno's intuitions up to date when he observed that "since the end of the Cold War in 1989/1990, the independent state has been problematised as the source of the world's problems. Indeed, the West's 'humanitarian intervention' has been largely premised on the idea that states are suspicious and untrustworthy things. Sovereignty has become a dirty word, seen as something that tyrants like Milosević and Saddam Hussein hide behind as they get on with the business of persecuting their peoples. . . . The Cold War world order, which was based (at least in words) on respect and equality for sovereign states, nurtured political movements and guerilla armies that aspired to create their own states. . . . In present-day Iraq, we can glimpse what violent struggle looks like in the absence of politics. Without the old structures, or any new ones to take their place, the Iraqi insurgents express no distinct political interest or ideology, show no interest in winning mass support or strength, and focus their efforts, like many others today, on making an impact through the media. . . . Freed from responsibility to a distinct community, and with few ties to national territory or political principles, they have fewer constraints on their actions. It is because the insurgents are really free-floating agents rather than rooted political actors, reflecting the broader demise of politics in recent years, that they can execute what appear to be unthinkable acts." Brendan O'Neill, "Iraq: The World's First Suicide State," *Spiked Online* (September 26, 2006), http://www.spiked-online.com/index.php?/site/article/1700/.

166. Arthur C. Danto, "Outline of a Theory of Sentential States," *The Body/Body Problem: Selected Essays* (Berkeley: University of California Press, 1999), p. 88.

167. George Johnson, *Fire in the Mind: Science, Faith, and the Search for Order* (New York: Knopf, 1995), p. 318.

168. Rachel Fermi and Esther Samra, *Picturing the Bomb: Photographs from the Secret World of the Manhattan Project* (New York: Abrams, 1995), p. 156.

169. Robert M. Gates, *From the Shadows: The Ultimate Insider's Story of Five Presidents and How They Won the Cold War* (New York: Simon & Schuster, 1996), pp. 113–15.

170. Anna Badkhen, "Russia Sees Profit in Spent Nuclear Fuel," *San Francisco Chronicle*, May 26, 2001, p. 1.

171. Don DeLillo, *Mao II* (New York: Viking, 1991), pp. 156–57. The *New York Times* printed a summary report from European sources eight days after the September 11, 2001, destruction of the World Trade Center, quoting remarks about the attacks by composer Karlheinz Stockhausen. "What happened there—they all have to rearrange their brains now—is the greatest work of art ever," Stockhausen is supposed to have said. "That characters can bring about in one act what we in music cannot dream of, that people practice madly for ten years, completely, fanatically, for a concert and then die. That is the greatest work of art in the whole cosmos. I could not do that. Against that, we, composers, are nothing." Stockhausen, quoted in "Attacks Called Great Art," *New York Times*, September 19, 2001, p. E3.

172. Aby Warburg, "Images from the Region of the Pueblo Indians of North America," in *The Art of Art History: A Critical Anthology*, ed. Donald Preziosi (New York: Oxford University Press, 1998), pp. 203–04.

173. Eric McLuhan, *The Role of Thunder in Finnegans Wake* (Toronto: University of Toronto Press, 1997), pp. x–xi.

174. Warburg, "Images from the Region of the Pueblo Indians," p. 206.

175. Many commentators, beginning with Samuel Beckett, have noted that Joyce's thunder also refers bemusedly to Giambattista Vico's conjecture on the origins of spoken language and society. Speech, Vico suggested, began with onomatopoetic imitations of thunder by early humans driven into caves by their terror of lightning storms.

176. See Guy Gugliotta, "Space Sugar a Clue to Life's Origins," *Washington Post*, September 27, 2004, p. A07.

177. Lightning and electricity appear in Romantic arts and thought as metaphors for spiritual energy. "Music is the electrical soil in which the spirit thrives, lives and invents," Ludwig Beethoven wrote to Bettina Brentano. "All that is electrical stimulates the mind to flowing, surging, musical creation. *I am electrical by nature*." (Beethoven quoted in Wilfred Mellers's review of *Music and the Occult*, by Joscelyn Godwin *Times Literary Supplement*, January 24, 1997, p. 18).

178. Roberto Calasso, *Ka*, trans. Tim Parks (New York: Knopf, 1998), p. 163.

179. Irving Feldman, *Collected Poems, 1954–2004* (New York: Schocken, 2004), p. 242.

Bibliography

Books

Ackroyd, Peter. *London: The Biography*. London: Chatto & Windus, 2000.

Adorno, Theodor W. "On Lyric Poetry and Society." In *Notes to Literature*. Vol. 1. Trans. Shierry Weber Nicholsen, pp. 37–54. New York: Columbia University Press, 1991.

Alexander, Christopher. *The Nature of Order. Book One: The Phenomenology of Life.* Berkeley: Center for Environmental Structure, 2002–6.

Alvarez, A. *Night: An Exploration of Night Life, Night Language and Dreams*. New York: W. W. Norton, 1995.

Arendt, Hannah. *The Origins of Totalitarianism*. New York: Harcourt Brace Jovanovich, 1951. Rev. ed., New York: Schocken Books, 2004.

——. *The Human Condition*. Chicago: University of Chicago Press, 1958.

——. *The Life of the Mind*. New York: Harcourt Brace Jovanovich, 1978.

——. *The Promise of Politics*. Ed. Jerome Kohn. New York: Schocken Books, 2005.

Arendt, Hannah, and Martin Heidegger. *Letters, 1925–1975*. Ed. Ursula Ludz. Trans. Andrew Shields. Orlando, Fla.: Harcourt, 2004.

Baker, Kenneth. *Minimalism*. New York: Abbeville Press, 1988.

Barber, Benjamin R. *Jihad vs. McWorld*. New York: Times Books, 1995.

Barrow, John D. *The Universe That Discovered Itself*. Oxford: Oxford University Press, 2000.

Benjamin, Walter. *Reflections: Essays, Aphorisms, Autobiographical Writings*. Trans. Edmund Jephcott. New York: Harcourt Brace Jovanovich, 1978.

Berger, John. *The Shape of a Pocket*. New York: Pantheon, 2001.

Berlin, Isaiah. *The Sense of Reality: Studies in Ideas and Their History*. New York: Farrar, Straus and Giroux, 1996.

Bernstein, Michael André. *Foregone Conclusions: Against Apocalyptic History*. Berkeley: University of California Press, 1994.

Birnbaum, Norman. *After Progress: American Social Reform and European Socialism in the Twentieth Century*. Oxford: Oxford University Press, 2001.

Blanchot, Maurice. *Awaiting Oblivion*. Trans. John Gregg. Lincoln: University of Nebraska, 1997.

Bollas, Christopher. *Cracking Up: The Work of Unconscious Experience*. New York: Hill and Wang, 1995.

Bowie, Malcolm. *Proust among the Stars*. New York: Columbia University Press, 1998.

Brown, Norman O. *Love's Body*. New York: Random House, 1966.

Burroughs, William S. *The Ticket That Exploded*. New York: Grove Press, 1967.

Cage, John. *Silence*. Middletown, Conn.: Wesleyan University Press, 1961.

Calasso, Roberto. *Ka*. Trans. Tim Parks. New York: Knopf, 1998.

Canetti, Elias. *Crowds and Power*. New York: Farrar, Straus and Giroux, 1984.

Chaisson, Eric J. *Cosmic Evolution: The Rise of Complexity in Nature*. Cambridge, Mass.: Harvard University Press, 2001.

Conrad, Peter. *Modern Times, Modern Places*. New York: Knopf, 1999.

Danto, Arthur C. *Connections to the World: The Basic Concepts of Philosophy*, Berkeley: University of California Press, 1997 (1989).

Dantzig, Tobias. *Number, the Language of Science: A Critical Survey for the Cultured Non-Mathematician*. 4th ed. New York: MacMillan, 1943/1930.

Dawkins, Richard. *Climbing Mount Improbable*. New York: W. W. Norton, 1996.

DeLillo, Don. *Mao II.* New York: Viking, 1991.

Dennett, Daniel C. *Darwin's Dangerous Idea: Evolution and the Meanings of Life.* New York: Simon & Schuster, 1995.

Dienstag, Joshua Foa. *Pessimism: Philosophy, Ethic, Spirit.* Princeton: Princeton University Press, 2006.

Donoghue, Denis. *The Old Moderns: Essays on Literature and Theory.* New York: Knopf, 1994.

Durrell, Lawrence. *Spirit of Place: Letters and Essays on Travel.* New York: Dutton, 1969.

Eliot, T. S. *The Waste Land and Other Poems.* New York: Harcourt, Brace and World, 1962.

Elkins, James. *Why Are Our Pictures Puzzles? On the Modern Origins of Pictorial Complexity.* New York: Routledge, 1999.

Emerson, Ralph Waldo. *Essays and Journals.* Selected and with an introduction by Lewis Mumford. Garden City, N.Y.: Doubleday, 1968.

Emmeche, Claus. *The Garden in the Machine: The Emerging Science of Artificial Life.* Trans. Steven Simpson. Princeton: Princeton University Press, 1994.

Feldman, Irving. *Collected Poems, 1954–2004.* New York: Schocken, 2004.

Fermi, Rachel, and Esther Samra. *Picturing the Bomb: Photographs from the Secret World of the Manhattan Project.* New York: Abrams, 1995.

Fisher, David E., and Marshall Jon Fisher. *Strangers in the Night: A Brief History of Life and Other Worlds.* Washington, D.C.: Counterpoint, 1998.

Foucault, Michel. *Essential Works. Vol. 3: Power.* Ed. James D. Faubion. New York: The New Press, 2000.

Freud, Sigmund. *Civilization and Its Discontents.* Trans. James Stachey. New York: W. W. Norton, 1961.

Gadamer, Hans-Georg. *Truth and Method.* Trans. Garrett Barden and John Cumming. New York: Seabury Press, 1975.

Galeano, Eduardo. *Walking Words.* New York: W. W. Norton, 1995.

Gardner, Martin. *The Colossal Book of Mathematics: Classic Puzzles, Paradoxes, and Problems.* New York: W. W. Norton, 2001.

Gass, William H. *Tests of Time.* New York: Knopf, 2002.

Gates, Robert M. *From the Shadows: The Ultimate Insider's Story of Five Presidents and How They Won the Cold War.* New York: Simon & Schuster, 1996.

Geras, Norman. *The Contract of Mutual Indifference: Political Philosophy after the Holocaust.* New York: Verso, 1998.

Gray, John. *Enlightenment's Wake: Politics and Culture at the Close of the Modern Age.* New York: Routledge, 1995.

Gribbin, John, with Mary Gribbin. *Almost Everyone's Guide to Science: The Universe, Life, and Everything.* New Haven: Yale University Press, 1999.

Grossman, Vasily. *Life and Fate.* New York: Harper & Row, 1986.

Guéhenno, Jean-Marie. *The End of the Nation-State.* Trans. Victoria Elliot. Minneapolis: University of Minnesota Press, 1995.

Harrison, Edward. *Darkness at Night: A Riddle of the Universe.* Cambridge, Mass.: Harvard University Press, 1987.

Heidegger, Martin. *Parmenides.* Trans. André Schuwer and Richard Rojcewicz. Bloomington: Indiana University Press, 1992.

Heidmann, Jean. *Extraterrestrial Intelligence.* Trans. Storm Dunlop. Cambridge: Cambridge University Press, 1995.

Hobsbawm, Eric J. *Age of Extremes: The Short Twentieth Century, 1914–1991.* New York: Pantheon, 1994.

——. *On the Edge of the New Century: A Conversation with Antonio Polito*. Trans. Allan Cameron. New York: New Press, 2000.

Honig, Edwin. *Four Springs*. Chicago: Swallow Press, 1972.

Illich, Ivan. *Energy and Equity*. New York: Harper & Row, 1974.

Ivins, William A., Jr. *On the Rationalization of Sight*. New York: Da Capo Press, 1973.

Jameson, Fredric. *Postmodernism, or, The Cultural Logic of Late Capitalism*. Durham: Duke University Press, 1991.

Johnson, George. *Fire in the Mind: Science, Faith, and the Search for Order*. New York: Knopf, 1995.

Jordan, William. *Divorce Among the Gulls: An Uncommon Look at Human Nature*, New York: North Point Press, 1991.

Josipovici, Gabriel. *Touch*. New Haven: Yale University Press, 1996.

Kelly, Michael. *Martyrs' Day: Chronicle of a Small War*. New York: Random House, 1993.

Kolko, Gabriel. *Century of War: Politics, Conflict, and Society since 1914*. New York: New Press, 1994.

Lehman, David. *The Last Avant-garde: The Making of the New York School of Poets*. New York: Doubleday, 1998.

Levi, Primo. *The Voice of Memory: Interviews, 1961–1987*. Ed. Marco Belpoliti and Robert Gordon. New York: New Press, 2001.

Lockley, Martin. *The Eternal Trail: A Tracker Looks at Evolution*. Reading, Mass.: Perseus, 1999.

Magee, Bryan. *Confessions of a Philosopher*. London: Weidenfeld & Nicolson, 1997.

Marx, Karl. *Early Writings*. Trans. and ed. T. B. Bottomore. New York: McGraw-Hill, 1963.

May, Rollo. *The Discovery of Being: Writings in Existential Philosophy*. New York: W. W. Norton, 1983.

McCurdy, Howard E. *Space and the American Imagination*. Washington, D.C.: Smithsonian Institution Press, 1997.

McLuhan, Eric. *The Role of Thunder in Finnegans Wake*. Toronto: University of Toronto Press, 1997.

Menand, Louis. *The Metaphysical Club*. New York: Farrar, Straus and Giroux, 2001.

Moravia, Alberto. *Contempt* (first published in Italy as *Il disprezzo* in 1954). Introduction by Tim Parks. Trans. Angus Davidson. New York: New York Review Books, 1999.

Munroe, Alexandra, with Jon Hendricks, eds. *Yes Yoko Ono*. New York: Japan Society, in association with Abrams, New York, 2000.

Murdoch, Iris. *Existentialists and Mystics: Writings on Philosophy and Literature*. London: Chatto & Windus, 1997.

O'Doherty, Brian. *Inside the White Cube: The Ideology of the Gallery Space*. Berkeley: University of California Press, 1999.

Panek, Richard. *Seeing and Believing: The Story of the Telescope, or, How We Found our Place in the Universe*. London: Fourth Estate, 2000.

Paz, Octavio. *Children of the Mire: Modern Poetry from Romanticism to the Avant-garde*. Trans. Rachel Phillips. Cambridge, Mass.: Harvard University Press, 1974.

Perloff, Marjorie. *Wittgenstein's Ladder: Poetic Language and the Strangeness of the Ordinary*. Chicago: University of Chicago Press, 1996.

Reed, Edward S. *The Necessity of Experience*. New Haven, Conn.: Yale University Press, 1996.

Roethke, Theodore. *The Far Field*. New York: Doubleday, 1964.

Ronell, Avital. *The Telephone Book: Technology – Schizophrenia – Electric Speech*. Lincoln: University of Nebraska Press, 1989.

Rorty, Richard. *Philosophy and the Mirror of Nature*. Princeton: Princeton University Press, 1979.

Roy, Arundhati. *Power Politics*. Cambridge, Mass.: South End Press, 2001.

Scott, James C. *Seeing Like a State: How Certain Schemes to Improve the Human Condition Have Failed*. New Haven: Yale University Press, 1998.

Shukman, David. *Tomorrow's War: The Threat of High-Technology Weapons*. New York: Harcourt Brace, 1996.

Smolin, Lee. *The Life of the Cosmos*. New York: Oxford University Press, 1997.

Steiner, George. *Errata: An Examined Life*. New Haven: Yale University Press, 1998.

———. *No Passion Spent: Essays 1978–1995*. New Haven: Yale University Press, 1996.

Tournier, Michel. *The Mirror of Ideas*. Trans. Jonathan F. Krell. Lincoln: University of Nebraska Press, 1998.

Trow, George W. S. *Within the Context of No Context*. New York: Atlantic Monthly Press, 1980.

Tuan, Yi-fu. *Cosmos and Hearth: A Cosmopolite's Viewpoint*. Minneapolis: University of Minnesota Press, 1996.

Virilio, Paul. *The Information Bomb*. Trans. Chris Turner. New York: Verso, 2000.

Wachhorst, Wyn. *The Dream of Spaceflight: Essays on the Near Edge of Infinity*. New York: Basic Books, 2000.

Warner, Marina. *No Go the Bogeyman: Scaring, Lulling, and Making Mock*. New York: Farrar, Straus and Giroux, 1998.

Weyl, Hermann. *Philosophy of Mathematics and Natural Science*. Trans. Olaf Helmer. Princeton: Princeton University Press, 1949.

Wilbur, Richard. *Advice to a Prophet and Other Poems*. New York: Harcourt Brace, 1961.

Wilson, Edward O. *In Search of Nature*. Washington, D.C.: Island Press, 1996.

Zeldin, Theodore. *An Intimate History of Humanity*. London: Sinclair-Stevenson, 1994.

Zubrin, Robert. *The Case for Mars: The Plan to Settle the Red Planet and Why We Must*. New York: Free Press, 1996.

Articles and Essays

"But It's Not Just the Birds." *POPline*, no. 23 (May–June 2001): 1.

"2.5 Billion More People by 2050, UNFPA Reports." *POPline*, no. 26 (November–December 2004): 1.

Ashbery, John. "The One Thing That Can Save America." (1975) In *The New York Poets. Frank O'Hara, John Ashbery, Kenneth Koch, James Schuyler: An Anthology*, pp. 78–79. Ed. Mark Ford. Manchester: Carcanet, 2004.

Badkhen, Anna. "Russia Sees Profit in Spent Nuclear Fuel." *San Francisco Chronicle*. May 26, 2001: p. 1.

Berger, John. "The Changing View of Man in the Portrait." In *Selected Essays and Articles: The Look of Things*. Ed. Nikos Stangos, pp. 35–41. Middlesex: Penguin, 1972.

———. "The Hals Mystery." In *Selected Essays*, pp. 393–398. New York: Pantheon, 2001, 393–98.

Burroughs, William S. "Origin and Theory of the Tape Cut-ups." Lecture, Jack Kerouac School of Disembodied Poetics, Naropa Institute, Boulder, Colo., April 20, 1976.

Caldicott, Helen. "NASA Nuclear Roulette: The *Cassini* Mission's Plutonium Peril." *Nation*. September 29, 1997: 29–30.

Cohen, Stephen F. "The New American Cold War." *Nation*. July 10, 2006: 9–17.

Commission to Assess United States National Security Space Management and Organization. "Statement." Spring 2001: http://space.au.af.mil/space_commission/.

Danto, Arthur C. "Outline of a Theory of Sentential States." In *The Body/Body Problem: Selected Essays*, pp. 82–97. Berkeley: University of California Press, 1999.

Dyson, Freeman. "Can Science Be Ethical?" *The New York Review of Books*. April 10, 1997: 46–49.

Epstein, Helen. "An Infectious Sense of Danger." *Times Literary Supplement*. August 15, 1997: 25.

Erikson, Erik. "Human Strength and the Cycle of Generations." (1960) In *The Erik Erikson Reader*. Ed. Robert Coles, pp. 188–225. New York: W. W. Norton, 2000.

Faulkner, William. "Nobel Prize Acceptance Speech." (1949) Stockholm, 1950: http://nobelprize.org/literature/laureates/1949/faulkner-speech.html.

Ferris, Timothy. "Is This the End?" *New Yorker*. January 27, 1997: 44–55.

Goldberg, Michelle. "The New Monkey Trial." www.salon.com. January 10, 2005.

Goodman, Nelson. "On Starmaking." In *Starmaking: Realism, Anti-Realism and Irrealism*. Ed. Peter J. McCormick, pp. 143–47. Cambridge, Mass.: MIT Press, 1996.

Greenberg, Clement. "Avant-Garde and Kitsch" (1939). In *Clement Greenberg: The Collected Essays and Criticism*. Vol. 1. Ed. John O'Brian, pp. 5–22. Chicago: University of Chicago Press, 1986–93.

——. "The Situation at the Moment" (1948). In *Clement Greenberg: The Collected Essays and Criticism*. Vol. 2. Ed. John O'Brian, pp. 192–96. Chicago: University of Chicago Press, 1986–93.

Gugliotta, Guy. "Space Sugar a Clue to Life's Origins." *Washington Post*. September 27, 2004: A07.

Harpham, Geoffrey Galt. "Postmodernism's Discontents." *Times Literary Supplement*. June 28, 1991: 6–7.

Hayles, N. Katherine. "Simulated Nature and Natural Simulations." In *Uncommon Ground: Toward Reinventing Nature*. Ed. William Cronon, pp. 409–25. New York: W. W. Norton, 1995.

Highfield, Roger. "Alphabets Are as Simple as . . ." *Telegraph*. April 18, 2006.

Hirshfield, Jane. "Komachi at the Stoop: Writing and the Threshold of Life," *American Poetry Review*, no. 25 (September–October 1966): 29–38.

Holmes, Stephen. "No Grant Strategy and No Ultimate Aim." *London Review of Books* 26, no. 9. May 6, 2004: 9–14

Human, Katy. "Alpinists' Ice-Dreamy Mountains Melting Away." *Denver Post*. January 12, 2005: A01.

Huxley, Aldous. "Silence." (1945) In *The Perennial Philosophy*, pp. 216–18. London: Chatto & Windus, 1946.

Johnson, Barbara. Introduction to *Freedom and Interpretation: The Oxford Amnesty Lectures, 1992*, pp. 1–16. New York: Basic Books, 1993.

Judt, Tony. "Downhill All the Way." *The New York Review of Books* 49, no. 9 May 25, 1995: 20–25.

Keane, John. "The Humbling of the Intellectuals: Public Life in the Era of Communicative Abundance." *Times Literary Supplement*. August 28, 1998: 14–16.

Lieven, Anatol. "The Modern Limits of Democracy." *Financial Times*. January 12, 2005: 17.

Mellers, Wilfred. "'I am electrical by nature': Joscelyn Godwin. *Music and the Occult*." *Times Literary Supplement*. January 24, 1997: 18.

Mills, Stephen. "Pocket Tigers: The Sad Unseen Reality behind the Wildlife Film." *Times Literary Supplement*. February 21, 1997: 6.

Nakagaki, Toshiyuki, et al. "Maze-Solving by an Amoeboid Organism." *Nature*, vol. 407. September 28, 2000: 470, 493–96.

Norris, Robert S., and Hans M. Kristensen. "U.S. Nuclear Forces, 2004." *Bulletin of the Atomic Scientists* 60, no. 3 (May–June 2004): 68–70.

O'Neill, Brendan. "Iraq: The World's First Suicide State." *Spiked Online*. September 26, 2006; *http://www.spiked-online.com*.

Pilger, John. "The Other Tsunami," *New Statesman*. January 10, 2005: 10–12.

Powers, Thomas. "Who Won the Cold War?" *New York Review of Books.* June 20, 1996: 20–27.

Report of the Commission to Assess United States National Security Space Management and Orientation. January 11, 2001: http://space.au.af.mil/space_commission/.

Richter, Paul. "Pentagon Broadens Nuclear Strategy." *San Francisco Chronicle.* March 9, 2002: A1, A14.

Rorty, Richard. "Solidarity or Objectivity?" In *Philosophical Papers: Objectivity, Relativism, and Truth.* Vol. l, pp. 21–34. Cambridge: Cambridge University Press, 1991.

Roy, Arundhati. "The End of Imagination." *Nation.* September 28, 1998: 11–19.

Schell, Jonathan. "The Unfinished Twentieth Century: What We Have Forgotten about Nuclear Weapons." *Harper's* (January 2000): 41–56.

——. "Nuclear Madness." *Nation* 270, no. 21. May 29, 2000: 5–7.

——. "Letter from Ground Zero: The Power of the Powerful." *Nation.* October 15, 2001: 7, 32.

——. "The Growing Nuclear Peril." *Nation* 274, no. 27. June 24, 2002: 11–14.

Shapin, Steven. "What Did You Expect?" *London Review of Books* 27, no. 27. September 1, 2005: 31–32.

Sherry, Michael S. "Patriotic Orthodoxy and American Decline." In *History Wars: The* Enola Gay *and Other Battles for the American Past.* Ed. Edward T. Linenthal and Tom Engelhardt, pp. 97–114. New York: Metropolitan Books, 1996.

Smithson, Robert. "A Sedimentation of the Mind: Earth Projects." (1968) In *Robert Smithson: Collected Writings.* Ed. Jack Flam, pp. 110–13. Berkeley: University of California Press, 1996.

——. "Entropy Made Visible: Interview with Alison Sky." (1973). In *Robert Smithson: The Collected Writings.* Ed. Jack Flam, pp. 301–9. Berkeley: University of California Press, 1996.

Stockhausen, Karlheinz. "Attacks Called Great Art." *New York Times.* September 19, 2001: E3.

Stone, Allucquère Rosanne. "In the Language of Vampire Speak: Overhearing Our Own Voices." In *The Eight Technologies of Otherness,* Ed. Sue Golding, pp. 58–66. New York: Routledge, 1997.

Terborgh, John. "Cracking the Bird Code." *New York Review of Books.* January 11, 1996: 40–44.

Turkle, Sherry. "Tamagotchi Love." *London Review of Books* 28, no. 8. April 20, 2006: 36–37.

Warburg, Aby. "Images from the Region of the Pueblo Indians of North America." In *The Art of Art History: A Critical Anthology.* Ed. Donald Preziosi, pp. 177–206. New York: Oxford University Press, 1998.

Wasserman, Jim. "Growth Overwhelms California's Gains in Diversion, Recycling." *San Francisco Chronicle.* October 3, 2001.

Wheeler, John Archibald. "Information, Physics, Quantum: The Search for Links." In *Complexity, Entropy and the Physics of Information.* Ed. Wojciech H. Zurek, pp. 3–28. Redwood City, Calif.: Addison-Wesley Publishing, 1990.

White, E. B. "Here Is New York." In *Writing New York: A Literary Anthology.* Ed. Philip Lopate, pp. 693–711. New York: Library of America, 1998.

Wilbur, Richard. "Advice to a Prophet." In *Advice to a Prophet and Other Poems,* pp. 12–13. New York; Harcourt, Brace and World, 1961.

Wilson, Edward O. "Is Humanity Suicidal?" *New York Times Magazine.* May 30, 1993: 24–48.

Ziegler, Charles A. "Analysis of the Roswell Myth: A Traditional Folk Motif Clothed in Modern Garb." In *UFO Crash at Roswell: The Genesis of a Modern Myth,* pp. 30–73. Washington, D.C.: Smithsonian Institution Press, 1997.

Zweig, Connie. "The Death of the Self in the Postmodern World." In *The Truth about the Truth: De-Confusing and Re-Constructing the Postmodern World.* Ed. Walter Truett Anderson, pp. 145–50. New York: G. P. Putnam's Sons, 1995.

Kenneth Baker has been art critic for the *San Francisco Chronicle* since 1985. He served as art critic for the *Boston Phoenix* between 1972 and 1985, and has contributed to publications ranging from *Art + Auction*, *Artforum*, *ArtNews*, *Arts Magazine*, *Connoisseur*, and *Smithsonian* to the *New York Times Book Review*. The author of *Minimalism: Art of Circumstance*, Baker has also written for exhibition catalogues devoted to Giorgio Morandi, David Rabinowitch, Manuel Ocampo, and Edward Burtynsky, among other artists. Baker has lectured extensively and taught art history and criticism at colleges including Brown and Stanford Universities, the Rhode Island School of Design, and California College of the Arts.

Lynne Cooke is curator at Dia Art Foundation, New York, and chief curator at the Museo Reina Sophía, Madrid. Co-curator of the 1991 Carnegie International, and artistic director of the 1996 Sydney Biennale, she has also curated exhibitions in numerous venues in North America, Europe, and elsewhere. In addition to teaching at Columbia University in the graduate fine arts department, she is on the faculty for curatorial studies at Bard College. Among her numerous publications are recent essays on the works of Francis Alÿs, Rodney Graham, Jorge Pardo, Richard Serra, and Agnes Martin.